KARSH
CANADIANS

KARSH
CANADIANS

Yousuf Karsh

University of Toronto Press

TORONTO BUFFALO LONDON

© University of Toronto Press 1978
Reprinted 1978
Toronto Buffalo London
Printed in Canada

CANADIAN CATALOGUING IN PUBLICATION DATA

Karsh, Yousuf, 1908–

Karsh Canadians

ISBN 0-8020-2317-7

1. Photography – Portraits. 2. Canada –
Biography – Portraits. I. Title.

TR681.F3K375 779'.2'0924 C78-001418-9

To the people of Canada
and to my uncle, George Nakash
who brought me here

Contents

Introduction

On the stormy New Year's Eve of 1924, the liner *Versailles* reached Halifax from Beirut. Her most excited passenger in the steerage class must have been an Armenian boy of sixteen years who spoke little French and less English. I was that boy.

My first glimpse of Canada was the Halifax wharf, covered with snow. What lay beyond that Atlantic port? What country, what people, what chances for a penniless immigrant? I could not yet begin to imagine the sweep, the grandeur, and the infinite promise of this land, nor expect it to offer me a life rich in satisfaction, friends, and experience throughout the world.

For the moment, it was enough to find myself safe in Canada, the massacres, torture, and heartbreak of Armenia behind me; to feel, even then, that I was coming home. During the next half-century, this feeling was continually reaffirmed so that now, with thanks inexpressible, I consider myself an old Canadian. Never, in all those years, have I been tempted to live anywhere except in the country and among the people who first welcomed me as one of their own.

This book is my expression of gratitude to them, through the medium of photography. This book contains exclusively Canadian portraits, and is wholly produced in Canada. Since only a fraction of my Canadian portfolio, collected over some five decades, can be included in a single volume, the choice has been difficult and entirely personal but unprejudiced, I hope, by friendship. Countless men and women who deserve a place are omitted because I lacked the opportunity to photograph them.

My gallery is incomplete, but then so is the portrait of Canada in photography, in written words, in the arts, and in the collective mind of its people. A photographer would need several lifetimes to explore and portray my homeland – for me, the most fortunate nation.

All this I could not have foretold when I landed at Halifax on a steely cold, sunny, gleaming, and typically Canadian winter day. I had no money and no schooling that could formally be called an education, but I had an uncle, my mother's brother, who awaited me and recognized his nephew from a crude family snapshot. George Nakash, whom I had not seen before, sponsored me as an immigrant, guaranteed that I would not be a public charge, and travelled all the way from Sherbrooke, Quebec, for our meeting – the first of innumerable kindnesses beyond my repayment.

The immigration officials allowed Uncle Nakash to stay beside me at the night-long formalities of checking and re-checking my papers. He was impatient with the delay, but I was fascinated by these strange surroundings and too unaware of Canadian distances to fret about missing the train next morning.

There was no time to spare when we were taken from the dock to the

station in a taxi, the like of which I had never seen, a sleigh drawn by two brisk horses. Their harness bells jingled merrily and the bells of the city rang out to mark a New Year. The sparkling decorations in the windows of shops and houses, the people on their way to church, the laughing crowds on the streets – for me this was a fantasy, unbelievable but true. An immigrant boy who had yet to drink alcohol felt intoxicated with joy. I had come a long way from my tortured nation in the Middle East, and the years there already seemed part of another life.

I was born in Mardin, Armenia, on December 23, 1908, of Armenian parents. My father travelled widely, importing and exporting art works, furniture, rugs, and spices. Although he could neither read nor write, he had a fine taste in rare and beautiful things. My mother, unlike most Armenian women of her time, was well read, particularly in her beloved Bible.

Of their three living children I was the eldest. My two brothers, Malak and Jamil, had been born in Armenia. My youngest brother, Salim, born later in Syria, alone escaped the ruthless persecution soon to reach its climax in our birthplace. The atrocities of 1915, the starvation, the typhus, the relatives suffocated or pitched into wells, are among my earliest memories. They remained with me when, in 1922, the road to freedom opened a crack and our family was one of the first allowed to flee. With us we took no baggage – only our lives. In Syria, my father painstakingly tried to rebuild our lives. It was a continual struggle, day after day. Somehow he found the means to send me to Canada, then to me no more than a name, a vague space on my schoolboy's map.

Uncle Nakash was a photographer of established reputation, a bachelor and a man of generous heart. Like a good father, he packed me off to the Sherbrooke High School. I went reluctantly, fearing my companions, but within a few days they were teaching me to skate and to speak English. Soon I was invited regularly to their homes. I had made my first Canadian friends.

Still better, I applied for naturalization in Canada a week after my arrival and now, as I thought, belonged to this hospitable country. But my formal education ended almost before it began.

In the summer of 1925, I went to work for Uncle Nakash at his studio. From then on, photography was to be my goal, my livelihood, and my passion. I roamed the fields and woods around Sherbrooke every weekend with a small camera, one of my uncle's many gifts, developed the pictures myself, and showed them to him for criticism. They had no merit but I was learning.

Once I photographed a landscape with children playing and gave it to a

classmate as a Christmas gift. Secretly, he entered it in a contest conducted by the T. Eaton Company. To my amazement and delight, my photograph won the first prize of fifty dollars. I gave ten dollars to my friend, and happily sent the rest to my parents in Aleppo, the first money I could send to them from Canada.

Evidently Uncle Nakash was impressed for, shortly after, he arranged my apprenticeship with John H. Garo of Boston, a distinguished portraitist, a fellow Armenian, and a wise counsellor. Garo encouraged me to attend evening classes in art and guided me to study the work of the great masters. Although I never learned to paint, or to make even the simplest drawing, I learned much about lighting, design, and composition.

I also became a voracious reader in the humanities at the Boston Public Library, and this discovery made me realize the greater dimensions of photography. Garo prepared me to think for myself and evolve my own distinctive interpretations.

Since we worked by natural light in those days, and stopped long before dusk, I had many opportunities to hear the stimulating conversation of Garo's friends – all prominent in music, letters, art, and the theatre – who would gather in his studio. My narrow world broadened. My education was augmented. It was in Garo's studio that I first set my heart on photographing those men and women who leave their mark on the world. Full of ambition, I prepared for an independent career.

But where? After pondering the vital question at length, I chose Ottawa because I was now a Canadian and because the capital of my adopted country – a crossroads of world travel – would give me the chance to photograph its leading figures and its many foreign visitors. The choice was the wisest I ever made. Ottawa would always remain the centre of my professional and private life.

I arrived there in the autumn of 1932 as an assistant to John Powis, a photographer, who later retired. At first, struggling to earn a livelihood, I had a modest studio, where the furniture consisted mostly of orange crates covered with monk's cloth.

Within a year, so early in my career, I was most fortunate to meet B.K. Sandwell, the learned editor of the prestigious and elegantly illustrated magazine, *Saturday Night*. There, along with Sandwell's political and social comments, my photographs were reproduced for the first time.

It was at the Ottawa Little Theatre where I first discovered the world of incandescent light. At rehearsals and performances I photographed the players on the stage, using spotlights and floodlights instead of daylight, experimenting and seeking to create the mood, the atmosphere, of what was happening.

One of the leading actors at the Little Theatre was young Lord Duncannon, the son of the Governor General, Lord Bessborough, and Lady Bessborough, who were themselves avidly interested in stage production. In their own castle in Scotland, they had a miniature theatre.

Without too much hope, I asked Lord Duncannon if he could persuade his father and mother to sit for me. They accepted, but the first photographic attempt was disastrous. The Bessboroughs proved most understanding of a nervous young photographer's feelings, and consented to sit for me again. This time, their portraits were a great success and appeared as double-page spreads in the *Illustrated London News*, *The Tatler*, *The Sketch*, and many newspapers across Canada. That was my photographic breakthrough.

Something much more important than my work came out of the theatre. I met its leading actress, Solange Gauthier, who had been born in Tours, France, and, like me, had chosen Canada for her home. Our marriage was happy, our lives serene until, to my searing grief, she died long before her time in 1960.

Lord Bessborough's successor as Governor General was Lord Tweedsmuir, better known to readers of adventure thrillers as John Buchan, the author of *The Thirty-Nine Steps*. He was the most unassuming of men, impatient with the strict protocol and rigid formality his position sometimes demanded. During his tenure of office, in 1936, President Franklin Delano Roosevelt of the United States visited Quebec City to confer at the Citadel with Lord Tweedsmuir and Prime Minister Mackenzie King. I was invited to photograph this eminent guest of Canada, and it was on this occasion that I first met personally Mr King, who was later to become my patron and friend.

When the President emerged from the Citadel on the arm of his son, James, accompanied by Tweedsmuir and King, they stood formally on the terrace, ready to be photographed. Then Tweedsmuir began to tell one of his humorous Scottish stories and they relaxed; the resultant photograph was my first foray into photojournalism.

It was Mackenzie King who made it possible for me to photograph Winston Churchill in December 1941, after the great wartime leader addressed the combined Houses of Parliament in Ottawa. The world's reception of that photograph – which it was said epitomized the indomitable spirit of the British people – changed my life. Soon after, I was on my way to England to photograph other British personalities. It was a slow and rather frightening voyage on board a Norwegian freighter, carrying a cargo of explosives, part of a 93-ship convoy; but we arrived safely.

In London, Vincent Massey, the Canadian High Commissioner, facilitated appointments with such men as H. G. Wells, Sir Alan Brooke, Lord Beaverbrook, Ernest Bevin, Clement Attlee, Lord Mountbatten, the Archbishop of Canterbury, King Haakon of Norway, Jan Masaryk, Paul Henri Spaak, Field Marshal Smuts, Lord Wavell and, as a happy culmination, King George VI, Queen Elizabeth, and Princess Elizabeth. This exhausting, though rewarding, journey to Britain was the first of many photographic odysseys all over the world which have taken me from Buckingham Palace to a Zulu kraal, from New York to the Arctic, from the Zen Buddhist temples of Japan to the temples of avarice in Las Vegas, and to almost every region of Canada.

My mind is at ease while I travel for I have been especially fortunate in my studio family, who help me greatly.

Ignas Gabalis, a superb printer and an artist in his own right, has worked diligently with me for over a quarter of a century and has participated in the preparation of this book.

Hella Graber, who now pursues her own artistic career, was for many years my technical assistant and librarian and helped me immeasurably..

Joyce Large, before her retirement, was my secretary for twenty-five years.

Mary Alderman, my present secretary, sees to the smooth running of the studio. With her alert eye for details, she has patiently typed and retyped this manuscript.

With my marriage to Estrellita Nachbar, a gifted medical writer from the United States, the house outside Ottawa, called Little Wings in honour of its visiting birds, became lively again – a sanctuary from the day's work and the world's tumult, a gathering place for friends, a minor museum for my *lares* and *penates*, the household gods collected at random in our travels. With her editorial skill, Estrellita has helped me formulate my thoughts.

With gratitude, I dedicate this book to the Canadian people, and with enthusiasm I look forward to the portrait I will make tomorrow.

Yousuf Karsh
Ottawa, July 1978

KARSH
CANADIANS

Margaret Atwood

1977

Margaret Atwood is, I suppose, the outstanding literary heroine of her generation in Canada, although her writing – poetry, fiction, and criticism – sometimes enrages her readers. But none can deny her far-ranging talents.

They drew me to a secluded farmhouse outside Alliston, Ontario, on a cold, stormy November day. The first thing that caught my eye as I entered was a pot-bellied stove. Its thick, shiny pipe dominated the living room and reminded me that Miss Atwood was a true countrywoman, not a rustic poseur.

I wondered if she would be as caustic and provocative as some of her books. On the contrary, as I soon found, she was as natural, friendly, and unassuming as her home. Everything, from its simple furnishings to the duck pond and the fruit trees gracing the property outside, suggested the ideal setting for the writer's craft, a task that demands concentration and serenity. Miss Atwood has both those qualities, despite her onerous work load which she discussed with me in frank, unhurried fashion. Her fellow writer, Graeme Gibson, and their tiny daughter, Eleanor, listened eagerly to my questions and her brisk answers.

I chose to photograph Miss Atwood against a circular patchwork quilt which hung over the dining room table. At her side is a small stack of books, all with a special meaning in this house: her recent collection of short stories, *Dancing Girls*; Graeme Gibson's novel, *Five Legs*; and a volume by another important author, Joyce Carol Oates.

Miss Atwood talked mostly about her efforts on behalf of Canadian writers but I sensed that her central interest was in her home. Evidently she held her literary achievements and domestic happiness in magical balance.

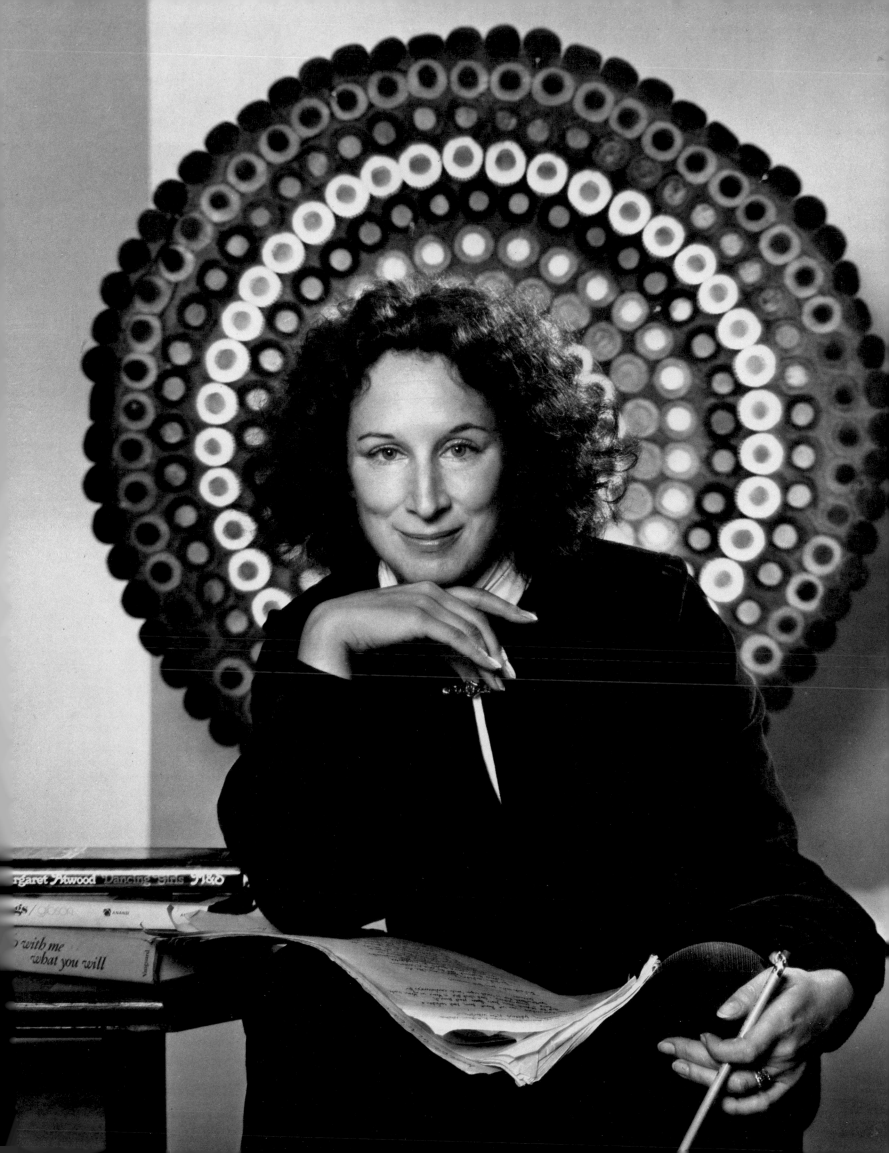

Marius Barbeau

1966

Long before most Canadians realized they had inherited a precious treasure in the artifacts of the Pacific Coast Indians, the Eskimos, and the early Quebec craftsmen, a humble scholar in Ottawa was working to preserve them. Thanks to Marius Barbeau more than anyone else, the nation discovered late, but not too late, the value of this unique legacy. It was unique, in the literal sense of the word, because Canada's native artists followed methods and invented designs unknown in any other part of the world.

Barbeau was among the first to appreciate what the forgotten pioneers of our culture had accomplished and he devoted his life to their vindication. As early as 1926, when few Canadians were interested in the totem poles of British Columbia, he rightly saw them as an extraordinary concept, inspected them at first hand, and was shocked to find them neglected, rotting under the coastal weather or taken away to foreign museums.

His attempt to save them was a lonely, uphill job but he finally enlisted the support of governments, art galleries, and the public. As a result, many irreplaceable carvings, dug-out canoes, and other exhibits are now safe for future Canadians. Even more gratifying to Barbeau, although he did not live to see it, a new generation of Indian carvers as successful as the old, a brilliant school of workers in metal, stone, and paint, has appeared and won wide recognition.

Barbeau travelled wherever he could to see the artists at work in their own surroundings. He published books and monographs to describe his experiences, collected family histories, and recorded ancient native songs that had never before been written down and would otherwise have been lost.

Still more important, perhaps, was his transcription of folklore and music. Some twenty thousand examples are preserved in the National Museum of Man. So is the memory of Barbeau's achievements. Yet to the end he remained a modest, quiet little man who used to dine with us frequently, when he would tell stories of his adventures among the original Canadians. I photographed him in his home where he sometimes sang Indian songs and beat a primitive drum to accompany them for the delectation of my wife, Estrellita. Those evenings with a scholar, an artist, and a fine citizen of Canada are unforgettable.

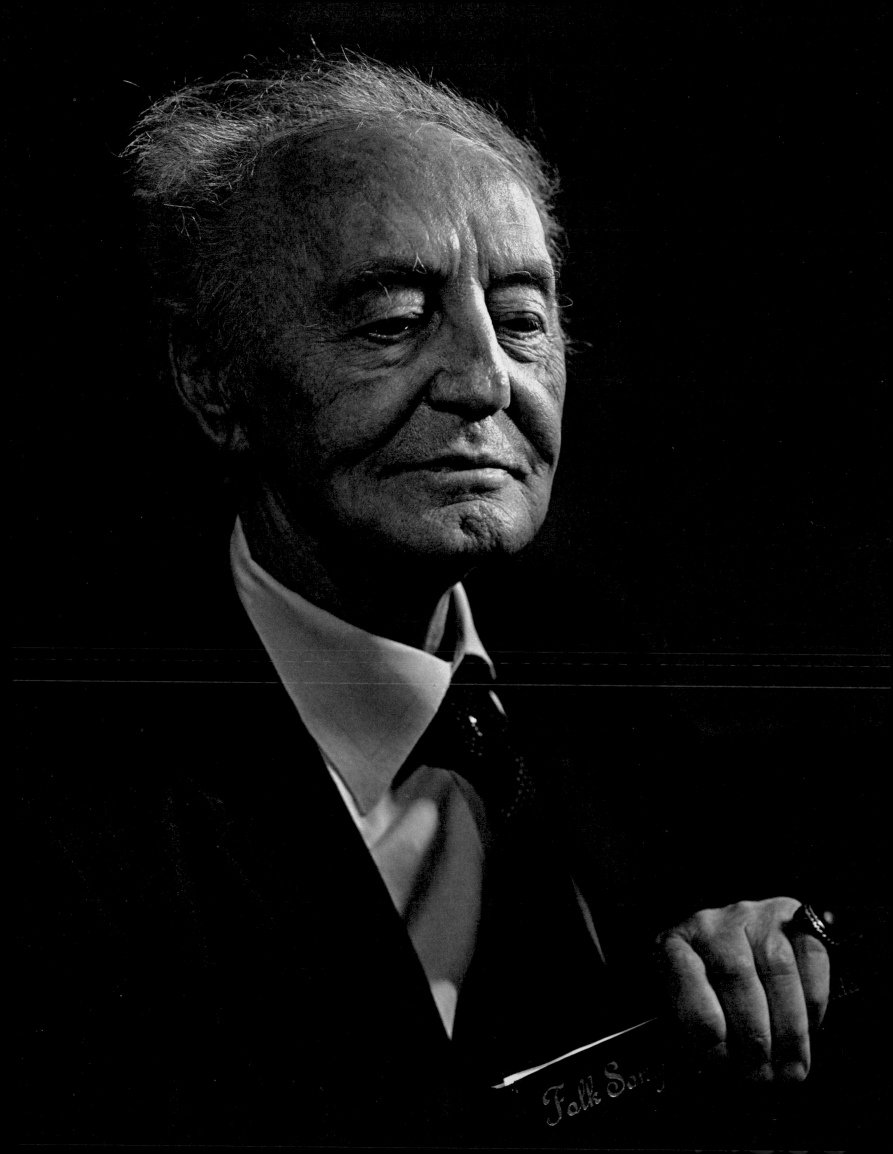

Lord Beaverbrook

1943

When, in 1943, Lord Beaverbrook (the Beaver as everyone called him) agreed to let me photograph him, the Canadian clergyman's son had become one of Britain's most influential figures. I wanted his portrait for my international collection, then beginning, but he had no time to discuss such trivia in the deepening crisis of world war. This tiny, dynamic, and restless man appeared to scorn small talk of any kind and urged me to get on with the job.

Studying the face already familiar everywhere, I judged it to be in the French phrase, *d'un bel laideur* – a handsome ugliness. Or, if not quite handsome, powerful, expressive, and changing from moment to moment with his mercurial temper.

Thus, of a sudden, he demanded that I photograph him without his jacket and pulling on suspenders. That, I gathered, was his notion of a wartime leader at work.

'Surely,' I protested, 'you don't really mean to be pictured in that fashion?'

'I don't give a damn how you photograph me,' he relented, and I hastened to focus my camera on him before he could remove the jacket.

My portrait of Beaverbrook was reproduced almost immediately on a full page of the *Illustrated London News* – and it delighted him. As soon as he saw the magazine he telephoned Vincent Massey, the Canadian High Commissioner, asking him to arrange for me to dine at Beaverbrook's great estate, Cherkley.

When I rang the entrance bell, he opened the door himself and, without giving me a chance to cross the threshold, announced: 'Karsh, you have immortalized me!' That compliment seasoned a very good dinner.

The next day, I repeated Beaverbrook's remark to his chief assistant, Sir Charles Porter, who inquired impishly: 'Do you think immortality was such a good idea?'

Over the years, Beaverbrook continued to touch my life. I photographed him again in 1949. And when Estrellita and I were married in 1962, at St Patrick's Cathedral in New York, the photograph of the bride and groom was the first beamed by satellite from New York to the *Daily Express* in London. There followed a warm correspondence between Beaverbrook and my wife. To me he remained friendly, baffling, and unforgettable.

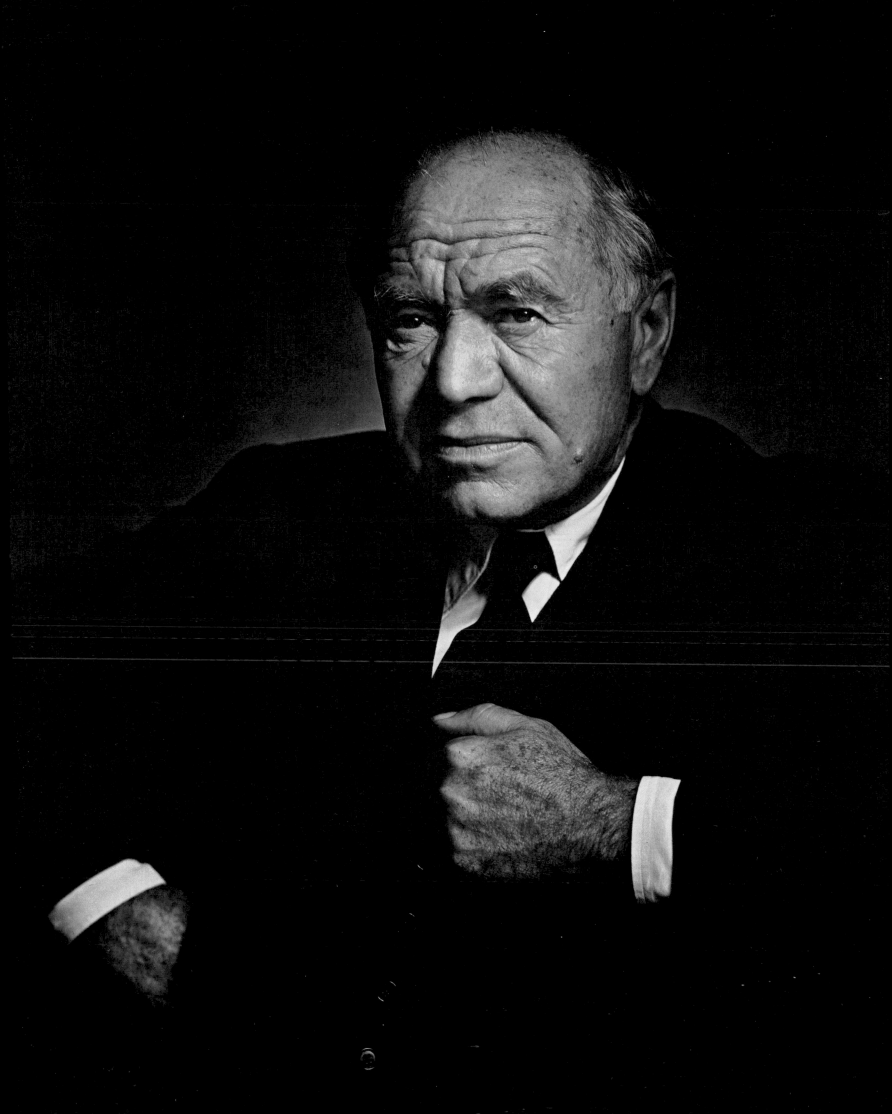

Mario Bernardi

1974

Mario Bernardi has always been a perfectionist and a hard worker. The National Arts Centre Orchestra of Ottawa was hailed as a superb musical ensemble from its very first performance in October 1969, despite its small size and specialized repertoire. And after an enthusiastic reception by New York audiences and critics in 1972, its international reputation was secure. Much of the credit for its success belongs to the conductor.

He had conducted the Sadlers Wells Opera in London for three years before returning to Canada to accept this challenge. Then he spent another full year hand-picking and training the members of the Ottawa orchestra to meet his high artistic standards.

Unfortunately, he no longer has time to appear in public as the fine solo pianist he is. In the early sixties his talent was recognized by no less an authority than Igor Stravinsky for an exceptional performance in the Symphony of Psalms. At that citation Bernardi burst into tears.

With his orchestra he is not given to emotional candour. An intense, compact man, a native of the northern Ontario mining country, he has a reputation, during working hours, for toughness and for a dazzling wit, his musicians say. Certainly he does not spare his own energies. They have made Ottawa a much livelier and more sophisticated cultural centre than it was when I first knew it.

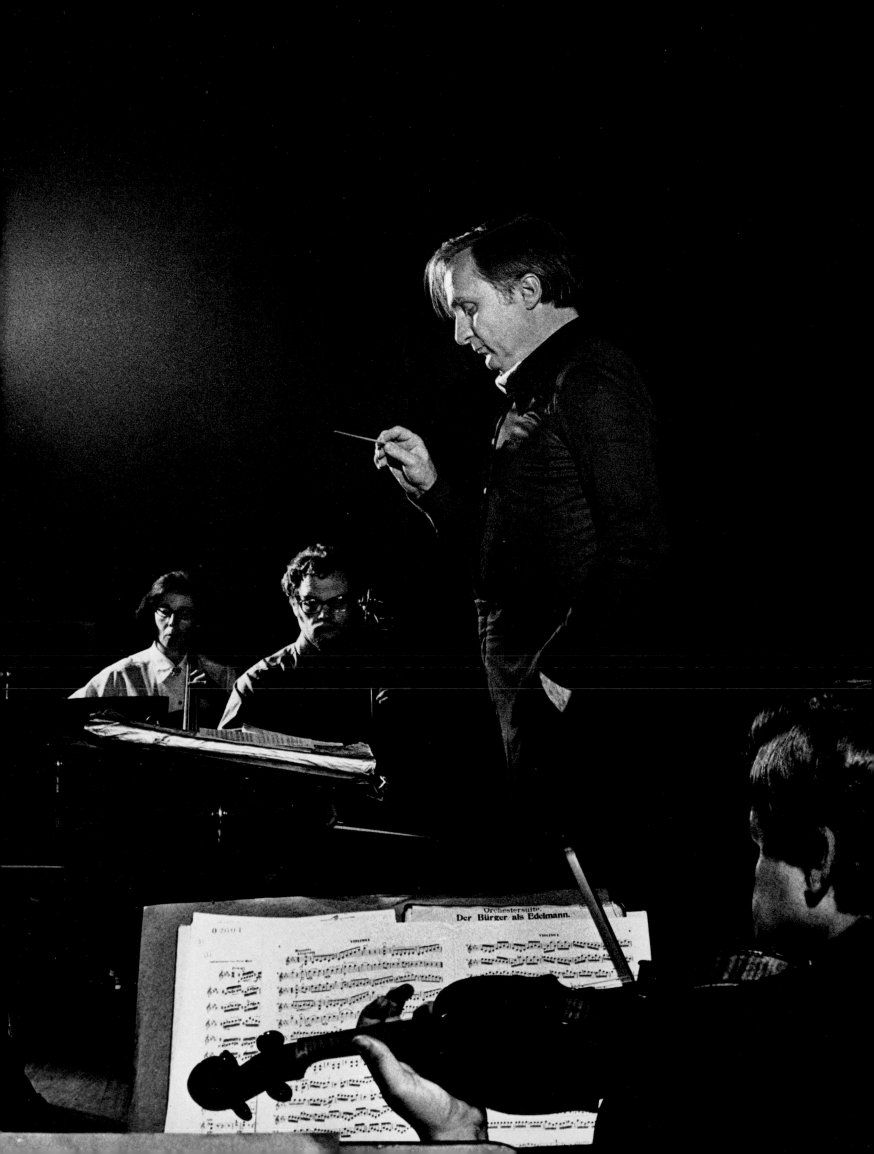

Pierre Berton

1974

To most men, including me, the sheer energy and perpetual motion of Pierre Berton are impressive. I admire him for his prolific achievements in Canadian letters, his deep authentic sense of the nation and its people.

My friendship with this electric personality began in 1953 when, as managing editor of *Maclean's* magazine, Pierre assigned me to interpret the mood of Canada in photographs. I crossed the country twice, winter and summer, visiting sixteen cities. This was my first chance to see Canada intimately and whole – a moving experience. Everywhere my first wife, Solange, and I received the warmest of welcomes. *Maclean's* even ran a Christmas cover showing me at the North Pole with Santa Claus facing my camera.

Since that tour, Berton and I have met often, at the opening nights of the Stratford Festival and in front of a microphone. I never miss his television show, 'Front Page Challenge.'

It seemed best to photograph him when he had paused, between books. The restless author relaxed in a garden chair on his patio. Surrounded in his home, outside Kleinburg, Ontario, by his lovely wife, Janet, and an abundance of children, Pierre radiated openness and contentment. Then, the portrait made, this man of many talents cooked an impeccable dinner, served it with vintage wine and, I suspect, meditated his next best-seller.

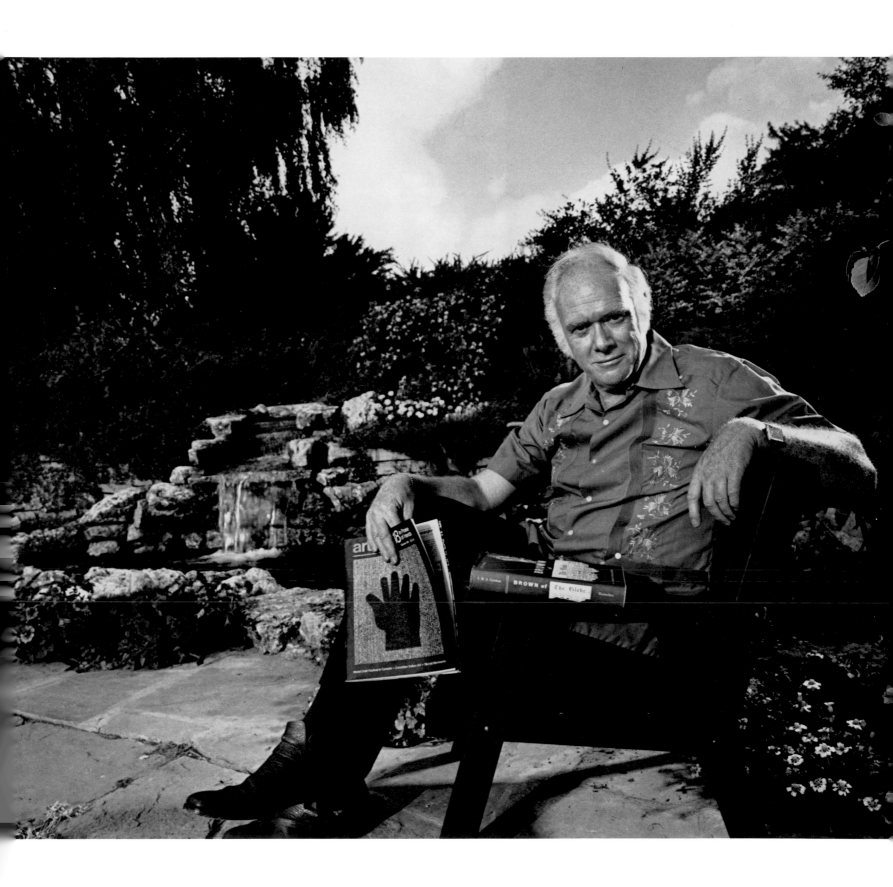

Charles H. Best

1954

On first meeting him no one unaware of his work would have taken the late Dr Best for a scientist. The great Canadian physician and co-discoverer of insulin was disarmingly informal and approachable – an all-round traveller, lecturer, painter and, I would think, what the English call an 'enjoying man.' But when I asked him about his own field of expertise, it was the scientist admired throughout the world who answered my questions.

His answers were prompt, businesslike, and simple, but they were full of substance and information which even I, as a layman, could understand.

The discovery of insulin, he told me, had not occurred, as the popular myth has it, by chance or wild surmise. It had been a systematic process that he and his colleague, the late Sir Frederick Banting, long and patiently conducted after first studying the fatal diabetes occurring in de-pancreatized dogs. The investigators were determined to find a substance in the pancreas capable of counteracting this disease and eventually they found it, to the incalculable benefit of mankind.

Dr Best admitted, however, that chance often played an important part in research, although as a rule only the well-trained researcher could recognize the opportunity when it appeared before him. He distinguished two types of research workers, the explorers and the developers. Best and Banting, I guessed, had been both.

I was encouraged by Dr Best's open manner to put forward an amateur's theory of my own. When one remedy for human illness is discovered, I said, it often seems to provoke another pest, as if a mysterious attack and counter-attack were under way in the body.

'Not so,' came the quick reply. 'The top of a newly scaled mountain reveals vistas of grand beauty and many previously unknown chasms.' Few men have seen more of this awesome scenery than the amiable doctor, the all-around enjoying man.

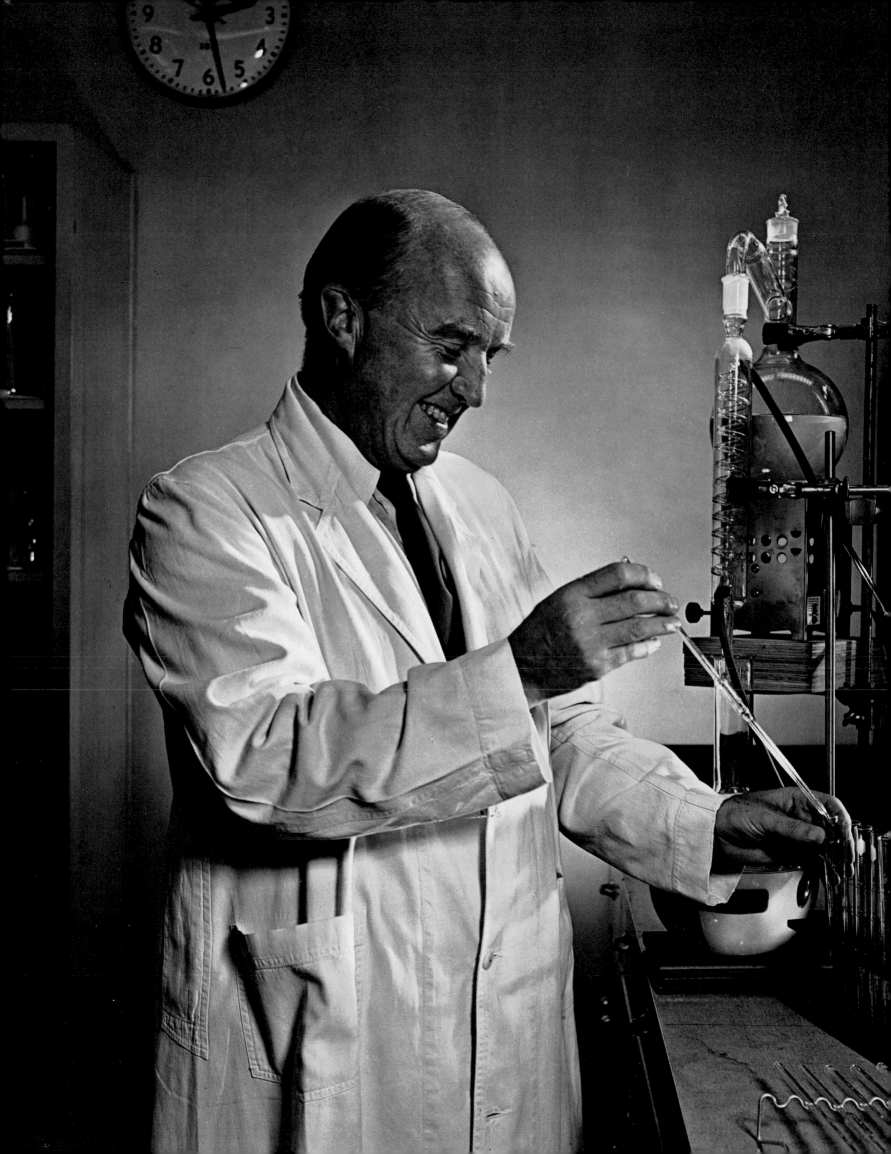

W. A. (Billy) Bishop

1943

Long before I photographed Billy Bishop during the second world war, the first world war had fixed him forever in Canada's folk memory beside the heroes of an earlier time. At the age of twenty-four he was already legendary, the matchless pilot who between 1914 and 1918 had shot down more than seventy enemy aircraft. His astounding, single-handed attack on a German aerodrome had made him the first Canadian airman to win the Victoria Cross.

Having studied his youthful record, I approached the middle-aged Bishop expecting to find a stern and solemn military personage. Instead, he was relaxed, informal, and quite charming – a true *bon vivant*. Rumour had it that whenever Winston Churchill visited Canada in the years of the second world war he would always seek out Bishop's sympathetic company, because Mr King, the Prime Minister, did not stock Churchill's favourite brandy. Even if that story contained an unlikely grain of truth, Bishop, when I made his portrait, was also a hard-working Honorary Air Marshal helping to direct Canada's aviation program.

Perhaps I had another reason for wishing to photograph him. He employed a very attractive secretary whom I also recorded on film. And Bishop proved to be so tolerant that he didn't object when my portrait of the beautiful Marget Northwood appeared on the front page of the newspaper – while his own was relegated to page four.

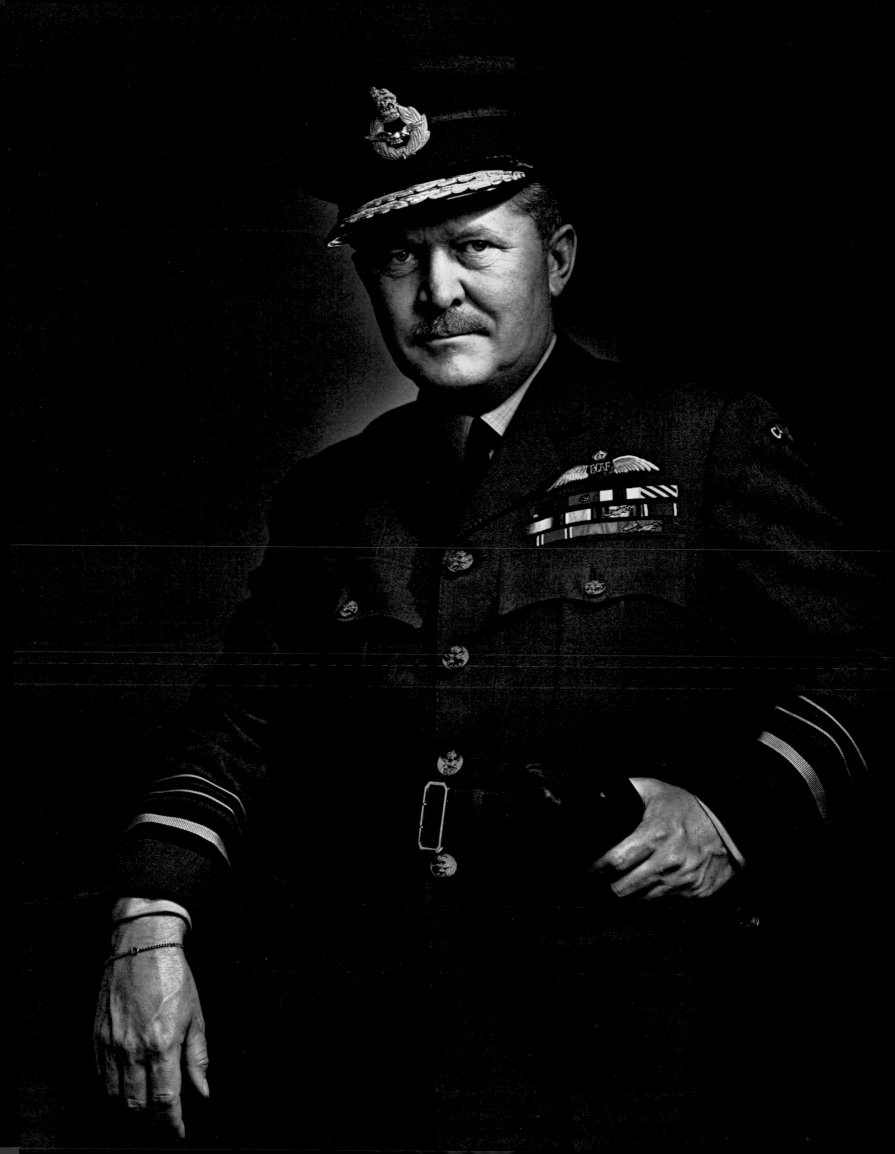

Sir Robert Borden

1933

When he visited my tiny studio on Sparks Street, Sir Robert Borden was in the Indian summer of his life – and thoroughly enjoying it. But it seemed to me, a newcomer to Canada, that his fellow countrymen had yet to appreciate the full significance of his magnificently successful career, rich in achievement, often agonizing in the responsibilities of wartime.

That recognition was to come only after he had died. In the meanwhile Harry Southam, publisher of the Ottawa *Citizen*, persuaded him to let me take his photogaph.

I was somewhat awed by the presence of Canada's Grand Old Man, as he was then called, but I need not have been. Borden carried his years lightly, with an old-fashioned courtesy and quiet charm. His manner was simple, his mind at peace, his conversation cheerful and modest. There was no pretence, no artificial image, and no personal ambition in this gentleman who now belonged to Canada's history.

Although he had deliberately kept himself outside politics after his retirement as Prime Minister in 1920, he remained active in other fields. He frequently attended the League of Nations (where he had secured Canada's independent membership), delivered lectures, and lent his patronage to many useful organizations.

In his private life he had time for hobbies, numerous and varied. At his Ottawa home, Glensmere, he cultivated his prize roses, and watched and catalogued the visiting birds, a pastime that I was soon to adopt myself, with equal pleasure.

Above all, Borden was a reader of good books. While I was making his portrait he told me that, by day, he re-read the complete works of Charles Dickens and Walter Scott, the favourites of his youth, and by night the plays of Shakespeare, the intimate of his age.

This portrait, I think, reflects the serene detachment of a truly great Canadian who served his people well and asked no reward beyond the satisfaction of his public work and the solace of privacy toward the end.

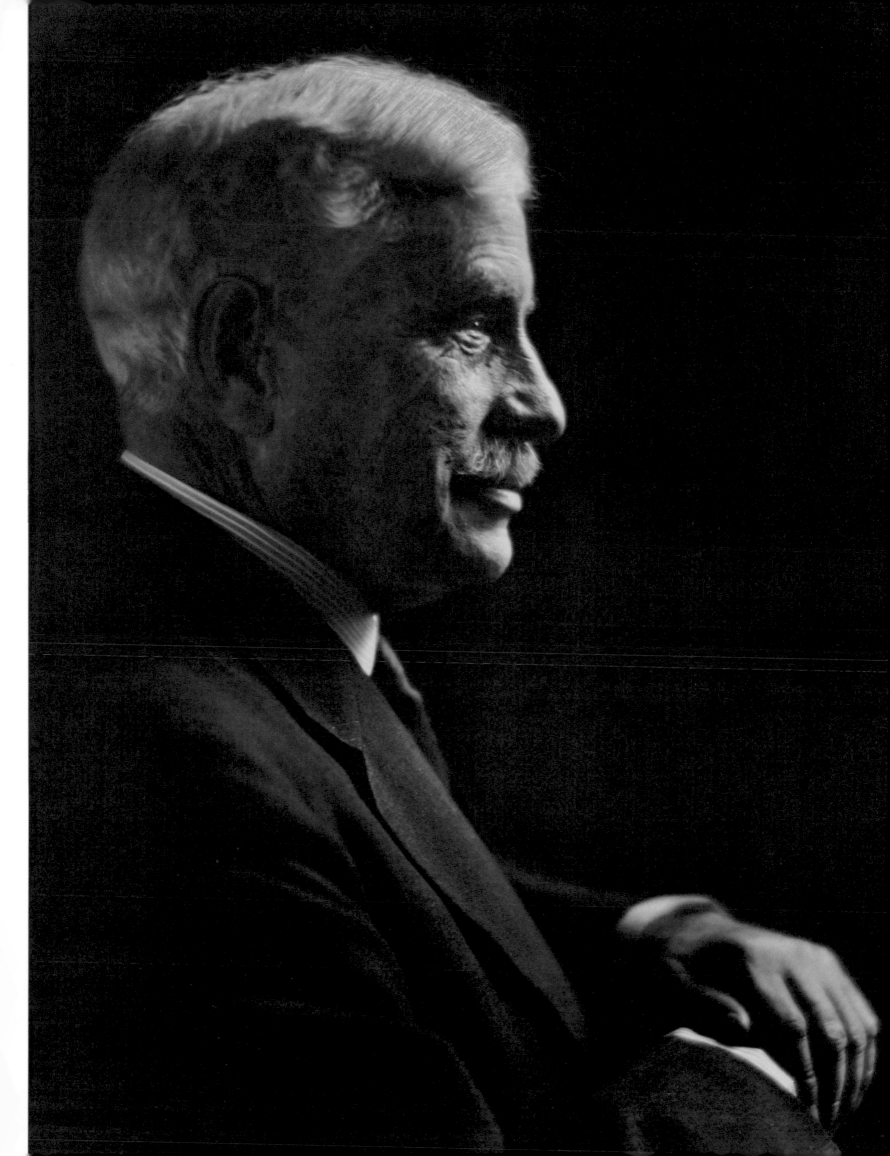

William Boyd

1949

'It doesn't matter what book you recommend – they will all read Boyd' is how one medical school professor put it. Visiting again with William Boyd, the great pathologist and medical writer, some years after I had photographed him in 1949, I found the Scottish burr and gentle charm were still there, as was the trained, articulate voice and characteristic puckish twitch of the eyebrow which had engaged generations of medical audiences.

We conversed in Boyd's study. Around us hung treasured photographs – of the Matterhorn, the Scottish manse where he was born, his hero, Lawrence of Arabia – and nearby lay a beloved book of hand-copied quotations dating from Edinburgh days. In Boyd's roster I was pleased to see the name of my physician-brother Jamil, who had spent a landmark year with him.

I asked how he became a pathologist. 'I practised as a psychiatrist in Edinburgh for three years before a letter from Winnipeg, Canada, arrived, inviting me to be their first professor of pathology. On the boat, I read Mallory's *Pathology* in preparation for delivering one hundred lectures. I knew very little, but the students knew even less. I always managed to keep one day ahead of them.' I was astonished to hear these modest remarks from an author whose texts had informed millions.

Boyd went on to remark that reading Shakespeare was as enjoyable to him as writing his books – which he never regarded as work. Later, reading his textbook, I understood. Through the exquisite precision of his prose glowed an intense respect for all living creatures. To pathology, a hitherto dead subject, he had brought his own sense of the celebration of life.

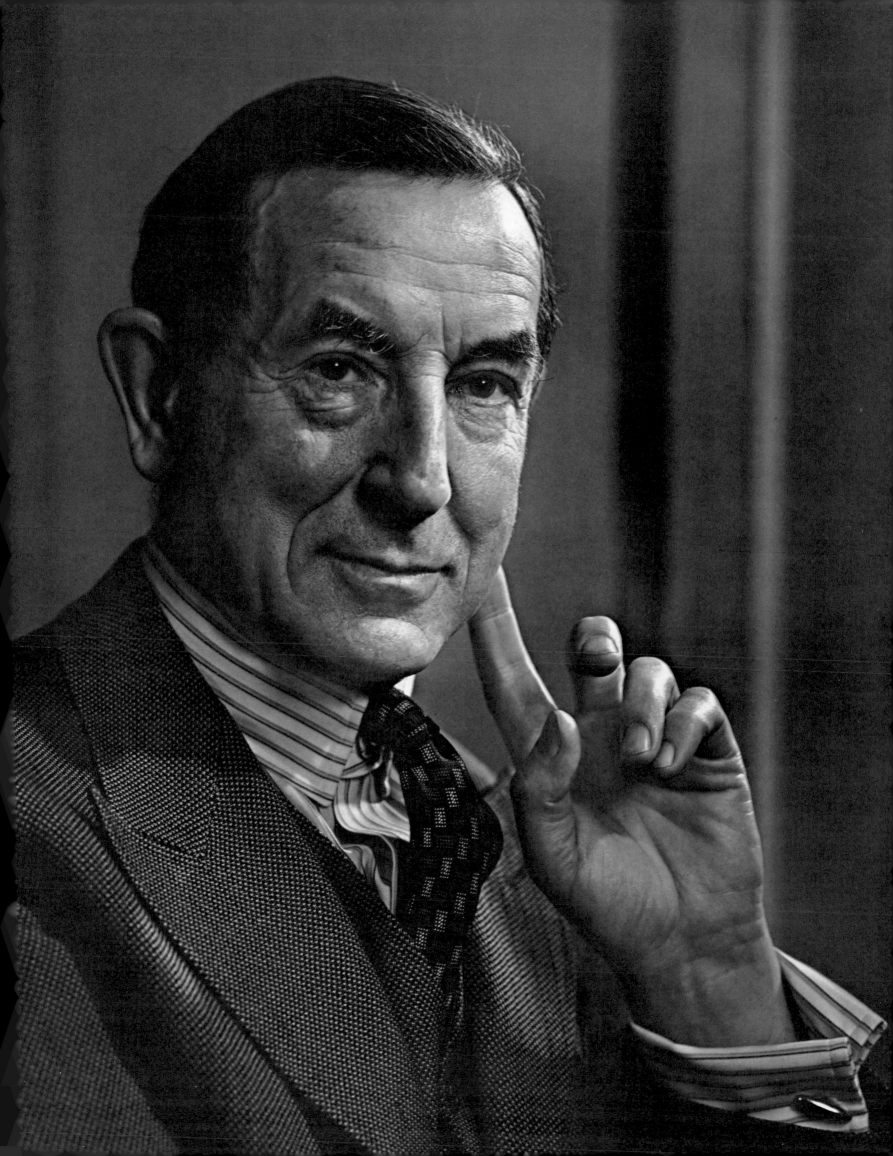

Leonard Brockington

1945

In his day, Leonard Brockington was accepted, admired, and enjoyed as Canada's finest orator and unequalled wit. Although he wrote well, and was the author of some notable speeches delivered by Prime Minister Mackenzie King, his true love was the English language, and his Welsh baritone voice was a perfect vehicle for the flair with which he used it.

Some of his prepared wartime speeches have been recorded, but his friends remember best the spontaneous jokes, puns, and mischievous asides that flitted through his conversation. With him, nothing was as delightful as lively talk about great affairs or the common round of life. Certainly I never heard a talker so witty, eloquent, and hypnotic.

There was much more to this remarkable man, however, than talk. He had been terribly stooped and handicapped by arthritis in middle life, when he practised law in Calgary, but later in Ottawa he never spared himself in war service, travelling more, and further, than most of his younger colleagues.

When I arrived in London on photographic assignments during those grim years, I discovered, to my delight, that Brock and I both were staying at the Savoy Hotel. There, in his suite, he held court every night, stimulating the minds of his guests with scintillating monologue and soothing their nerves with discreet potions of alcohol. When London lived under enemy bombs, alcohol was hard to come by, but somehow he always had a little store of scotch and wine which he generously shared.

He knew everyone of importance and briefed me on the personalities I was going to photograph – a spacious gallery of the great, including among others, Sir Alan Brooke, Clement Attlee, the Archbishop of Canterbury, and George Bernard Shaw. The evening sessions with Brock were the best sort of preparation I could have hoped to receive.

He, himself, was a treat to capture on film. This portrait was made in Ottawa at the request of the magazine *Popular Photography*. The assignment was for me to be photographed while I, myself, was photographing someone else. Without a second thought, I invited Brockington to be my subject since his magnificent leonine head and cleanly chiseled features were likely to make a striking composition.

In the following years, whenever he visited Ottawa, it was our pleasure to entertain him at our home, Little Wings. His stories, and his choice of words, harkened back to an earlier, leisured time when language was respected as a luxury to be savoured. He savoured it, and shared it, to the full.

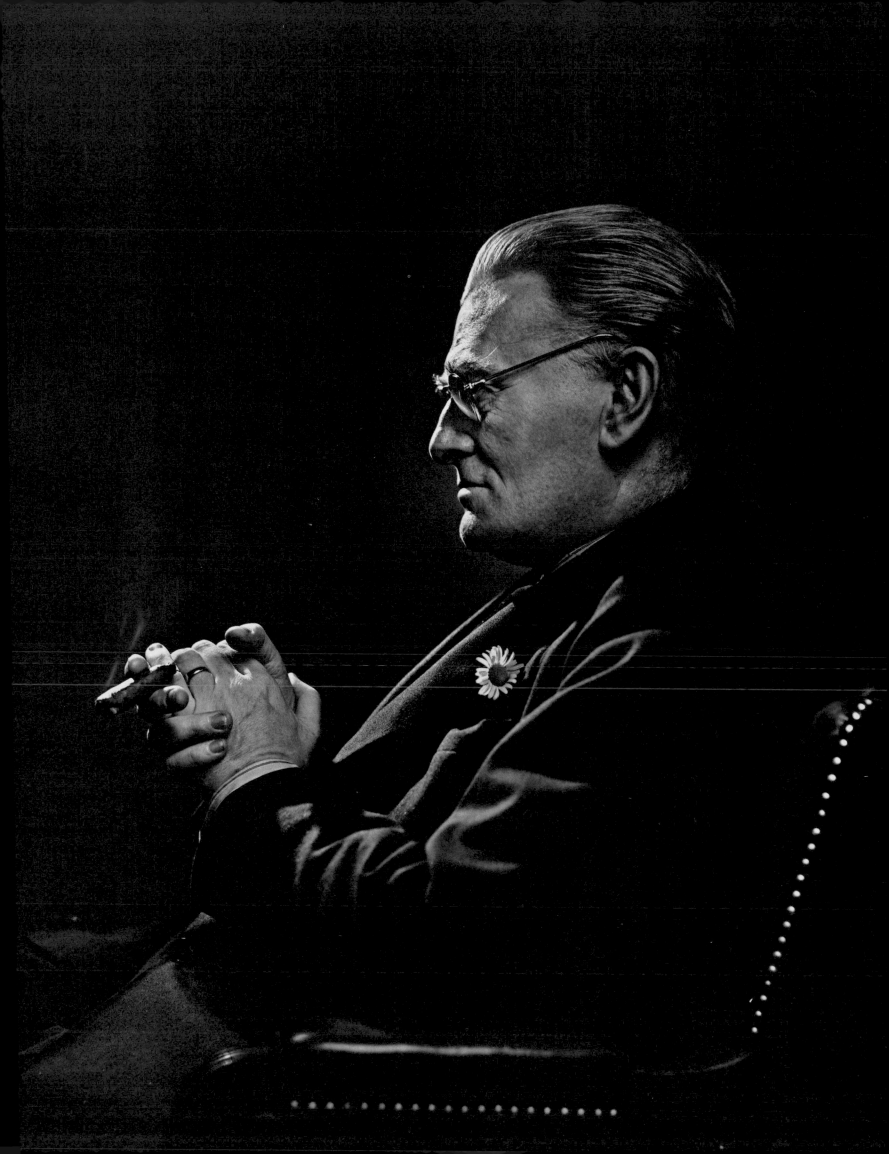

Jack Bush

1974

The personality of the late Jack Bush, the controversial contemporary Canadian painter, seemed to resemble his canvases – exuberant, vividly coloured, irrepressible, and forever young. His studio, shared with even younger colleagues, reminded me of a commune where everyone made his special contribution and enjoyed equal rewards. The heady smell of paint was a strong, though harmless, intoxicant.

Bush and I got along famously in a long discussion about art. He modestly expressed surprise at his success although he was, in fact, the only leading modern painter who had lived all his life in Toronto while commanding both international respect and the highest prices for his work.

He began humbly, he recalled, in commercial art with a style derived from that of the famous Group of Seven. It was not until 1968, when his paintings were selling first in New York, then in London, and finally in Canada – the prophet first honoured outside his own country – that he could at last abandon commercial art and pursue his painting.

Bush was so bluff and unassuming that I could hardly believe how radical his vision had appeared to the art world of the 1950s. As a founding member of Painters Eleven, with Harold Town and William Ronald, he was often attacked by the press for espousing a bold, abstract style. But he refused to modify it, persisted in his nonconformism, and continued to experiment.

'From the start,' he told me, 'my worry has been to try to paint like the boys, to fit in with the crowd, and fortunately for me I could never quite do it.' Instead, he kept searching for his true expression, and so successfully that, at the age of sixty-one years, his canvases, as judged by the critics, were the most vigorous, buoyant, and youthful of his career.

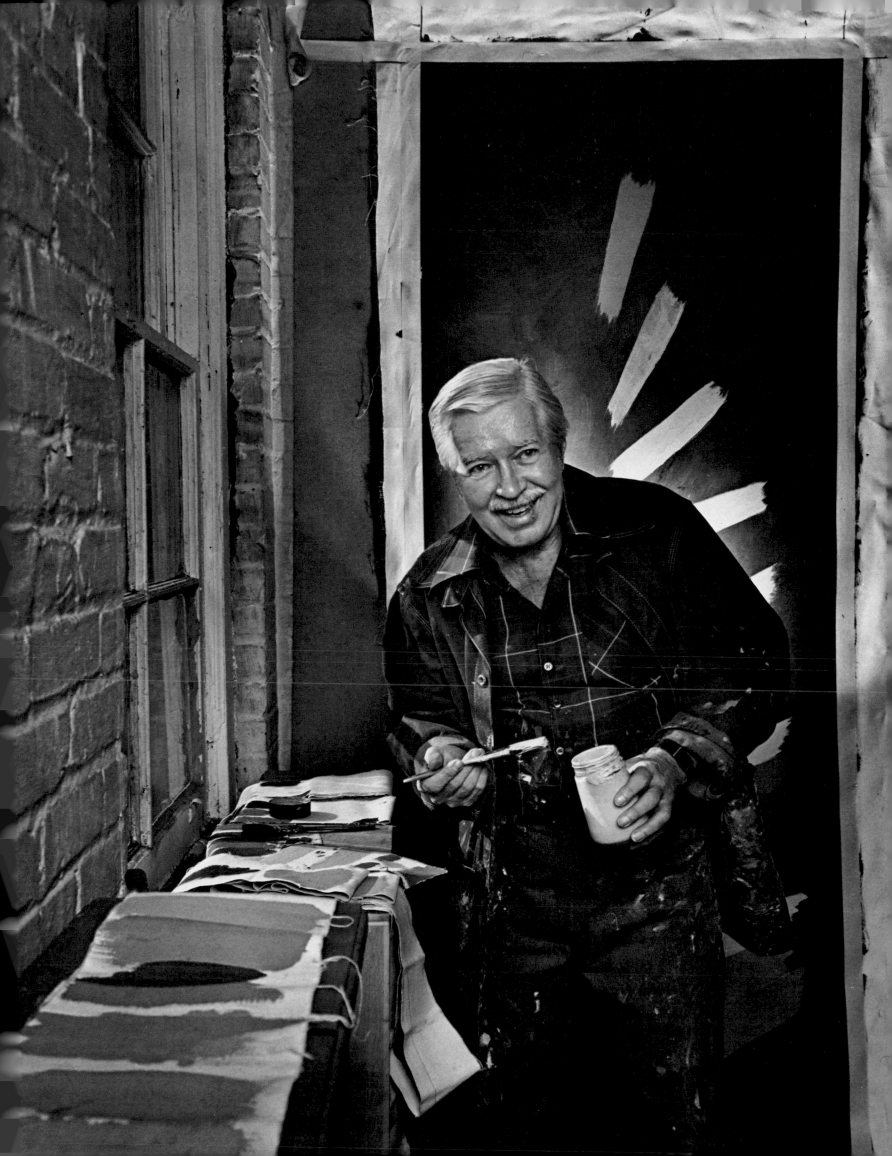

Morley Callaghan

1943

'People wonder why on earth, at seventy-two, I'm writing another novel,' Morley Callaghan remarked in the spring of 1976. And he explained, 'I write because I'm a writer.'

Actually, he has been a writer since boyhood. By the age of thirty-four he had produced eight novels, two books of short stories, and countless magazine articles. But he had yet to earn his international reputation, and his first serious work was published by the small literary magazines of Paris in the exciting days of the late 1920s and early 1930s (when, among other incidental triumphs, he beat Ernest Hemingway in a boxing match).

It was not until 1951 that his novel *The Loved and the Lost* won the Governor General's coveted Award and brought his talent, already recognized by Canadian and foreign critics, to the general attention of his own people. Last year his book, *Close to the Sun Again*, including a defence of older authors, was praised as one of his strongest works.

My photograph of him was taken during a hiatus in his career, a brief dry spell common to all artists. The portrait, commissioned for a series in the Montreal *Standard* called Man of the Week, shows a vigorous, undaunted – although very sensitive – person with a touch of the impishness which has always illuminated his work and his life.

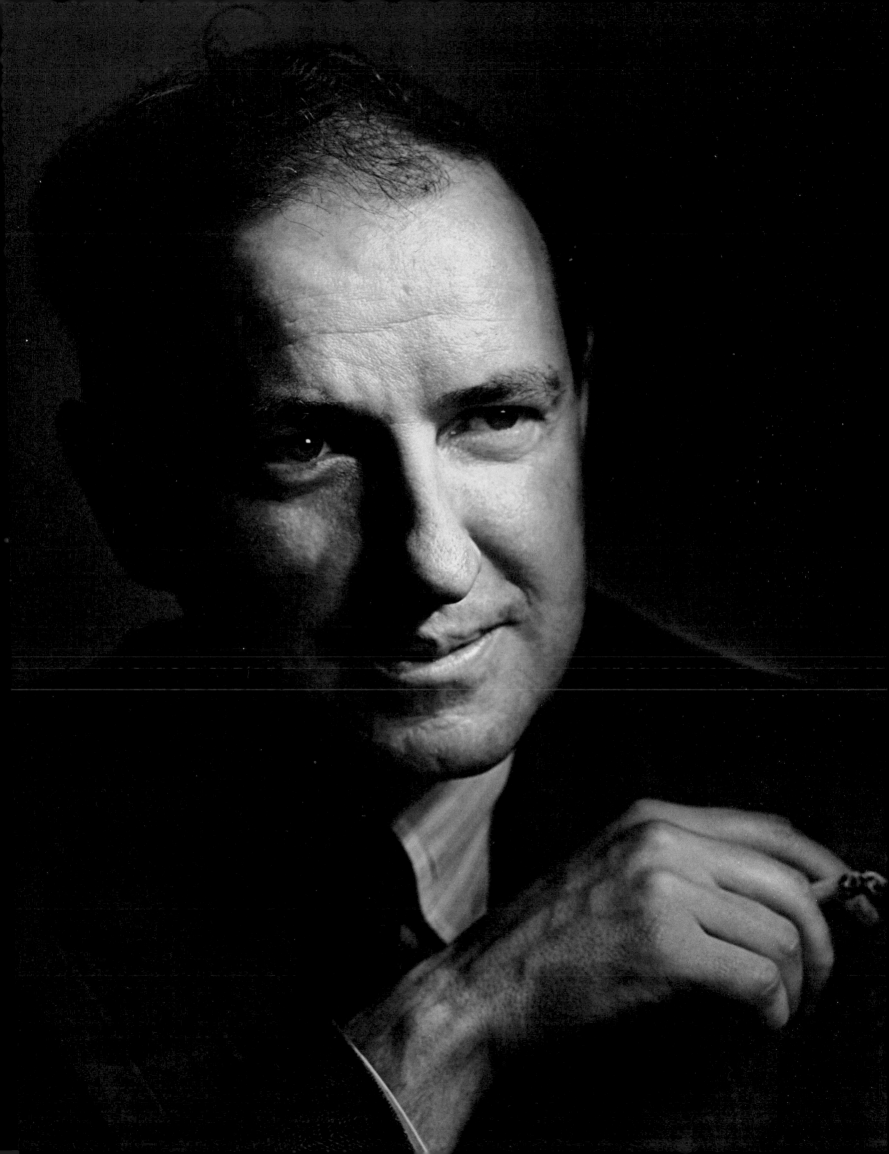

Rev. Moses Michael Coady

1949

No one is better known or respected among the people of the Maritime provinces than Father Coady. Yet he took no interest in his reputation, only in the welfare of the humble folk around him. A blunt man, unimpressed by honour or rank, he was annoyed when the Catholic Church elevated him to the title of Monsignor.

'They can't do that to me,' he complained. His superiors understood his apparent irreverence. It was the quality that made him the champion, the guide, and indeed the hero of the Nova Scotia fishermen, miners, and farm workers.

After studying theology and philosophy in Rome during the 1920s, Father Coady returned to the Maritimes and found them already in a depression, years before the world economy collapsed. As a teacher at St Francis Xavier University, his response was shrewd and practical. The workers, he believed, must first be educated if they were to solve their problems.

Beginning with the fishermen, he urged them to form co-operatives and thus control their own business. The results were spectacular. Fishermen in his area built and operated a cannery, shipping its products directly to the American market. Soon rural field labourers, and even miners, were meeting to establish co-operatives, handicraft shops, and credit unions.

Much to Father Coady's surprise, his Antigonish Movement developed into multi-million-dollar enterprises. His primary concern, however, was with the individual human being, the defenceless little man and woman. In his suspicion of big business, and the clergy who supported it, he feared that the title of Monsignor might identify him with the mercantile class.

His fear was unnecessary. He remained, and was recognized as, a devout Catholic.

Although he was eventually disappointed with some of the co-operative enterprises, his principles have not been forgotten. Visitors from all over the world come to the Coady International Institute in Nova Scotia, to study the work of an educator and pioneer who held that co-ops 'are the only way to secure the future of mankind.'

This photograph reveals, I hope, his combination of spiritual faith and pragmatic realism.

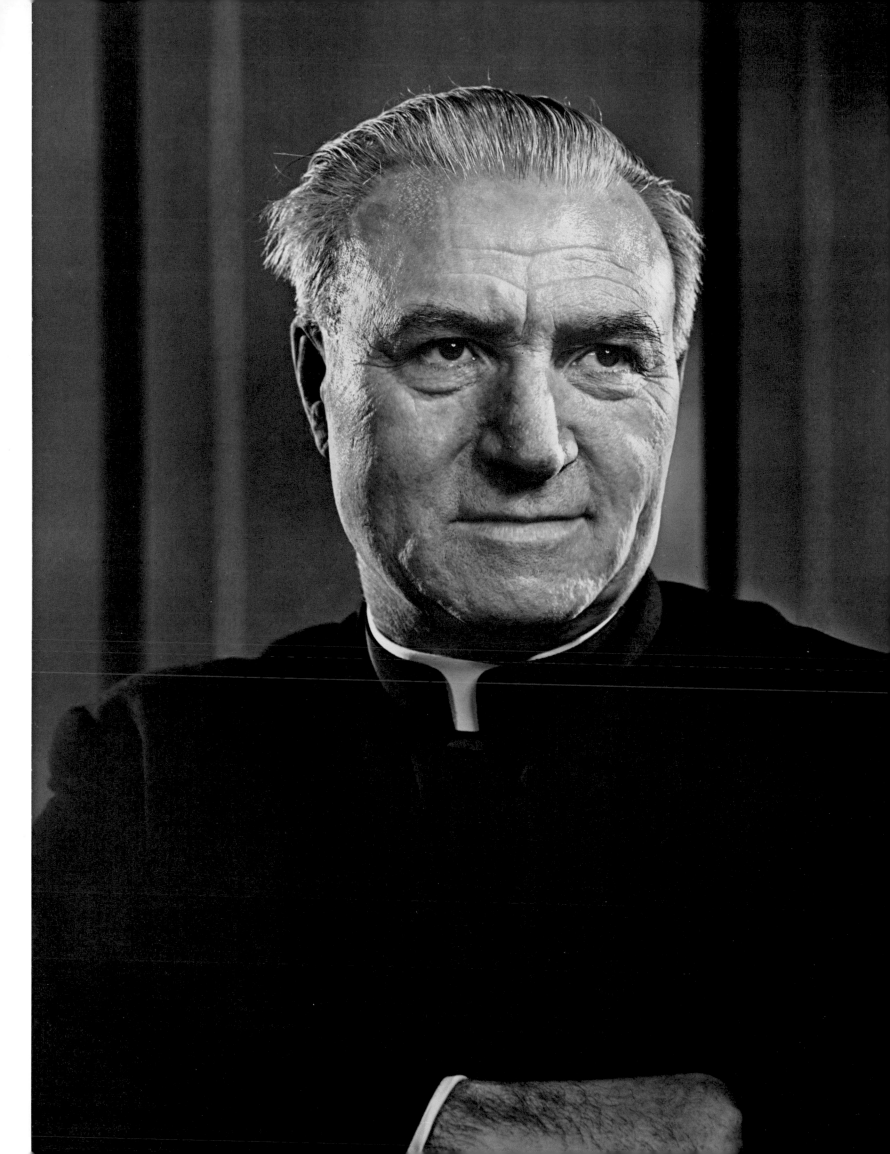

Toller Cranston

1977

It seemed fitting that I should first encounter the man who has been called 'Nureyev on skates' at a performance of the National Ballet of Canada in the New York Metropolitan Opera House. Anthony Bliss, director of the Opera, was entertaining a group of Canadians and among them was Toller Cranston. He leaped to my side in the lobby and asked, 'You photographed Karen Magnussen, why not me?'

Why not indeed? I told him: 'You're on tomorrow.'

Visiting his New York apartment, I discovered a man of many interests, all pursued with fervour. He is a painter, for example, in a style reminiscent of William Blake and Khalil Gibran. He describes it as Mystic Symbolism.

As a performer, Cranston is a natural image maker. Not only does he skate with consummate skill; he also invites the audience to participate in his dexterity and effortless perfection. But, for the photographer, he cannot be an easy subject because he never ceases to perform even when he is off the stage.

To capture the image of his own making – or at least my glimpse of it – I photographed Cranston several times with an ordinary lens and then, on a sudden whim, with a prism lens. Looking at the results, I prefer the dreamlike quality of the multiple image since the man, himself, is a multi-faceted personality.

He must not be faulted if he chooses to follow in private the dramatic manner of his public skating and painting. In a candid manifesto he once explained that 'I skate the way I think Isadora Duncan danced. I'm trying to explore every facet of my personality. I'm criticised as flamboyant, arrogant, and melodramatic. I'm black and white. I'm yes and no. I try to live my life touching extremes.'

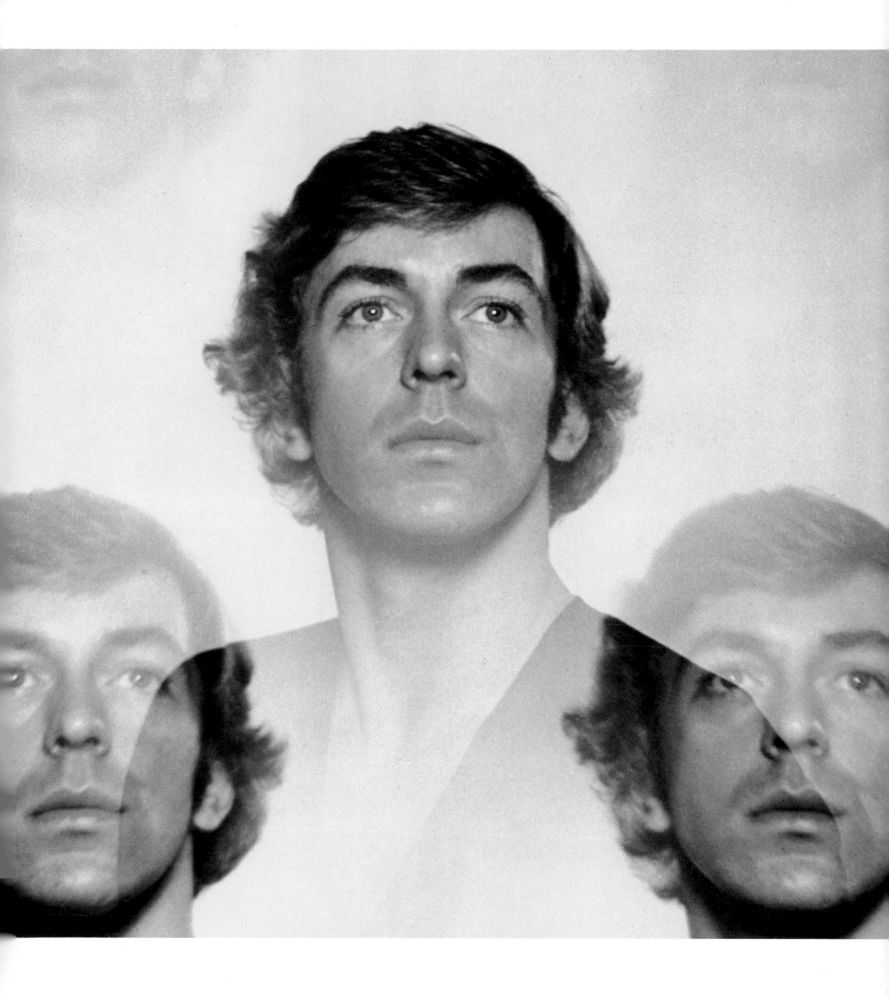

Thomas S. Cullen

1947

At the Johns Hopkins medical centre in Baltimore, Tom Cullen was an eminent gynaecologist. But at his summer retreat on Ahmic Lake, Ontario, he returned to the frugal ways of his boyhood as a Canadian Methodist minister's son. I found him there, in 1947, wearing patched clothes, mending his sneakers with old rubber tires, solemnly warning his nephews against neglect of their canoes, and presenting to these hapless youngsters a 'certificate of demerit' (which contained a five-dollar bill).

The master surgeon was warm, compassionate and, I found, something of a mystic. Early in his career, he had paused suddenly in the middle of an operation and exclaimed: 'Something is happening to my kid sister!' So it was. At that very moment, miles away, she had fallen into deep water and rescuers saved her from drowning in the nick of time. This type of strange experience often recurred in Dr Cullen's life. He had what he called 'premonitory, extra-sensory feelings' which went far beyond his science of physical medicine.

After our summer meeting I followed him on his rounds at Johns Hopkins and watched him reassure his patients with a few words of comfort, a lift of the famous bristling eyebrows, or a homely joke. To a woman who feared his surgery he explained: 'I think I know what you want me to do – as much as necessary but as little as possible.' No doubt he did precisely that next day, and on Christmas Eve was given payment for the operation. A sack of his favourite hickory nuts appeared on his doorstep, the offering of the patient's grateful husband.

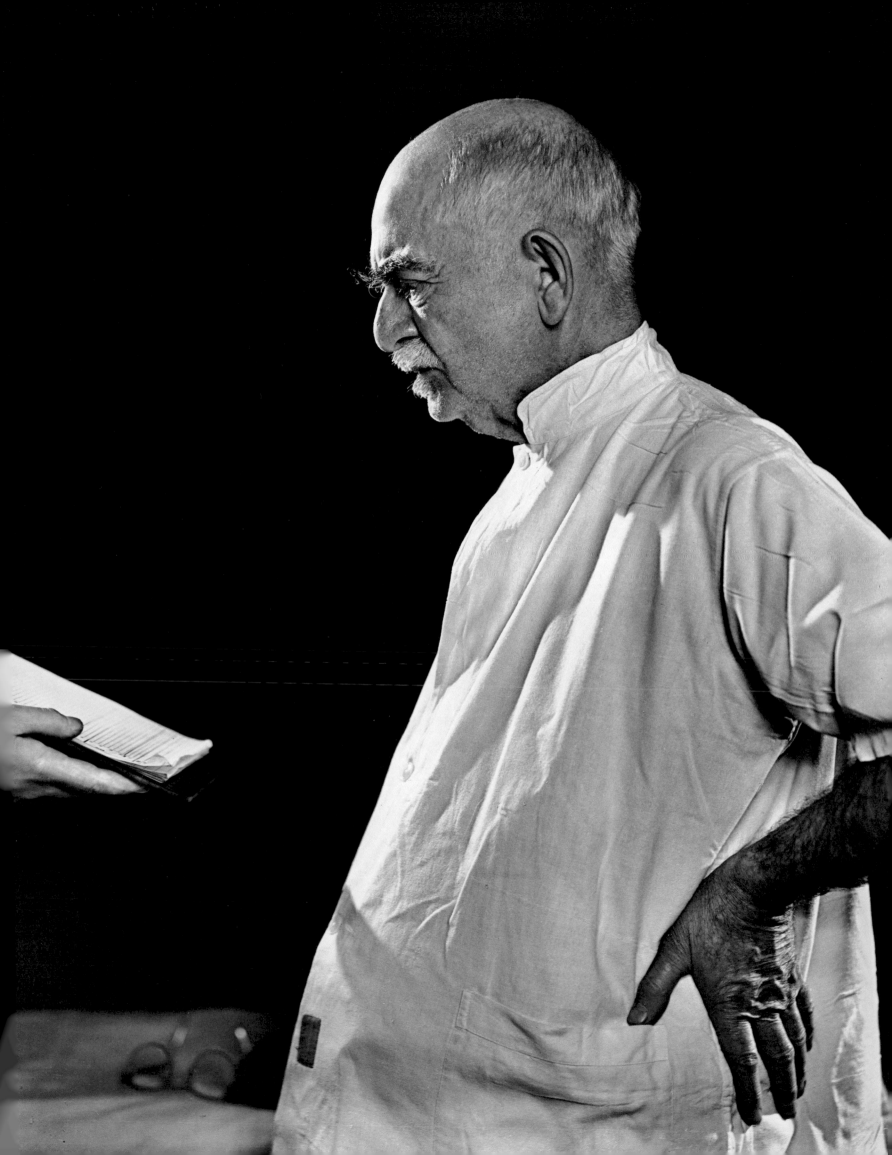

Robertson Davies

1977

The exotic ambience of the Master's Lodge at Massey College, Toronto, where Canada's pre-eminent man of letters resides, suits him perfectly. In the classic statues, antiques, and richly bound rare books around his home is evidence of his love for literature, art, and music. He is a civilized man, a scintillating conversationalist with a gift of combining erudition and earthy humour.

I find it interesting (and, I suspect, quite wrong) that Davies has interpreted his attachment to civilization as a special Canadian characteristic. 'I'm not a great lover of the wilderness,' he once remarked. 'In this I think I'm a real Canadian. My forebears were genuine pioneers and their idea was to get inside and keep the wilderness outside. The struggle was always toward civilization rather than toward all that rubbish out there that you had to clear up.'

The impeccable English tea which I shared with Davies and his wife, Brenda, was proof that he carries on the family tradition of exorcising the wilderness from his urban refuge. I doubt that Davies, so profoundly right about so many other things, has correctly judged the old instincts of his people. Nowadays most of them live in cities, yet the wilderness constantly pulls them back to its solitude and mystery, forever colouring and haunting the subconscious of a nation conceived in lonely places.

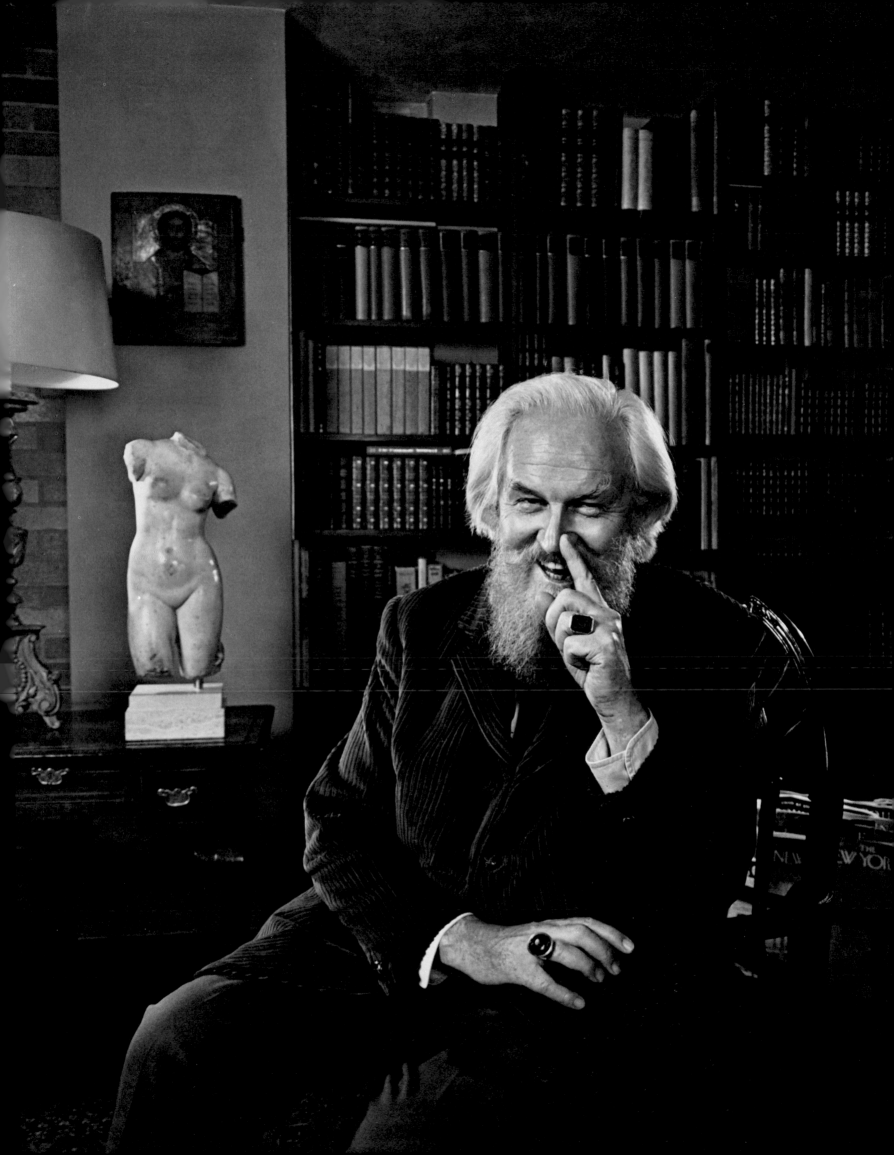

Yvon Deschamps

1977

The superb Quebec monologuist, when I met him face to face, was a pleasant surprise. He is a small, wiry man with expressive eyes, a mobile face and a lithe body, the perfect physical equipment for his art. His mind and imagination have made him a story teller, lyricist, actor, and writer – above all, a satirist of black, though compassionate, humour.

I had expected a very different sort of man, having read his chilly, almost existentialist statement: 'You know, I never go to bed without thinking of dying. It's not fear. I ask myself, why? What's the reason for being here? If your everyday concern is to find absurdity, which is what I do, you find it every day.'

Yvon Deschamps has turned such absurdity into a sardonic commentary on human life. His one-man performances have often filled the 2500 seats in Montreal's Place des Arts for seven consecutive weeks.

The pessimistic satirist is only one side of Deschamps. The other side I discovered in his Montreal home – a kindly domesticated fellow, more at ease off the stage than on it. His special happiness was justified by a great expectation. His wife was about to present him with their first baby and their home had already been decorated with a profusion of stuffed animals, toys, cradles. Anticipation and birth – not resignation and death – were on Deschamps' mind.

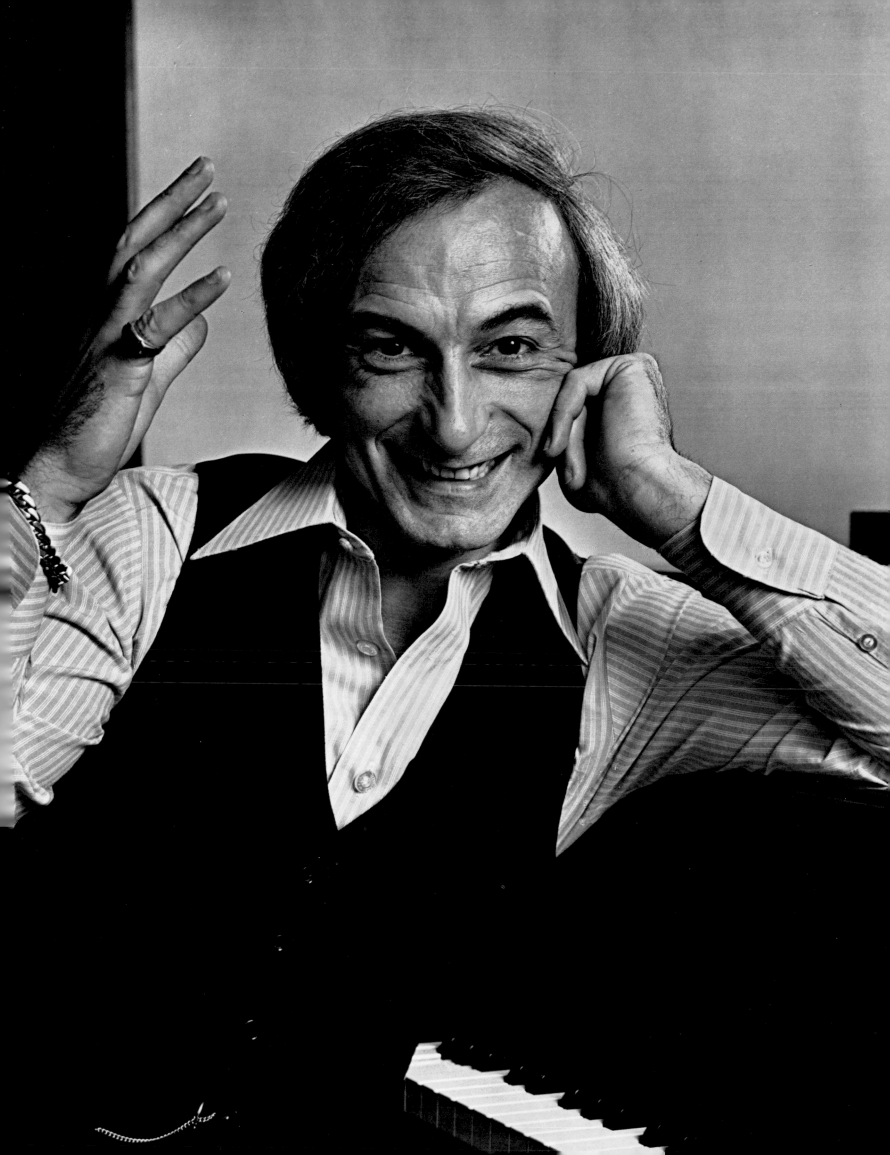

Paul Desmarais

1973

My wife, Estrellita, and I first met Paul Desmarais at his favourite *pied-à-terre*, Murray Bay (La Malbaie), Quebec, at the summer home of Richard E. Berlin, president of the Hearst Corporation. From the time the young Paul turned around his father's almost bankrupt bus business in Sudbury, to his leadership of Power Corporation, the largest conglomerate of economic power in the hands of a French Canadian, he has been called the business establishment's most intriguing figure. Indeed, the 'amazing pyramid' of his companies, including trust companies, paper companies, and bus and steamship lines, touches the lives of all Canadians.

Desmarais' personality – a combination of vivacity, charm, and quiet intensity – is immediately arresting. I photographed him one cold February evening in 1973 at his principal residence in Westmount, its large lemon and pale aqua living room dominated by exquisite art objects, among them works by Diego Rivera, Jean-Paul Riopelle, and the Desmarais' personal friend, the Quebec artist Jean-Paul Lemieux.

Desmarais' son, Paul, had just returned from a college class, and Estrellita, Desmarais, and young Paul became engaged in a lively discussion of academia. The senior Desmarais' interest and great delight in his children was immediately evident, and when his stunning wife, Jacqueline, came downstairs to greet us, it was apparent that his family was the centre of his life. The seeming contrast between Paul and Jackie Desmarais is charming. While his intensity plays under the surface, she is ebullient, and disarmingly Gallic. Her enthusiasm does not conceal a fine perception, a strong grip on reality, and a great sense of the ridiculous.

During our photographic session, I was struck by the directness of Desmarais' gaze, and could well understand why he prefers to deal with people face to face, on a personal one-to-one basis, and why he seeks out, in business transactions, those who are the decision-makers.

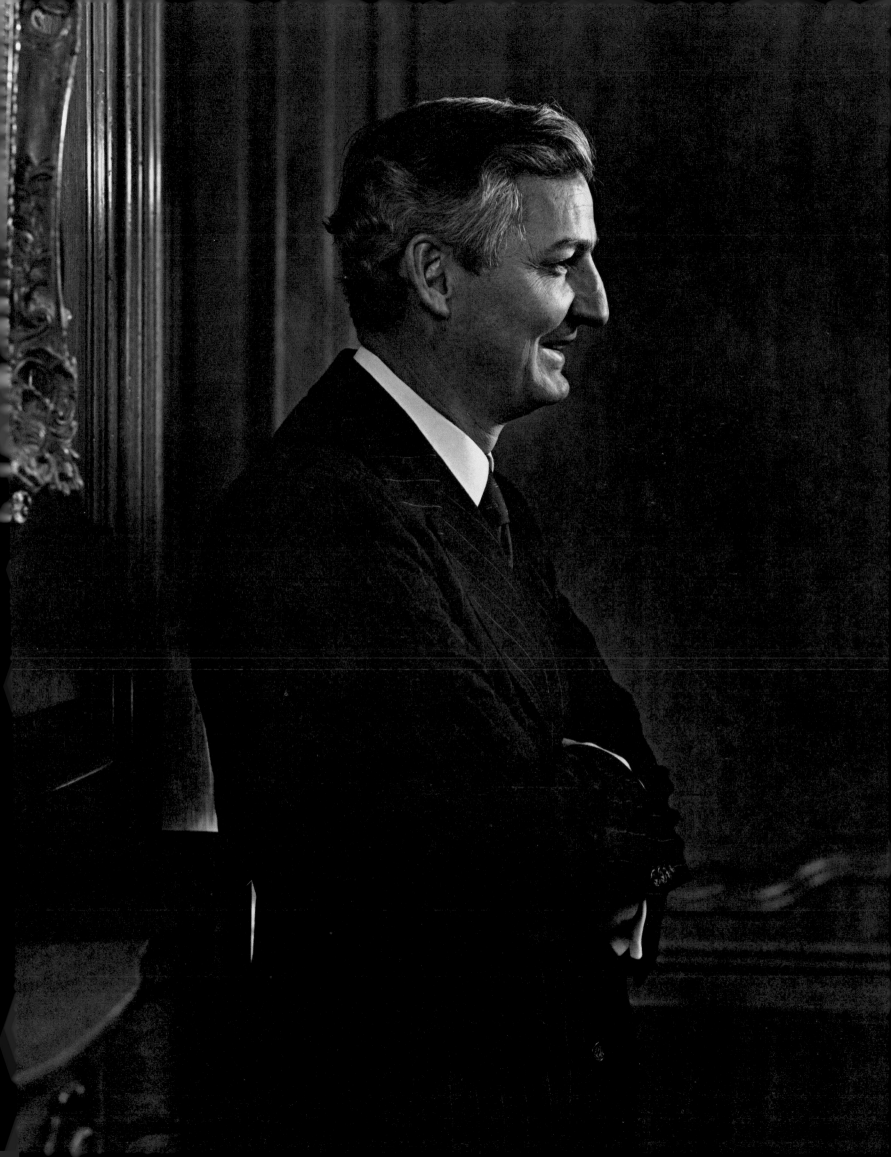

John G. Diefenbaker

1974

The unprejudiced historians of the future must judge the extraordinary career of John G. Diefenbaker. My own professional concern has been with the former Prime Minister as a portrait subject.

Since I first photographed him, his deeply graven face, metallic grey curls, sparkling eyes, and sudden changes of expression, from warmth to sudden cold fury, have become as familiar to Canadians as the landscape. In the four portraits I have taken of him, the attrition of time is clearly visible but his dauntless energy, his laughter, the cutting irony, the moral indignation, and the sense of mission remain the same. No photographer could ask for a more challenging and provocative subject.

I enjoyed my first session with him when he was Prime Minister of Canada. Arriving at his official residence, 24 Sussex Drive, Ottawa, on assignment for *Maclean's*, I was greeted by his radiant wife, Olive.

'Oh, Mr Karsh,' she exclaimed, 'it's so lovely to meet you! I understand that you have to drink champagne before you work.'

How such a reputation had preceded me I didn't inquire but, since it was early in the morning, I begged her to reserve the champagne till later as a reward instead of an incentive to photography.

So it was agreed, and I made many studies of her husband until I was satisfied. Then I photographed Mrs Diefenbaker before a parabolic mirror in the dining room.

After working, I looked forward hopefully to the champagne. Mrs Diefenbaker did not fail me. When the three of us sat down to lunch, champagne was served in generous quantity but the Prime Minister refused it, drinking his usual glass of milk.

He required no stimulant to entertain us with the story of another festive occasion. Grinning and winking, the peerless raconteur and master mimic told how, after his landslide electoral victory in 1957, Sir Winston Churchill entertained the Diefenbakers at dinner in London. After the guests had assembled, the British statesman came downstairs to join them, mischievously swinging a bottle of aged cognac in his hand. He placed it beside him until after dinner; then, rising to his feet, Churchill poured a glassful of this sacred vintage for his Canadian friend.

There was a moment of embarrassment because Diefenbaker, a teetotaller, did not wish to offend his eminent host. But Olive – always resourceful – saved the situation by explaining quietly, 'Sir Winston, John doesn't drink.'

'The first prime minister I worked with,' Churchill grumbled, 'was a prohibitionist, which was bad enough. But to be a teetotaller is a crime. Well, good luck, John!' With a flourish, he swallowed the cognac himself.

Here is the last portrait I made of Diefenbaker. Beside him lies a copy of the Canadian Bill of Rights which he considers the greatest achievement of a lifetime spent, as he believes, fighting for the underdog.

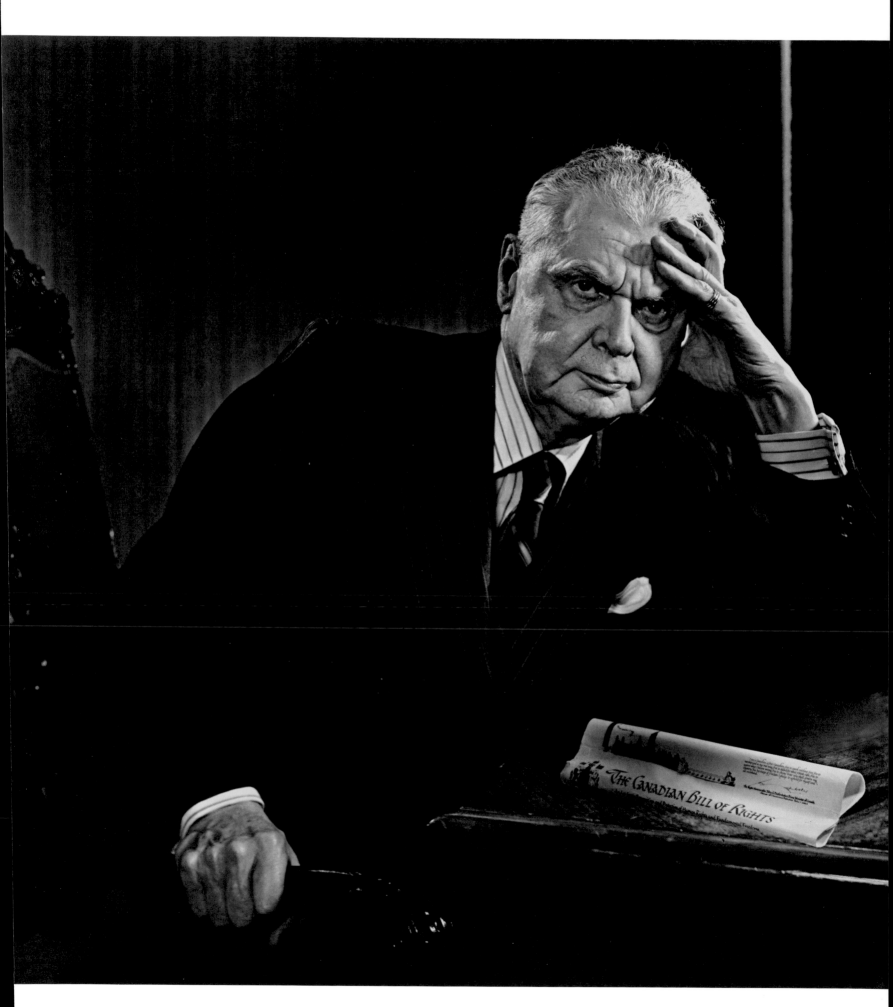

Cyrus Eaton

1963

When I was introduced to Cyrus Eaton and his charming wife, Anne, at the Stratford Festival in the summer of 1963, we immediately made arrangements to photograph him. A few months later I arrived at his estate in Pugwash, Nova Scotia – home of the famous Pugwash conferences on science and world affairs – where Eaton was very much the grand seigneur. The first event he had scheduled for my entertainment was a ride on a troika, a gift from Khrushchev. If, for a moment, it seemed strange, in the sixties, to find in these luxurious surroundings tokens of Soviet esteem for a great western capitalist, my surprise quickly turned to admiration for my host's controversial support of reasoned diplomacy with Russia. Steeped in the Greek and Roman classics, Eaton believed in the ancient ideals of balanced thinking and dialogue.

When I mentioned the possibility of my visiting Russia, he responded: 'Don't hesitate to let me know. I will send word and you'll be assisted greatly.' His kind promise bore fruit. One of the first invitations I received in Moscow was to a dinner at the Authors Club held in a building dating from czarist days. Thanks to him and the Canadian ambassador, Arnold Smith, my stay in Russia was a complete success. Every consideration and facility were given me until I had completed a large portfolio of photographs that included cosmonauts, academicians, actors, dancers, Brezhnev – and Khrushchev himself.

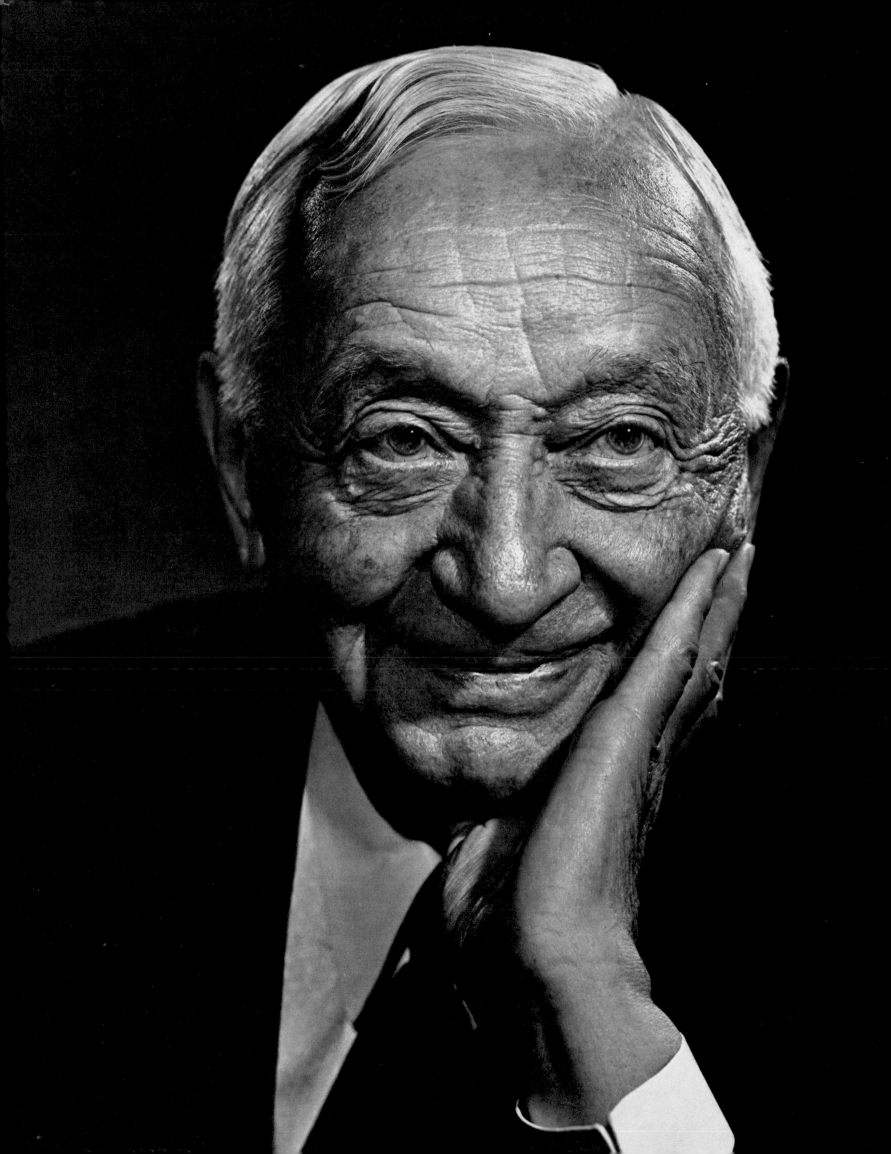

Arthur Erickson

1978

'The main thing is the quality of the light,' mused Arthur Erickson, as we watched the final construction of his Bank of Canada Building in Ottawa. Its facade, completely covered with mirrors, reflected both an old Gothic steeple and the new, rapidly changing face of Ottawa. I recalled the architect's first daring use of glass in his award-winning Canadian Pavilion at Japan's Expo 70. Knowing Erickson's fluency in the Japanese language and his sympathetic understanding of the Oriental aesthetic, I asked, 'Why mirrors?'

His original half-forgotten inspiration, Erickson explained, came from half a world away in Isfahan, where a little pavilion at the end of a garden, flanked by cypresses and roses, was faced with tiny facets of broken mirror. In the Canadian Pavilion, Erickson's intent was to symbolize the Canadian landscape – its overwhelming vastness, majesty, and impressive distances – in sharp contrast to the exquisite Japanese porcelain-like vistas. 'I even ordered the Pavilion roughly built to emphasize the contrast,' said Erickson, 'but the Japanese are capable only of "badly" building things so beautifully.'

'What the spire is to the Gothic cathedral, the mirror is to the twentieth century.' Before using mirrors, Erickson employed water as an integral part of his designs. His explanation might please a Zen Buddhist priest:

'Water is a mirror for the sky. In the North, where the ground is dark, and the sky is white, a person is in almost perpetual darkness; he can only reach for the remote, white, seemingly unattainable sky. A play of water reverses the order of Nature – the sky is below, and the human being flows in the centre.'

In his own New York apartment, with its spectacular floor-to-ceiling view, Erickson has mirrored the floor so that one seems to be in the heart of the light. The architect has put man, as he was before Copernicus so rudely replaced him, once more in the centre of his own universe.

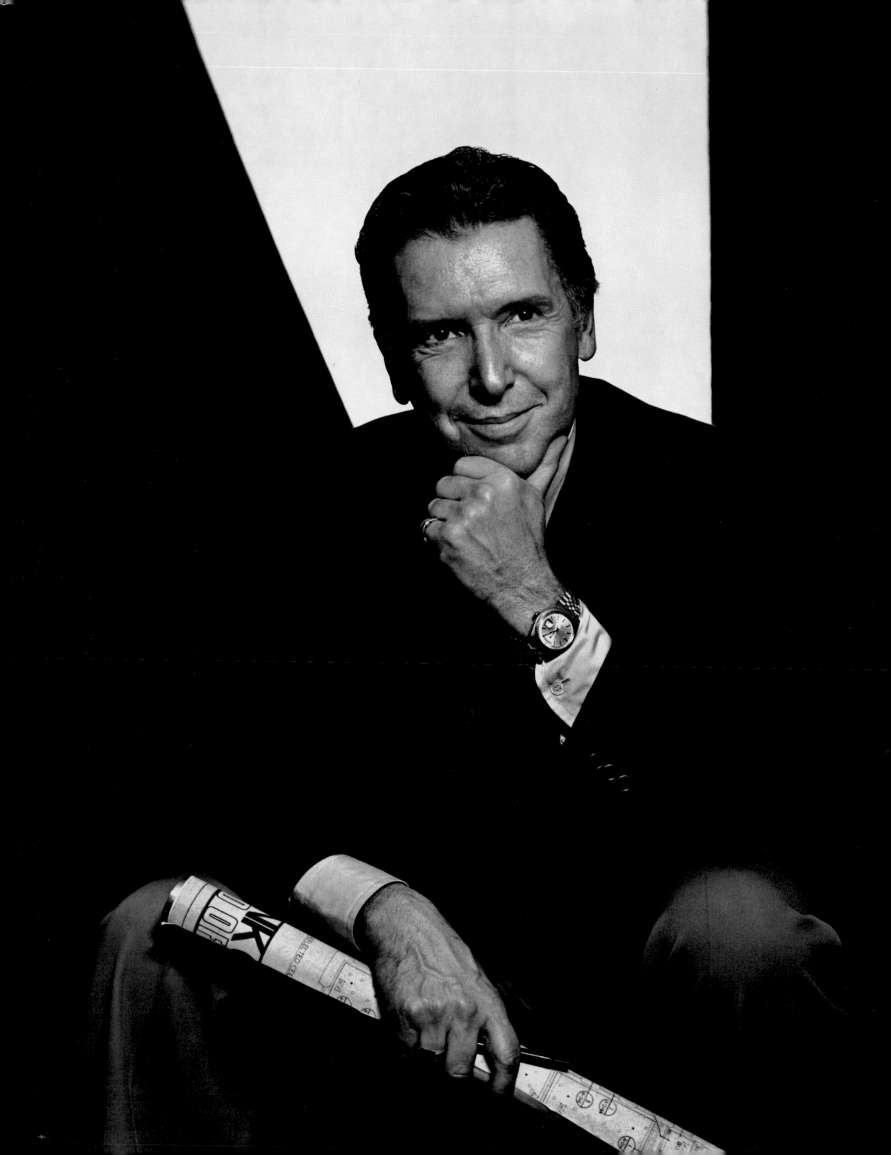

John Kenneth Galbraith

1966

When the Canadian Broadcasting Corporation wished to photograph me for television while I was photographing someone I had never met, Galbraith was my choice. He had a lined, craggy, and strikingly brooding look. He wrote with a clarity and power that make his books on economics so easy to read. Above all, he had a searing wit. He was, in short, a unique personality well worth meeting and recording.

Subsequently I included his portrait in an exhibition of 125 world figures entitled 'Men Who Make Our World,' which opened in New York to mark the Centennial of Canadian Confederation. Regrettably Galbraith could not attend. He had not, however, forgotten the occasion, and timed a telegram to reach me on the gala opening night: 'I would be there if I could, if only to discover who the other hundred and twenty-four people are.'

That message was typical. Galbraith likes to tease his friends as well as his critics, and attributes this quality to his childhood in Elgin County, Ontario. There, as one of his lighter and more charming books describes them, the inhabitants of the Lake Erie north shore were, like himself, descendants of Scots Highlanders – practical, dour, anti-English, anti-Tory, and highly suspicious of all patriotic appeals. It was from this background that he emigrated to the United States and became one of the world's most provocative economists.

As one writer who knows him has suggested, the vintage Galbraith distrust of privilege, authority, and conventional wisdom, his constant effort to unstuff distinguished shirts, are quintessentially Scottish-Canadian – and his trade mark, his delight.

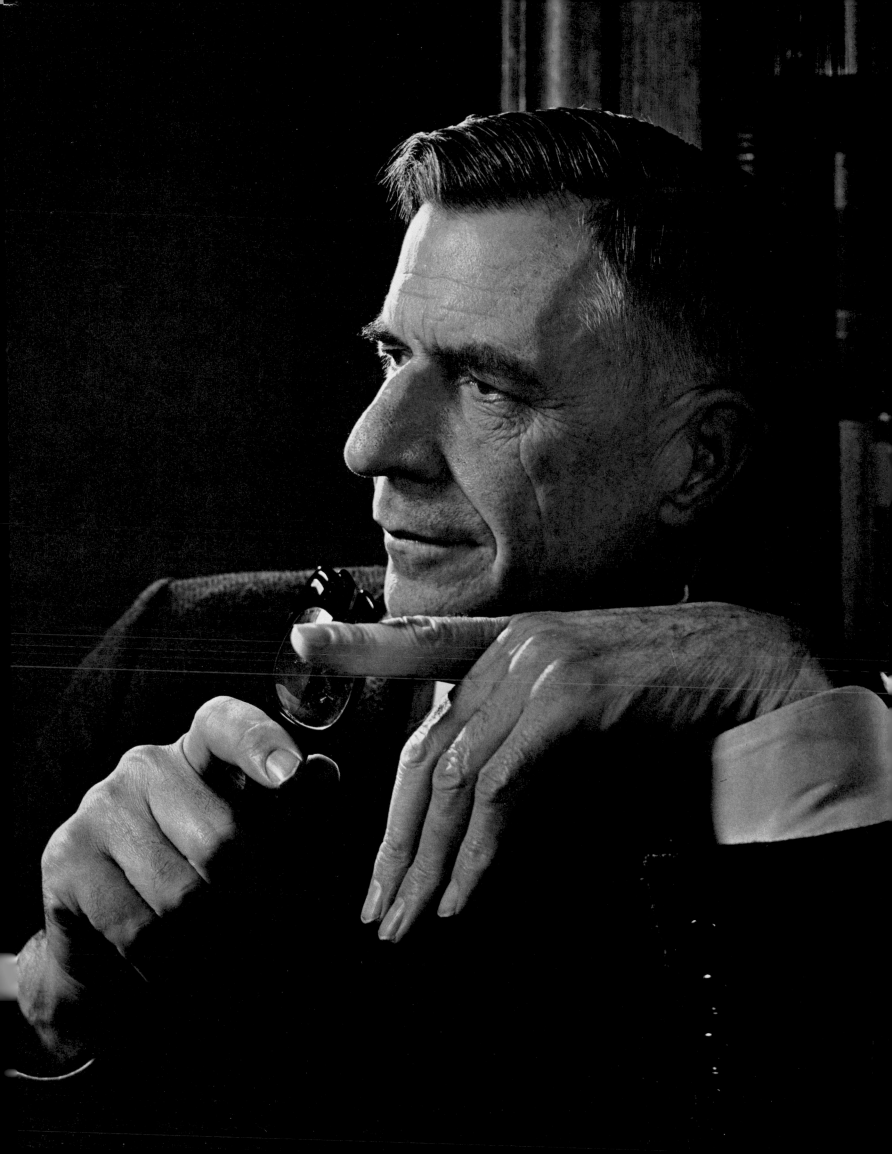

Gratien Gélinas

1945

It seemed to me that Gratien Gélinas was the living embodiment of the laughing clown who hides his secret anguish behind a grease-paint grin. Certainly he was the most amusing comedian ever seen on the stage of Quebec and could have been compared with Charlie Chaplin. (In his successful Fridolin Revue, a series of hilarious monologues, he invented the French-Canadian 'little man' vainly railing against the government, but this was only the beginning of a many-sided career. With his play, *Lazare's Pharmacy*, he also became a dramatist and soon was a producer and director as well.)

His play *Tit-Coq* had an astonishing two-year run in Montreal, broke all Canadian records and went on, in the English language, to Toronto and New York. It was followed by the satirical play *Bousille et les Justes* and *Yesterday the Children were Dancing* which revealed the deeper thoughts of the supposed clown. Here Gélinas perceptively articulated the isolated feelings of some Québécois, then little known elsewhere. Indeed, all his work expresses a poignant concern for ordinary people.

I made two portraits of him when we met. One shows a carefree mood, the Fridolin twinkle in his eye; the other a tragic pose, surrounded by studies of his sensitive hands in gestures of supplication, guilt, and innocence. I sensed that Gélinas was undergoing a critical transition, from the wild farce of his early sketches to work more profound and subtle.

It is good news, as this book took shape, that this artist, after nine years as chairman of the Canadian Film Development Corporation, will return to writing and acting.

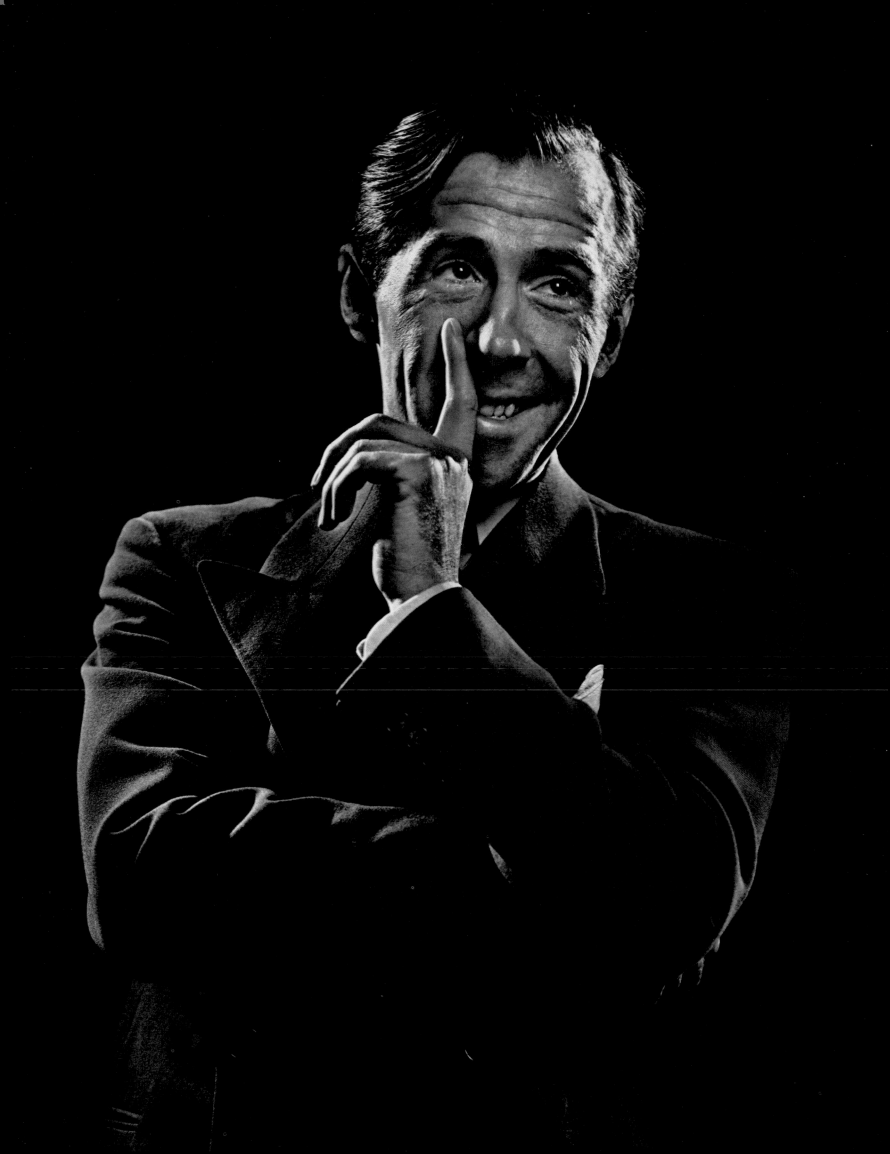

Donald Gordon

1945

I have always admired the drive, determination, and cool intelligence of Donald Gordon – a giant, physically and mentally, a master of business but always the unspoiled product of his boyhood struggles.

At the age of fifteen he was a junior bank clerk. By the time he reached his thirty-seventh birthday he had become deputy governor of the Bank of Canada. This was only the beginning of his versatile career.

When the Canadian government decided to impose direct economic controls to halt wartime inflation it picked Gordon for one of its most unenviable jobs. There could have been no better choice. As chairman of the Wartime Prices and Trade Board, which managed the rationing of food and other supplies, he was an instant success. I photographed him in 1945 as he was about to complete his assignment, only to face another equally challenging.

My fondest memories of him are associated with meetings at the Canadian Club of Ottawa, over which he used to preside with subtlety and skill. When Gordon introduced a speaker he did it with such brevity and clarity that the audience felt like applauding before the speaker himself had a chance to rise. Likewise, when Gordon stood up again to extend a vote of thanks, his words usually turned out to be a summary of everything the speaker had intended to say – but didn't. I couldn't help thinking that with all these talents Donald Gordon might become a prime minister; instead, he had to content himself with running the Canadian National Railways, a job fit for his monumental talents, a job for a giant.

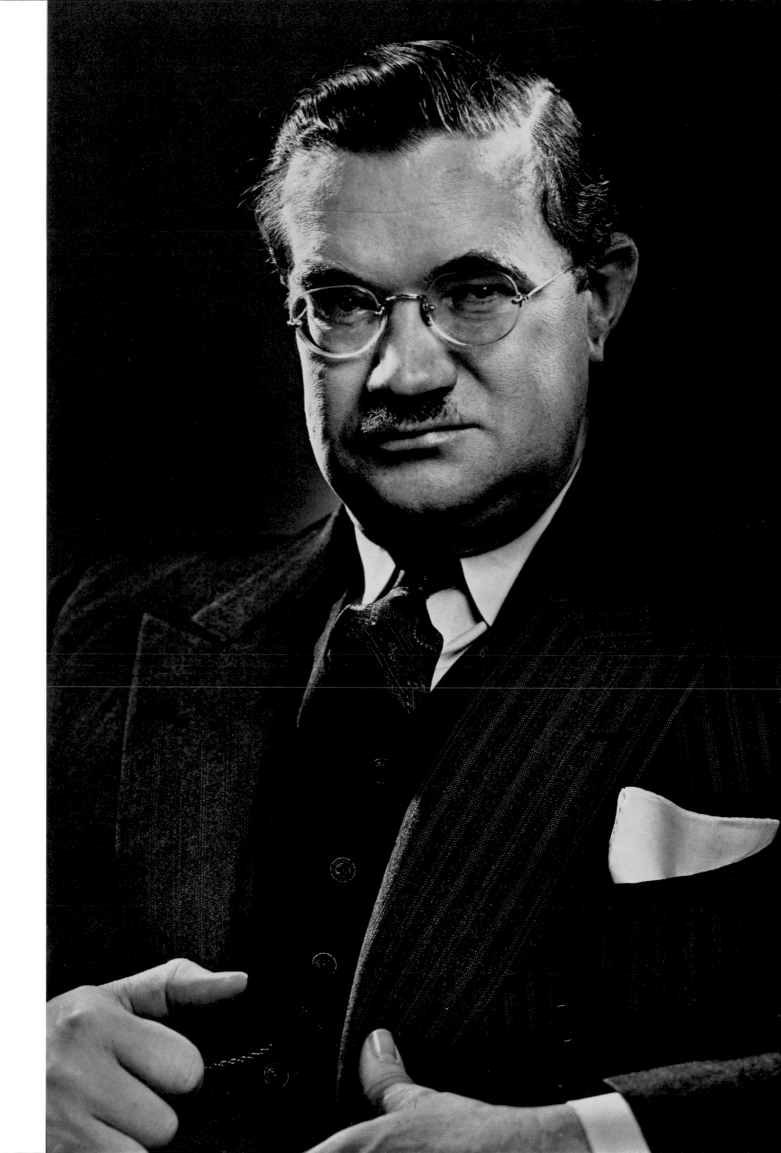

Glenn Gould

1957

While I photographed Glenn Gould at his Toronto home, in 1957, he never stopped playing the piano for a moment. The music, Bach and Alban Berg, was so arresting that I found myself captivated, forgetful of camera shutters and lights.

Critics have often muttered about Gould's unconventionality, but it seemed to me that his mittens, the frequent hand-soakings before a concert, his facial contortions and audible humming were all in keeping with his personality. There was, I thought, no deliberate eccentricity, only a total absorption in his art.

Recently, he had returned from a tour of the Soviet Union; he had been the first North American to play there. At the conservatories in Moscow and Leningrad he had insisted on playing contemporary western music of the Schoenberg-Anton Webern school.

'When I announced that I was going to play the kind of music that had not been officially recognized in the USSR since the mid-thirties, there was a rather alarming and temporarily uncontrollable murmuring from the audience,' he told me. 'I'm quite sure that many of the students were uncertain whether to remain or walk out. I managed to keep things under control by frowning ferociously. It turned out to be the most exciting musical occasion imaginable. In general, the students were wonderfully attentive and receptive. I felt like the first musician on Mars or Venus.'

Later he complained that frequent tours were seriously hampering his composition and he wished to spend less time playing in public. His wish came true. Gould played his last public concert on Easter Sunday, 1964. A child of the electronic age, he then retired to the recording studio and achieved the kind of perfection unobtainable, he believes, in any single performance.

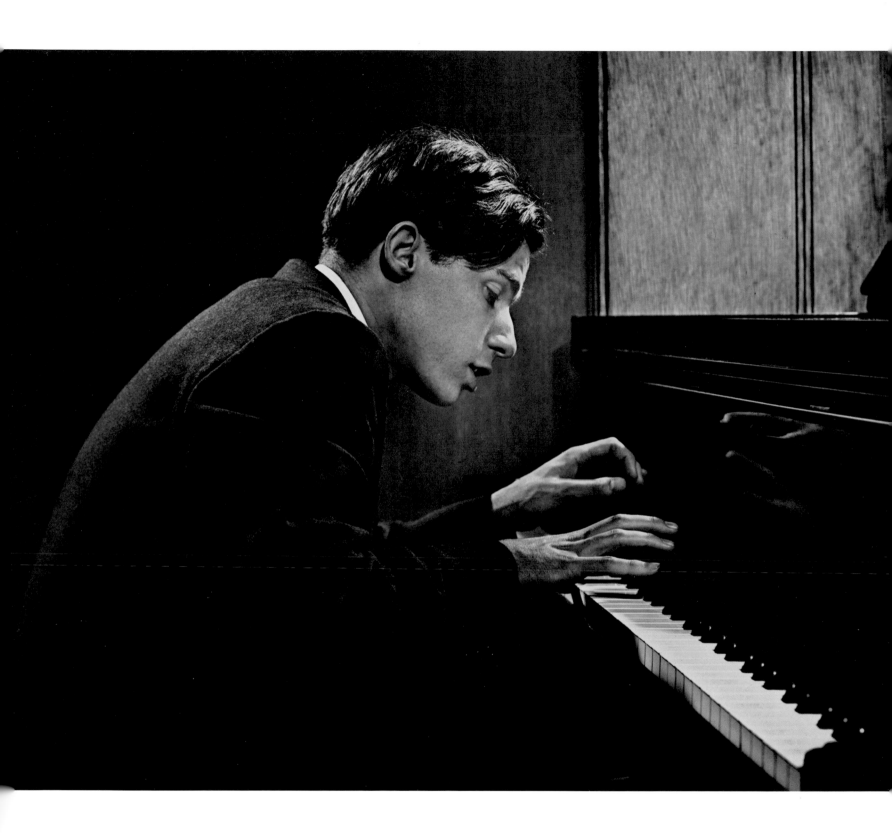

Grey Owl (Archibald Belaney)

1936

Like everyone who had met or read about him, I was impressed by Grey Owl, the counterfeit Indian of Canada, and his famous beavers, Jelly Roll and Rawhide, with whom he shared his cabin in the Prince Albert National Park – so impressed that I attempted a celebration for the gaudy imposter. That was a serious mistake but perhaps excusable.

For the distinguished occasion, my first little studio in Ottawa was furnished with orange crates upholstered in monk's cloth and I had arranged a catered supper. Among the guests were Duncan Campbell Scott, former deputy superintendent general of the Department of Indian Affairs, a group of writers and journalists, and some cabinet ministers. At the appointed hour they all turned up, in high expectation and hearty appetite – all, that is, except Grey Owl.

While my guests enjoyed the supper and awaited the arrival of the missing celebrity, I set out, in anxiety and embarrassment, to find him. When I arrived at his hotel he was raising a drunken row in the bar, and I decided to leave him there.

Not until John Buchan (then Lord Tweedsmuir and Governor General) came to the studio for a sitting and noticed my portrait of Grey Owl, did I learn that the thoroughbred Indian was, in fact, an Englishman named Archibald Belaney. Still, he looked his chosen part and played it superbly. The chiseled features and lustrous black hair must deceive anybody ignorant of his real origins, as I was when I photographed him.

His false identity cannot, however, diminish his achievements as one of Canada's earliest conservationists. His writings, speeches, and travels demonstrated a love of nature, the wilderness, and its animals, especially the beavers, those old symbols of our nation. He did much to convince the nation that they must be protected from man's greed and folly. In that sense he was not an imposter but, I like to think, a prophet.

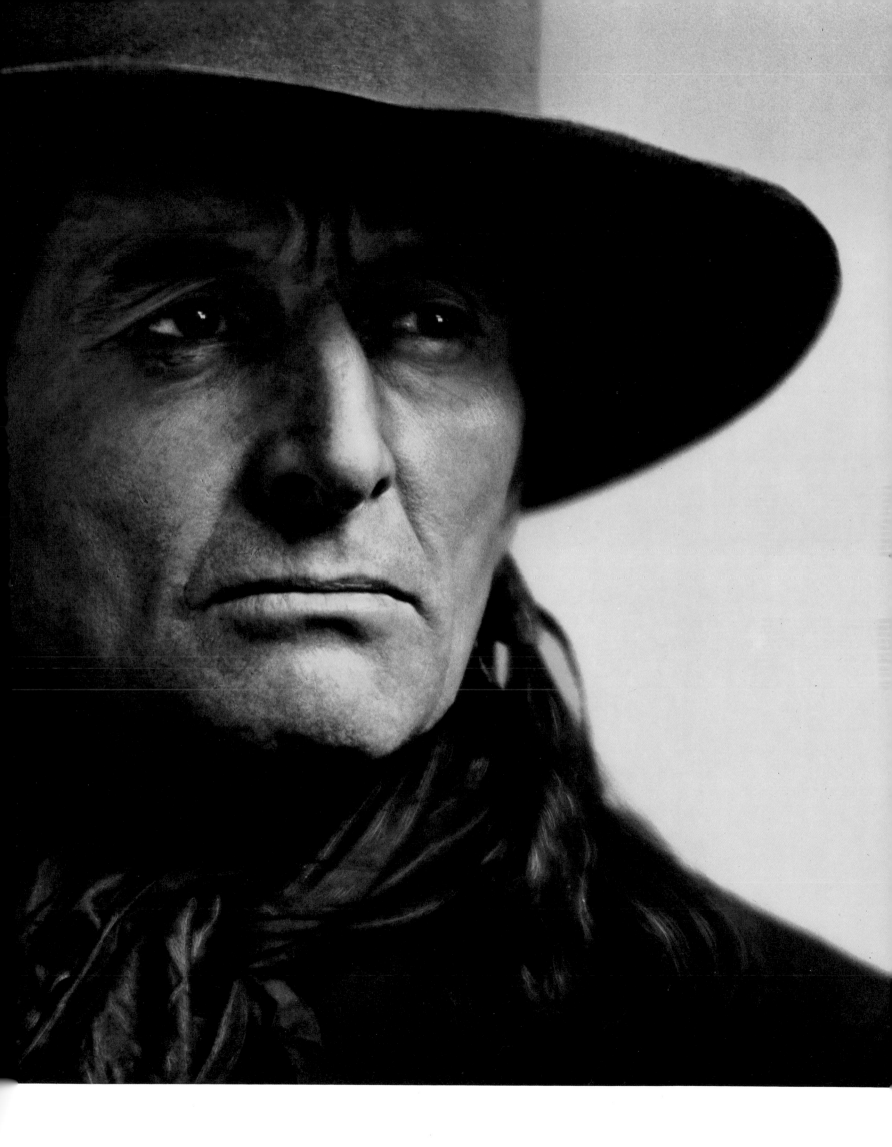

Lawren Harris

1946

By any reckoning Lawren Harris was one of Canada's finest painters, but in his art he searched for something far beyond visual images. He pursued a vision transcending physical life, for he was a philosopher, a scholar of many religions, ancient and modern, a man who had received his own intimations of immortality.

Of his credo he spoke little, but once wrote it in words never forgotten by his fellow artists: 'Every work of art which really moves us is in some way a revelation – it changes us. Experiences, much more than instruction, are a seeing with an inner eye, a door to our deepest understanding wherein we have the capacity for universal experience.'

These are the words of a mystic as well as a painter who had mastered many different styles, perfected his own, won a high reputation at home and abroad, but was himself never quite satisfied. Even in his last years he was still searching.

When he visited my studio one spring day in 1946 he already had painted some of the spiritual truths revealed to him by long communion with the northern landscape of Canada, his original inspiration. His style, like his thought, was constantly evolving, moving toward stark simplicity. Increasingly, he perceived the essence of life, of which art is only a reflection.

With him, art became a patriotic mission. He believed that if a country ignored its arts, it left no record worth preserving, no message to its successors. Moved by this conviction, he spent much time and money to help younger, struggling artists and was the moving spirit in the famous Group of Seven. As his friend A.Y. Jackson wrote: 'He provided the stimulus; it was he who encouraged us always to take the bolder course, to find new trails.'

By the time I met Harris, the Group had broken up and he had remarried and moved to Vancouver. Now his art was purely abstract, in final simplicity, the clearest vision of his inner eye. Not many could understand it, but he was careless of reputation, seldom exhibited his paintings and, though cheerful in conversation, had opened a very private door to what he called the universal experience.

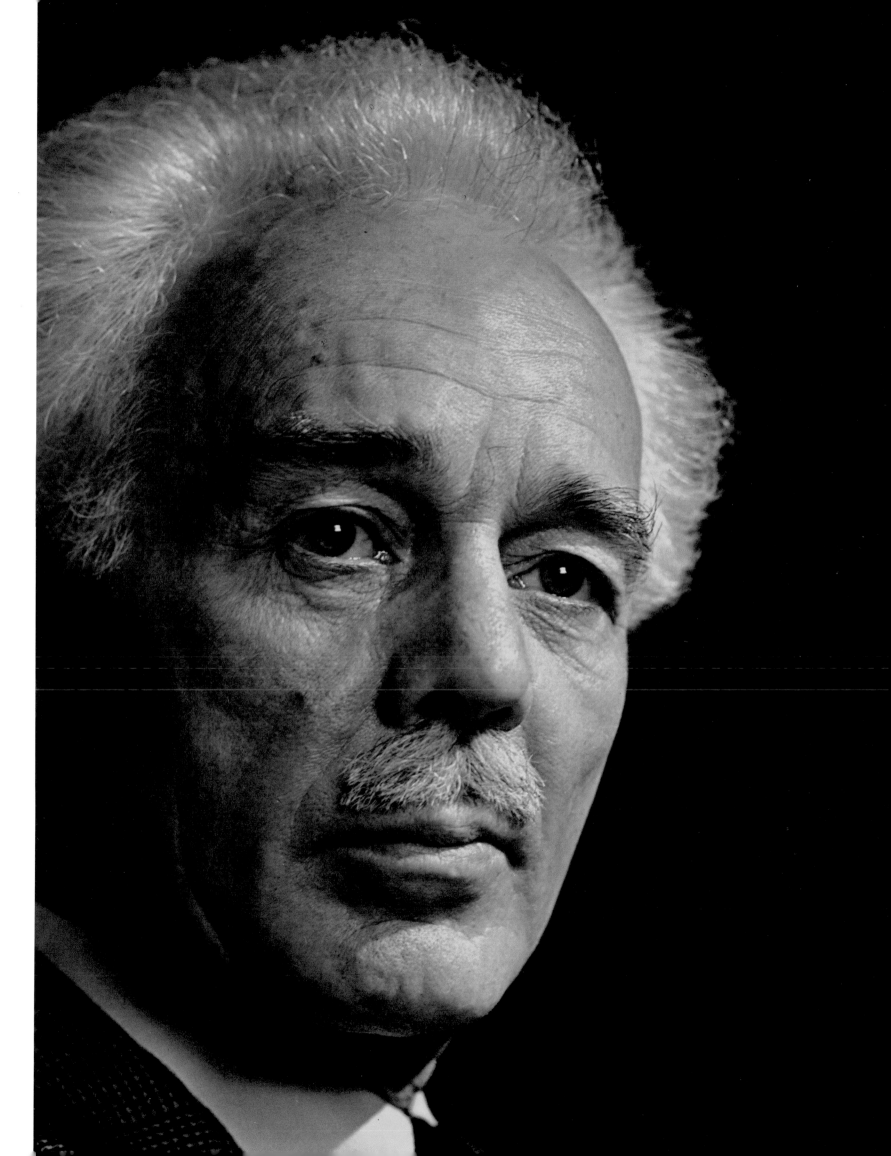

Gerhard Herzberg

1972

His friends say that Gerhard Herzberg would rather be an opera singer than a physicist and there is some truth in this. Actually, he sings arias for relaxation – and sings them very well. He also climbs mountains and takes a keen interest in many fields of activity.

But science is the centre of his life, both as an explorer of its laws and as a defender of its rights. His Nobel Prize, awarded for chemistry in 1972 – the third time Canadians have won that coveted honour – was the proof of his most deeply felt conviction: pure science is a creative process, a form of art, which should never be manipulated by politicians.

My portrait was taken in Herzberg's office at the National Research Council in Ottawa, where he has been working and teaching since 1948. In all aspects of his work he insists on setting himself positive goals and charting new frontiers.

Throughout his career he has been an outspoken champion of pure science, seeing it as an essential part of mankind's search for a better life. The conventional measurement of society does not impress him in the least.

'A high standard of living,' he has declared, 'is not, as such, a goal worth striving for unless a high standard of living includes a high standard of art, literature, and science ... If Canada is to be economically prosperous without at the same time supporting the arts and sciences for their own sakes, it will not reach the level of a great nation.' The only thing wrong with science, feels Herzberg, is the misuse of its technology, or the desire to control it for destructive purposes.

$$\nu = A - \frac{R}{(n-d)^2}$$

$$I.P.(H_2) = 124417.2 \text{ cm}^{-1}$$

William Holder

1952

This portrait of a humble but dauntless man was taken because his life, I thought, symbolized the life of his province and the decline of his ancient craft.

In 1952, when I was photographing the cities of Canada for *Maclean's*, the mayor of Saint John, New Brunswick, kindly provided me with many amenities and showed me some attractive homes, streets, and parks. But not everything was so pleasant. The slums, the squalid housing, and the look of helpless poverty depressed me.

Here was the legacy of a fire which had ravaged part of the city seventy years earlier, combined with the death of the wooden sailing ship, that masterpiece and profit-earner of the Maritimes before the age of steam and steel. Many of my photographs reflected a heartbreaking change in fortune, as a once-lucrative industry was destroyed and the nation's centre of economic gravity moved steadily westward from the Atlantic shore.

One of the expert craftsmen caught in the transition from one era to another was an eighty-year-old sailmaker, William Holder, who felt completely at home in his picturesque surroundings and accepted life's changes with good cheer. He told me that he had fitted out some of the finest barks, schooners, brigantines, and full riggers that used to ply the oceans of the world. Now there was no romance left in his trade. He made an occasional sail for a racing yacht, but most of his livelihood depended on tarpaulins, awnings, and storm curtains – for steam vessels.

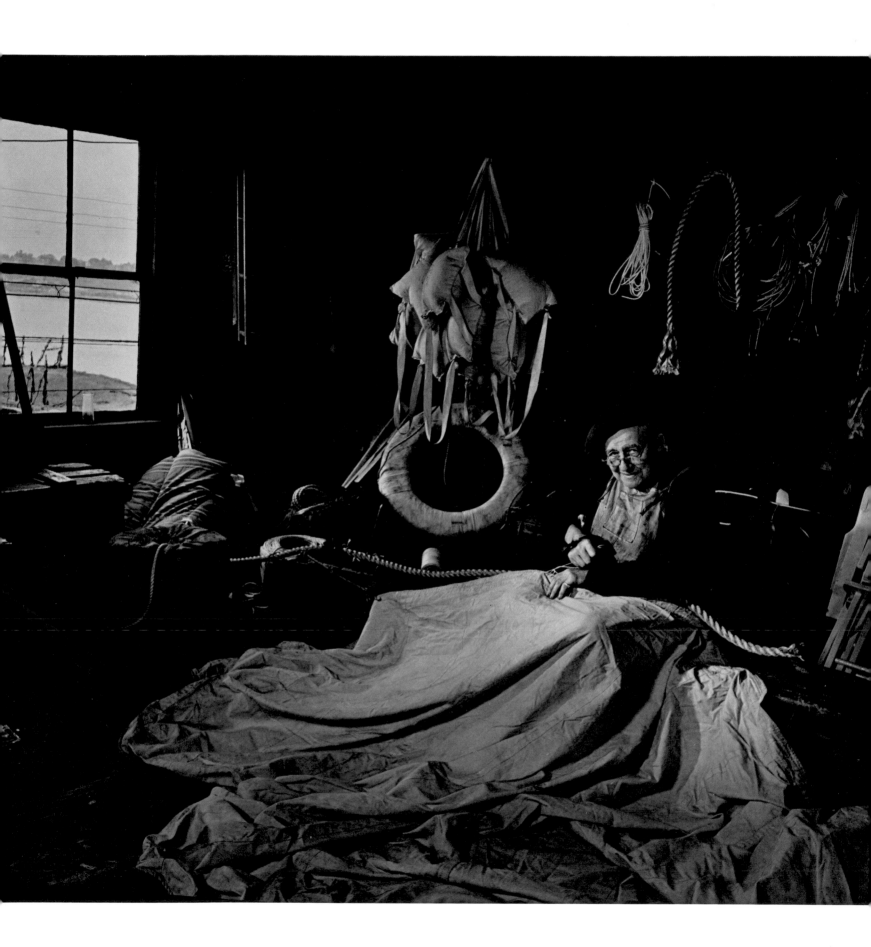

Camillien Houde

1952

In Canada, and indeed in nature itself, there could be only one Camillien Houde! He was mayor of Montreal for a long time but he regarded official office as a part-time job, or hobby. His real ambition was to be a character, a kind of native Canadian phenomenon, and in this he succeeded brilliantly. Although many people deplored his methods, nobody could dislike him after half an hour's conversation.

At close range, the gargoyle face, the glittering eye, the sly grin, the ceaseless torrent of words, the rotund, restless figure were irresistible. Even the federal government, which arrested him during the second world war, secretly admired his boundless appetite for life.

When he was sent to an internment camp in New Brunswick for advising Quebec citizens to ignore the National Registration Act, Houde thrived on imprisonment, physically and mentally. He lost about a hundred pounds of surplus weight and restored his health by cutting firewood. He read voraciously to repair the lack of education in his youth. Released at the war's end, he felt no bitterness toward the government; the voters of Montreal embraced him again and English-speaking Canada forgave his casual breach of the law.

Was it not curious, someone asked him, that he had played the gracious host to King George and Queen Elizabeth in 1939 and, the next year, was their prisoner? 'Not curious at all,' he replied. 'Return of courtesies.' As a sign of his own forgiveness, he kept my portrait of the Queen on the wall of his office and I saw it there when I photographed him for *Maclean's* magazine in 1952.

A group of English-speaking businessmen feared that he might vent his hostility against the anglophones of Montreal by declining to renew their contracts with the city, but he told them: 'Gentlemen, while I was a guest of His Majesty, I became a reader of books. I read about your great English statesman, Sir Robert Walpole. I learned what he thought was the secret of democratic government. He said it was patronage.' After a dramatic pause Houde added: 'Gentlemen, I intend to be the most democratic mayor you ever saw.'

By his lights he was. Surely no one but an instinctive democrat would have turned to King George on the balcony of the City Hall, before a cheering throng, and remarked to his sovereign: 'Sir, part of this enthusiasm is for you, also.'

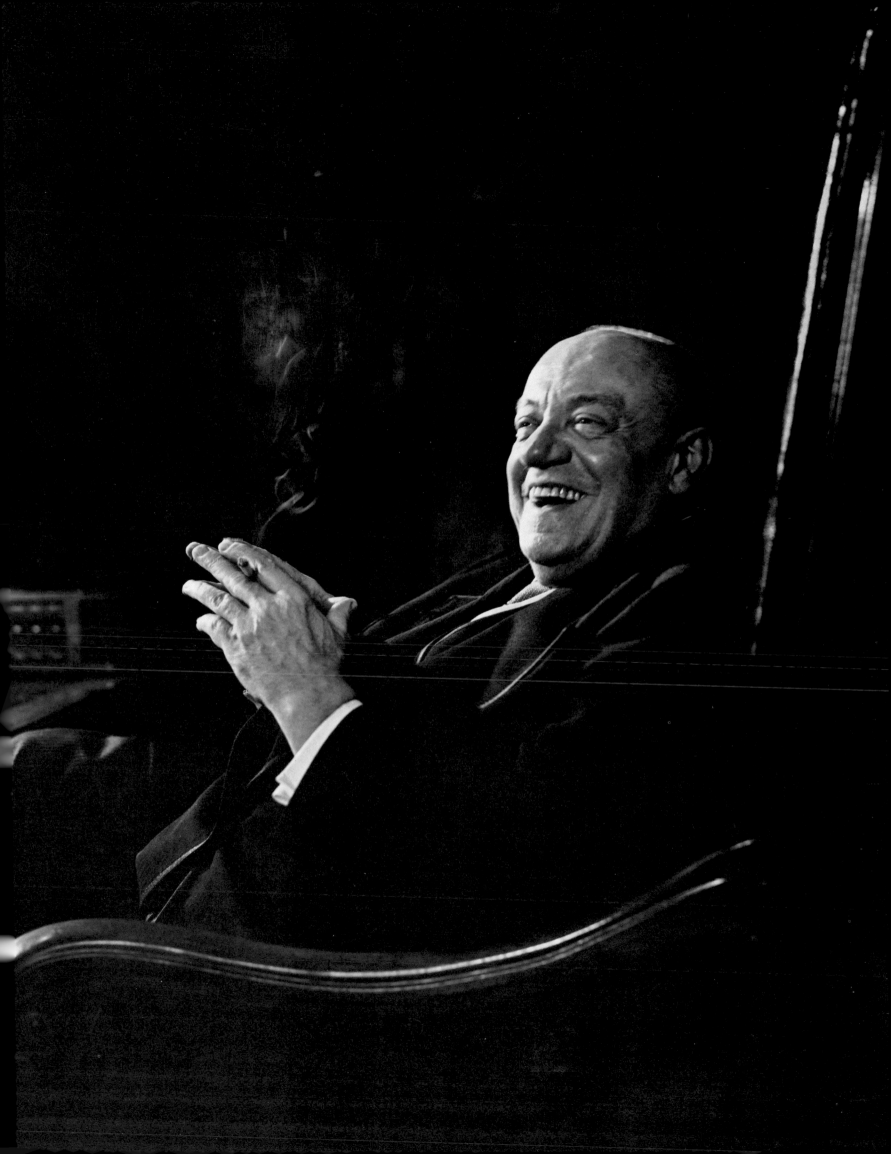

Bruce Hutchison

1964

What could be more Canadian than skiing from one's own front door across the frozen Rideau River? During such a winter pastime from my home, Little Wings, I became acquainted with the distinguished news-paperman who was to become one of my dearest friends, Bruce Hutchison. He had been invited by Kenneth Wilson, a respected contributor to *Maclean's* magazine, to join us in backyard skiing. My late wife, Solange, prepared a most delicious après-ski lunch – a rustic dish of sausages and cabbage – and over this steaming dish Hutchison and I laid the foundation for a friendship spanning four decades.

Not only do I admire Bruce greatly as a journalist-philosopher who has commented on the political careers of six prime ministers, and as a lucid interpreter of Canadian-u.s. relations but, even more, I value him as a compassionate human being. One incident in Victoria proved a test of his human qualities, as Bruce himself described in *The Far Side of the Street*. I was spending a weekend at his Shawinigan Lake cottage thirty miles north of the city. So beautiful was the afternoon light that I insisted he stop chopping wood and pause to be photographed. Swiftly, so as not to lose the light, I set up my camera and ordered someone sitting nearby to fetch a few pails of water and throw them onto an arbutus tree to make the leaves shine. The man meekly did as he was told. After I had clicked the shutter, Bruce introduced my assistant: 'Yousuf, please meet Chief Justice J.O. Wilson.' I was so chagrined to discover that I had been treating this important person as my flunky that I plunged into the lake, clothes and all.

I took the present photograph under calmer circumstances, in the Reading Room of the Senate in Ottawa. Stretched behind Bruce, like flags at half mast, are newspapers from every city in Canada – including the ones he has written for so effectively, the Vancouver *Sun*, the Winnipeg *Free Press*, and the Victoria *Daily Times*.

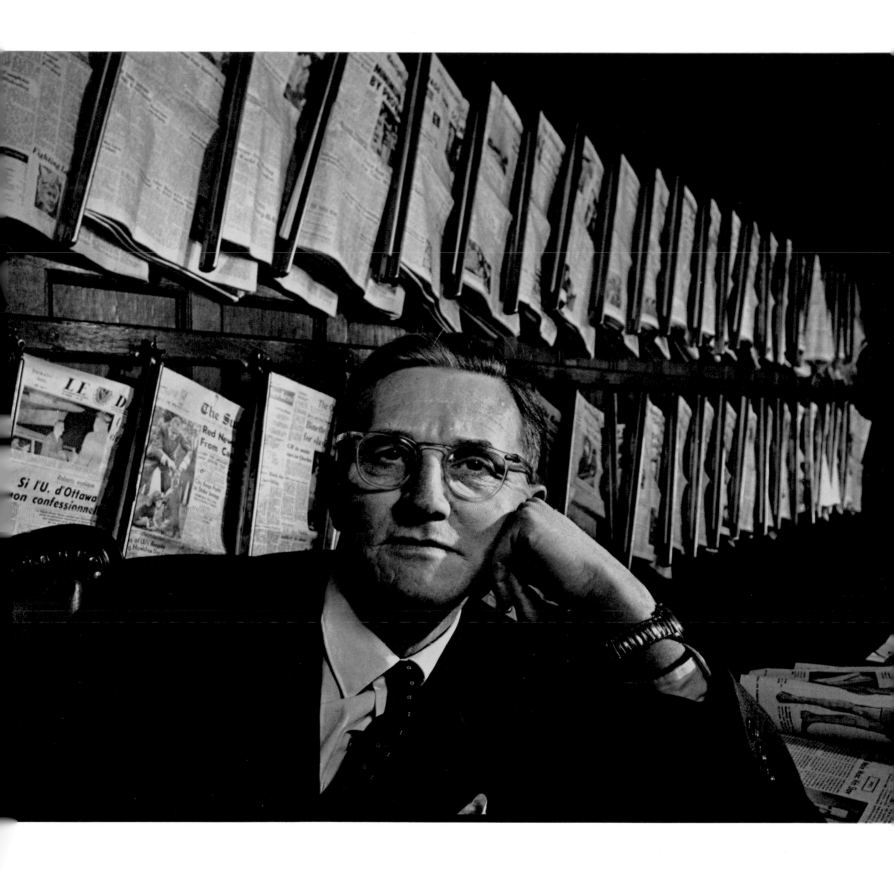

A. Y. Jackson

1953

When I photographed A.Y. Jackson, in 1953, he was ranked among Canada's greatest painters, with a bold style derived from the land and his own vision of it. But he remained the unpretentious, likeable man he had always been and talked little of himself, much of his fellow artists.

One of them, the already celebrated Lawren Harris, had been the first purchaser of a Jackson canvas, perceiving in it a genius not yet known to the public. After Jackson returned from his travels to Paris and the French countryside, and then to the wilderness of the Canadian Shield, he learned that the Group of Seven had been founded – and that he was one of its charter members!

The membership was well-earned, as was the subsequent endurance of the Group which had set out to create an authentic Canadian art form, indigenous and different from any other. Before that goal was reached Jackson and his friends lived through difficult times, since it is never easy to be in the vanguard of a new movement defying conventional artistic wisdom. Nowadays, when the Group's work is accepted as unique to Canada, few of us remember that Jackson's paintings, hanging in the National Gallery, were once called 'products of a deranged mind.'

Chuckling over these memories of his youth, Jackson was photographed in the McMichael Gallery in Kleinburg, northwest of Toronto. This perfect setting houses the largest collection of the Group's landscapes in a gallery built with beams hand-hewn long ago by pioneers of the district, the walls of weathered boards salvaged from old, ruined barns, the high windows looking out on the leafy, rolling scene Jackson loved and brilliantly painted. Against such a background his tales of early, heretical days took on a new meaning.

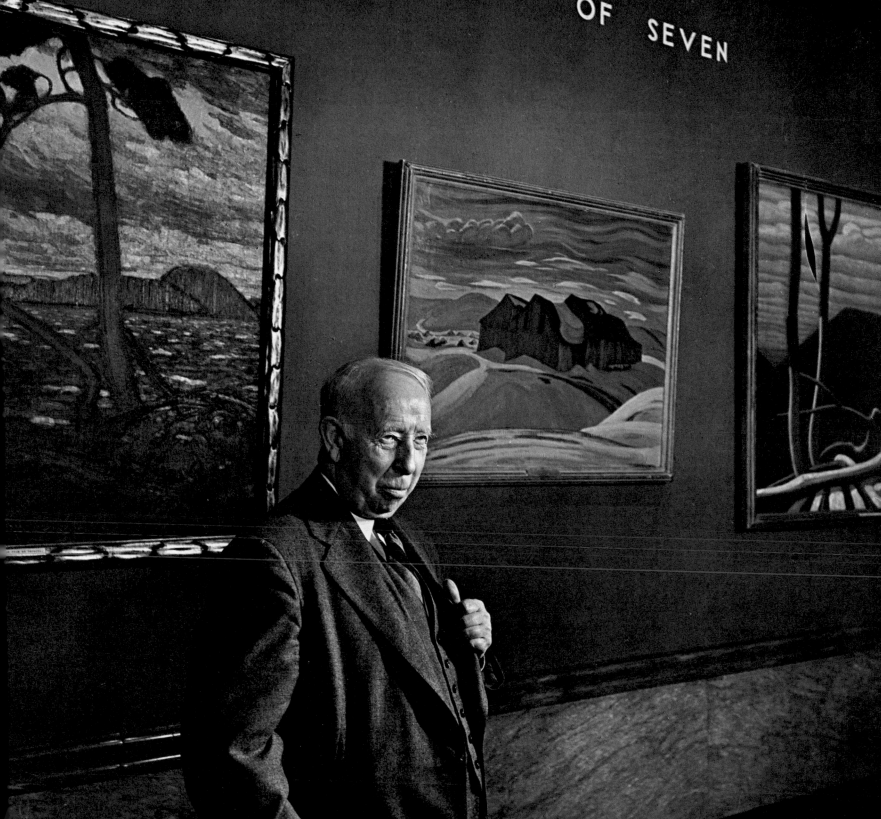
THE GROUP OF SEVEN

Norman Jewison

1973

My first meeting with Norman Jewison, the boldly innovative film producer, occurred in 1973. The Young Presidents Association of the United States, made up of enterprising men and women who were presidents of their companies before reaching the age of 40, persuaded a group of well known persons to serve as faculty on an ocean cruise they wryly labelled the 'Odyssey of Knowledge.' Whether much knowledge was actually disseminated in the course of the voyage is highly questionable. But as a member of the eclectic teaching staff assembled aboard the *Queen Elizabeth II* – along with diverse characters like Arthur Hailey, Art Buchwald, the Duke and Duchess of Bedford, and Jewison – I had a great deal of fun.

Only one brief incident marred everyone's pleasure. Jewison's film, *Jesus Christ Superstar*, had just been completed, amidst great controversy, and he had arranged for the world premiere to take place during our floating seminar. We all loved it – except for one pedantic diehard who insisted that it was irreligious, and expounded his theory, at length, in class. Jewison was deeply hurt. Considering the profound religious intent conveyed in his beautiful film, his reaction was understandable.

Of course his extreme sensitivity – his vulnerability, even – is part of his charm and originality. There is a delightful boyishness about him, an openness to other people, an interest in everything, that I saw again when I photographed him in London shortly after the cruise. He is also a superb listener, always alert for words and ideas that will help to inspire one more dazzling cinematic experience.

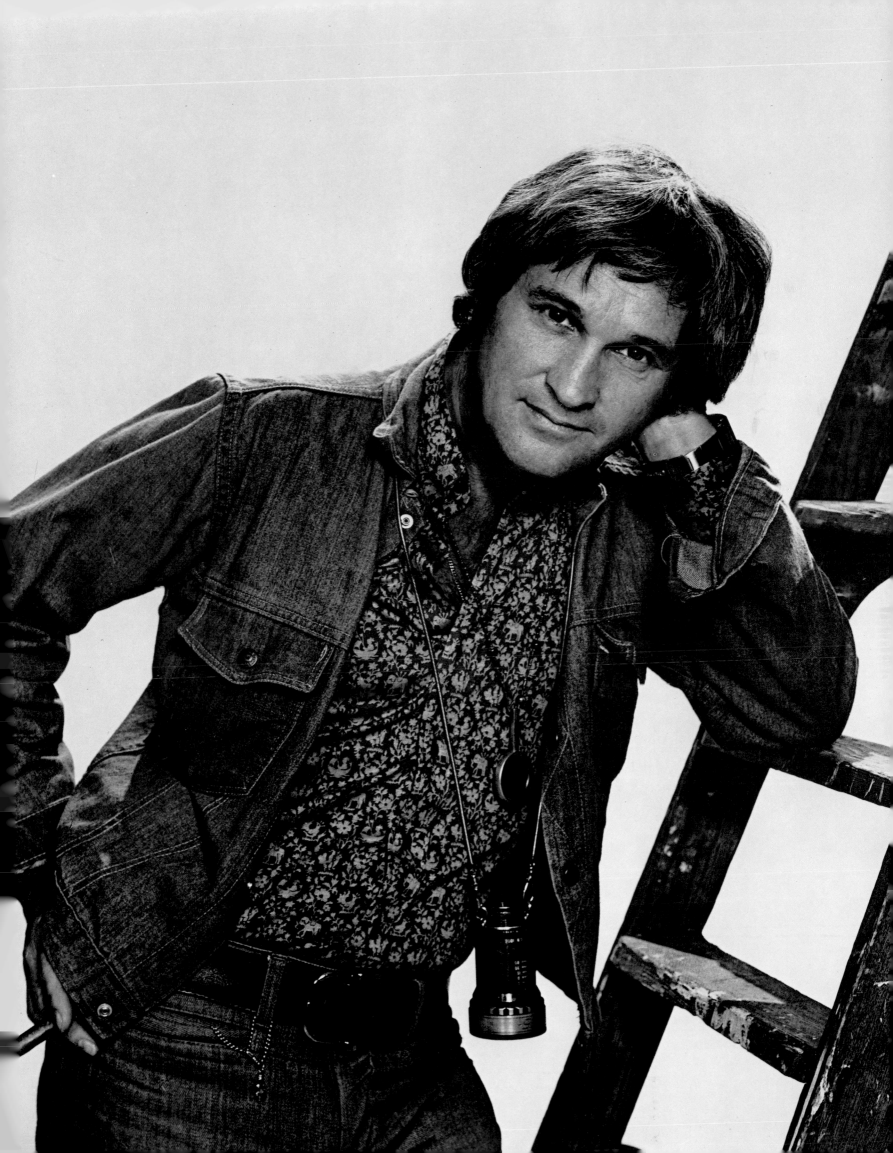

Claude Jutra

1977

In 1957 I visited the National Film Board in Montreal to photograph Norman McLaren, the genius of animation. He was working on a magnificent, surrealist production, *A Chairy Tale*, which, soon after, took first prize for experimental films in Venice. It concerned a man who is about to sit down on a chair and read a book during his lunch break. But the chair, under McLaren's graphic wizardry, refused to co-operate, with humorous and haunting results.

Although I did not know him then, the young man nibbling a sandwich in one of the studios was Claude Jutra, the leading player in the little masterpiece. At the moment he seemed to be rehearsing his lines in a rather nervous fashion. Or so I thought. It did not occur to me that he, too, had a special genius of his own, or that I would ever have occasion to photograph him.

Almost twenty years later, when he had directed five highly regarded feature films, as well as that fine piece of dramatized social history, *Dream Speaker*, I approached the famous Jutra, our first meeting quite forgotten. His recollections were clearer than mine.

While I prepared my camera he reminded me, in his quiet way, that we were already acquainted and, to prove it, took from his library shelves a film for inclusion in his portrait. The canister bore the label: *A Chairy Tale*.

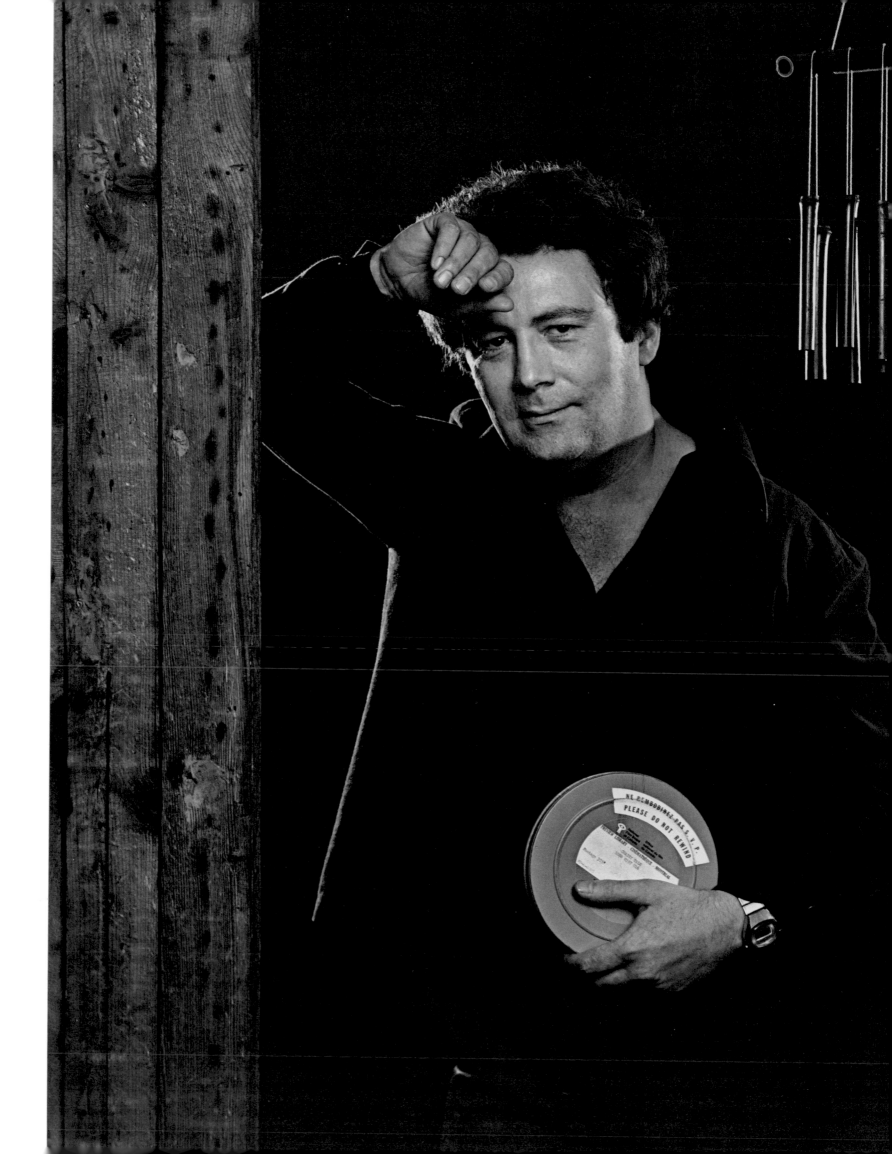

Karen Kain

1977

I had planned a portrait of the great ballerina immediately after she had danced at the National Arts Centre in Ottawa. But seeing Karen Kain when she had completed her wonderful but exhausting performance, I realized that photography must wait for another day. She agreed and the two of us retreated to Little Wings, where we joined my wife, Estrellita, for a late supper.

Seated in an easy chair, with legs crossed yoga-style, Karen talked freely about her work. To project the illusion of lightness on the stage, she said, a dancer endures almost constant physical pain but, of course, the audience must not suspect it. In her case dancing, as in *Swan Lake* or *The Sleeping Beauty*, seems to be second nature, the most difficult motions and turns quite effortless.

Measured against the secret trials of a ballerina's life, her success and worldwide reputation not only demonstrate a rare natural gift but a strong determination and much toil beyond the public's gaze. Her many triumphs are a source of happiness, well deserved. She relived for us her excitement at winning a silver medal as a solo dancer in the Moscow International Ballet Competition in 1973, and first prize for the pas de deux with her partner, Frank Augustyn.

When our delayed photographic session finally took place I thought that, by using multiple flashes, I could register Karen Kain's elegant and decisive steps most accurately. The result is proof of her complete victory over the physical limitations of her art.

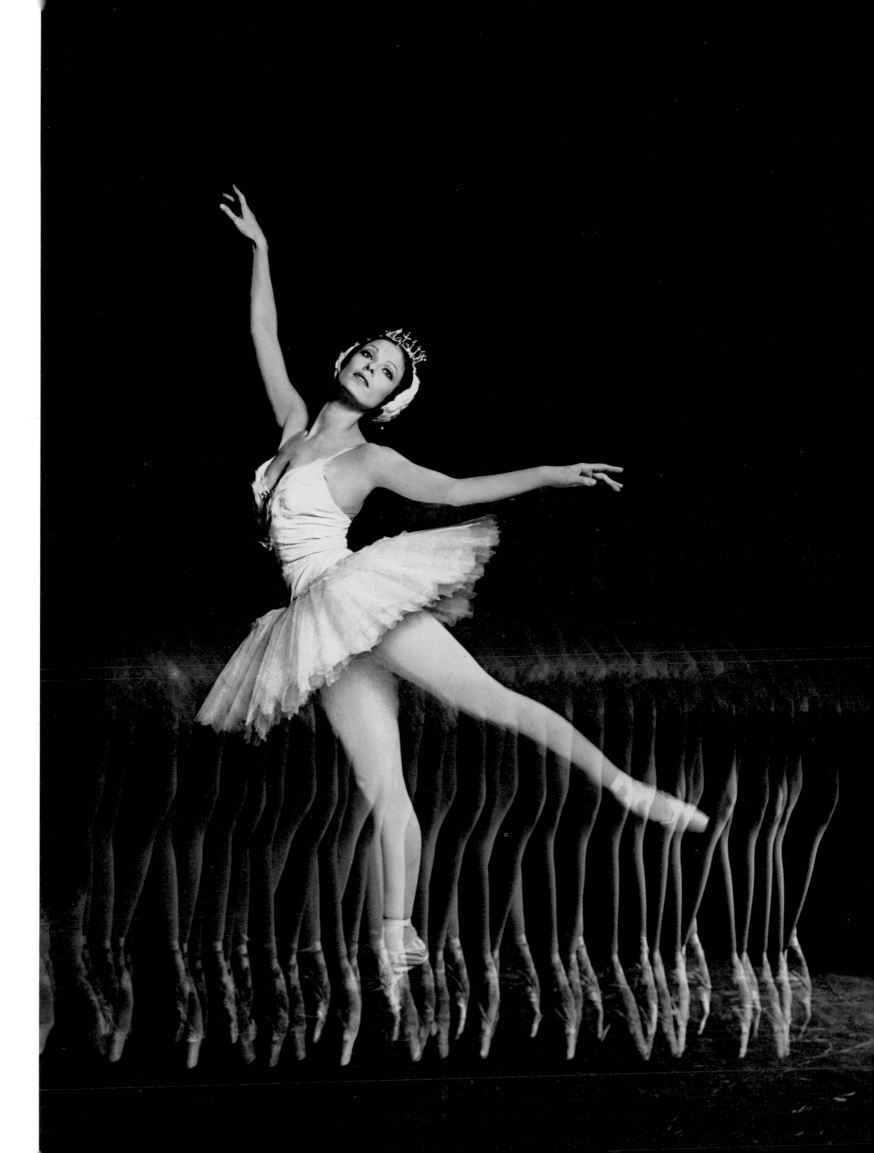

Kenojuak

1976

Since my wife, Estrellita, and I had always been fascinated by Eskimo art, and several of Kenojuak's prints were in our collection, it was a happy experience for me to meet that inspired Canadian artist of Cape Dorset.

Kenojuak was one of the twenty artists – many native painters and printmakers – commissioned by the Canadian Catholic Conference of Bishops in 1975 to illustrate a new Sunday Missal in the style, and events, of their own choice.

Through the kindness of Archbishop Emmett Carter of London, Ontario, who organized a cross-country tour of the resulting works, I had the chance to meet and photograph Kenojuak. She is physically small but she impressed me at once with her inner strength, the clear vision of the awesome land and the hardy people around her.

It was typical of this woman, I thought, that she had based her felt-pen drawing for the Missal on a quotation from the second chapter of the Book of Acts: 'With joyful and sincere hearts they took their meals together, praising God and winning the approval of the entire community.' The artlessness of her interpretation illuminates her ancient race which reached Canada, and mastered the Arctic, long before the first white inhabitants.

She herself has provided the best explanation of her depiction of the Scripture: 'Here they are about to eat, the children, men, and women. They are eating seal meat. One of the children, the one with the hood on, has just come in from playing. He is happy to find his family eating. There is also a child beside her mother. She wants some meat. They are happy to eat together and thankful for the food.'

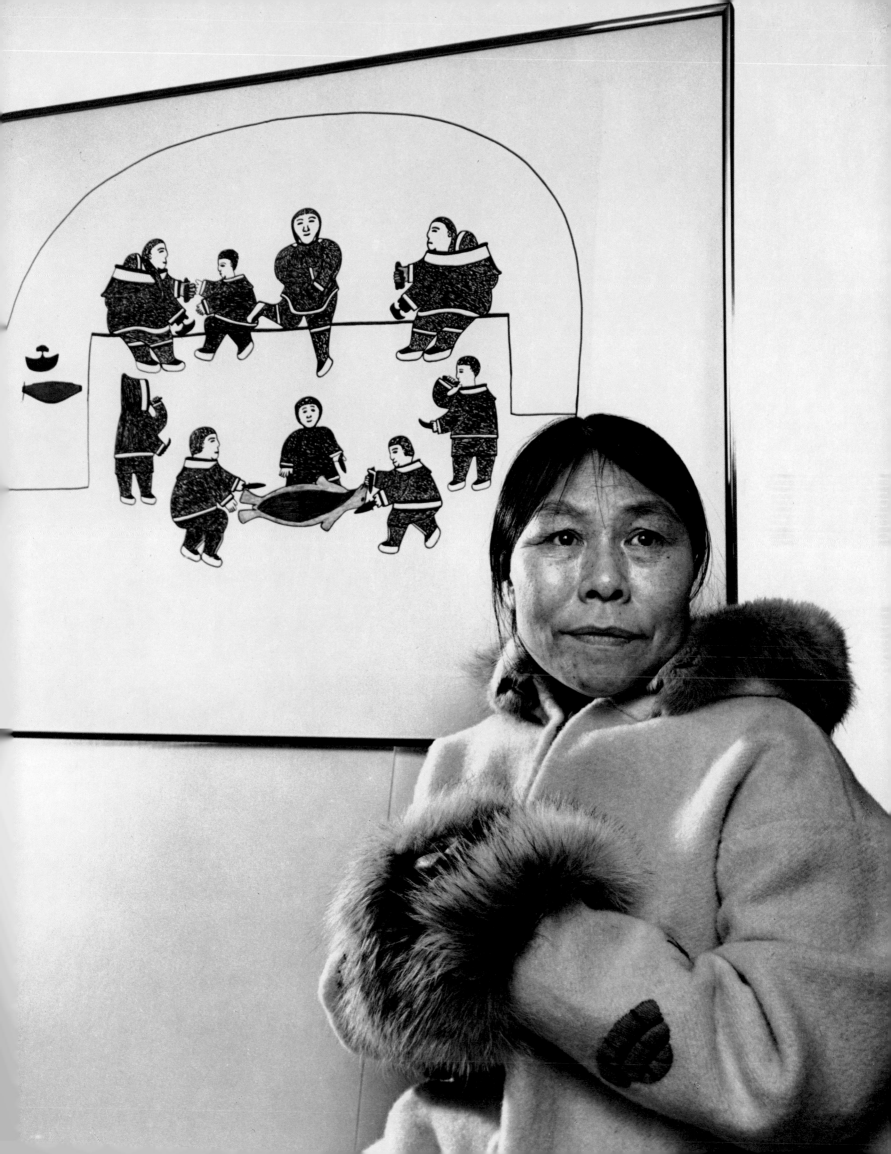

William Lyon Mackenzie King

1940

Meeting him often, as a photographer and friend, perhaps I should have suspected the vast gulf between Mackenzie King's public image and his private life. Through the Prime Minister's patronage, I obtained some of my most important photographs, including a scowling Winston Churchill in the darkest days of the second world war which was the turning point of my career. But it was not until the embargo on his diaries and papers had been lifted that I, and the nation, began to see the secret garden of emotion, obsession, and even sheer fantasy that blossomed beneath a Calvinist exterior.

There were come clues to his mystery, yet I failed to recognize them. Invariably, King wished me to depict the man he visualized himself to be. Like politicians everywhere, he professed humility, but he was fussy about the details of any picture, even about its composition.

Above all he was anxious to discourage the slightest animation or brightness in his personality because, I suppose, it contradicted the grey, colourless legend of his own making, the legend of solemn wisdom, compassion, and reliability. He might be laughing heartily at some anecdote, for he had a keen sense of humour and a dash of mischief, too. Then, at the threat of the shutter, he would struggle to retain his look of composure, his public stage act, protesting, 'Karsh, you must *not* take a picture now!'

Withal, though, he was a thoughtful and impeccable host, very fond of Solange, my first wife. During our frequent visits to Kingsmere, his country estate outside Ottawa, he always entertained graciously. My portrait of King and his beloved dog, Pat, was taken on one of these occasions. Possibly the informal rustic pose caught this giant figure in Canadian history off guard for a moment.

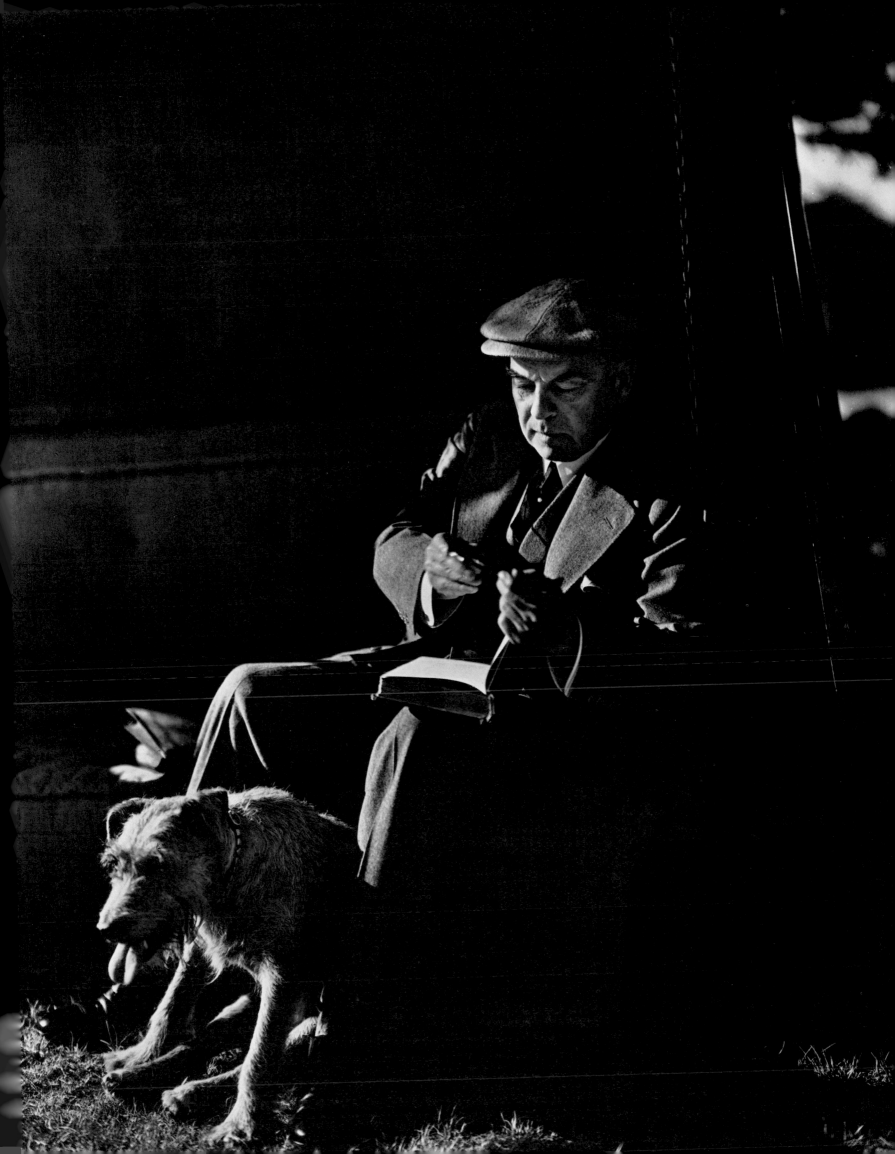

Margaret Laurence

1977

The literary career of Margaret Laurence has stretched over long geographical distances and many lands but success has not spoiled her. Now recognized as one of Canada's foremost novelists, she lives by choice in simple surroundings outside Peterborough. She has turned her Victorian house into a workshop for her craft and a cosy retreat for stray travellers like myself.

When I arrived with my camera and lights she led me immediately, not to the parlour, but to the kitchen and a steaming bowl of old-fashioned pea soup, with freshly baked bread, the contribution of her good Indian friend, Mrs Williams.

Mrs Laurence's conversation was as simple as her home and disarmingly candid. But I saw at once that I was in the presence of a powerful intelligence which scorned the fame and luxury of big cities and created best in a setting free from distraction.

She told me of her experiences in Africa where she had published her first book, a study of Somali poetry. After wandering across Europe and the Middle East – a collection of her travel pieces appeared not long ago – she spent several years in England, beginning her serious work as a writer. But her deep roots in Canada inevitably drew her home from exile. Although she had been born in Manitoba, she chose to settle in rural Ontario and there the roots grew even deeper, nourishing her books. Indeed the homeward voyage became a metaphor for her discovery of herself, her literary gifts, and her people.

In addition to the writing of books, she has many extra duties to perform. One chair in the living room bore a load of sixty-two books written by others and sent to her for detailed comments by the Governor General's Award Committee. I scooped up a few of these volumes, and set them on a handsome Victorian mirror stand in the hallway so that something besides her punishing homework might be included in the portrait.

On top of the pile I placed a copy of her novel, *The Diviners*, which she had just autographed for me. The dowsing rod suspended from the window frame behind her seemed to have been put there expressly as an illustration for her most popular – and controversial – book to date.

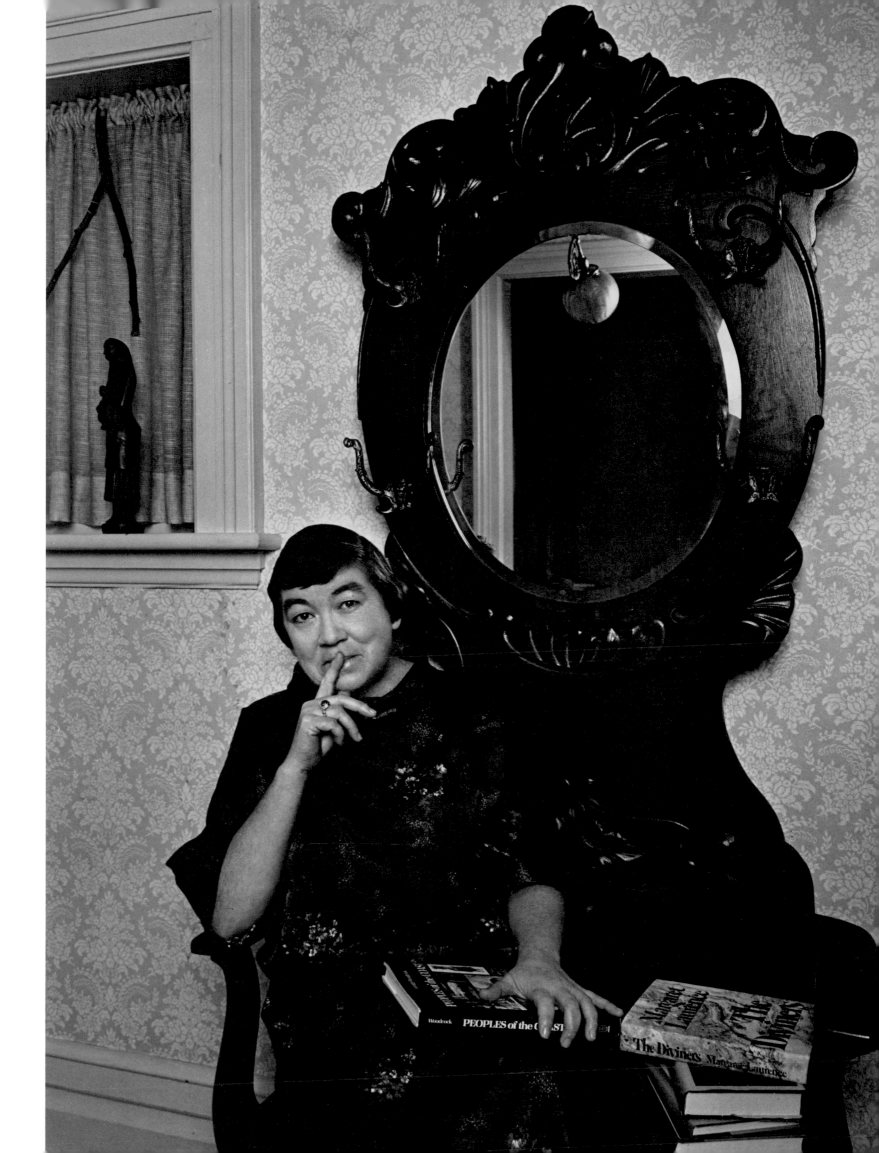

Stephen Leacock

1941

When, in 1941, I spent two and a half days with the great Canadian humorist I had yet to realize that his fame had spread throughout the world. Perhaps that ignorance simplified my task.

I photographed Leacock eating his breakfast; playing with Stevie, his son; fishing; listening to music; writing sixteen hundred words every morning; and, of course, laughing. He did not laugh, however (or so I thought), because he felt happy but because laughter was his profession. For he had not known much real happiness, especially in his domestic life.

Wit, a quality quite different from humour, constantly bubbled in his casual talk. One evening, for instance, he decided to take me fishing. Two craft were moored at his dock, a canoe and a motorboat. With my usual impatience I jumped into the motorboat. 'No, no,' Leacock shouted. 'We're going out in the canoe. I'll paddle.' When I asked him the reason for his choice, he answered: 'Because the motorboat always gets there.'

After seeing a set of his portraits, he awarded me the Stephen Leacock Non-Existent Gold Medal and wrote his own captions for the photographs. They soon appeared in the *Illustrated London News* and many other publications. Most of them now hang in the library of Leacock's house at Orillia, Ontario, which has been wisely preserved as a national shrine commemorating the wistful Englishman who brought his genius of humour to Canada.

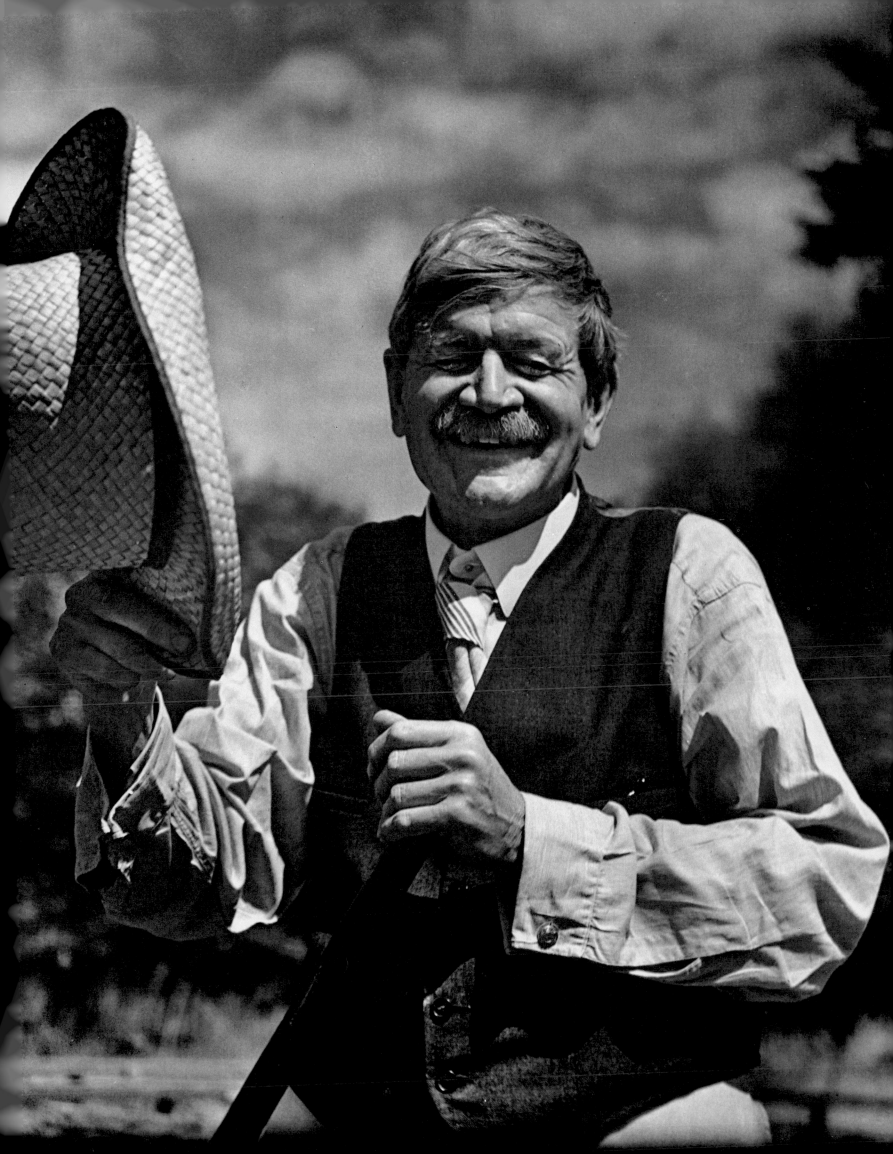

Paul-Émile Cardinal Léger

1974

Often, in the course of my photographic odyssey, I have seen human greatness at first hand; so it was with Cardinal Léger. Perhaps in 1957, when he was Archbishop of Montreal and I spent an entire week photographing him, he himself might have been unaware of the true dimensions of his Christianity.

The photographs were to illustrate *This is the Mass*, a book containing a series of depictions of the celebration of this sacrament, with a profound text by Henri Daniel-Rops. The Cardinal appeared in all the splendour of his vestments. As I was to learn, they did not reveal the real essence of the man.

Years passed. Cardinal Léger had requested Pope John XXIII to relieve him of his archbishopric so that he could devote himself to the care of lepers in Africa. Shortly afterward, I noticed a familiar figure at the Paris airport and suspected that he was the Canadian Cardinal – but I couldn't be sure. He was dressed like a simple priest. His face seemed to have undergone a spiritual transformation, reflecting an inner struggle, and a victory.

We boarded the same plane. It was not until we landed in Rome and the Canadian ambassador met him that I knew for certain that he was indeed the person I had once photographed in the magnificent raiments of the Church. It was then I resolved to make a new portrait of him, now almost a different man.

An appointment was arranged while Cardinal Léger was visiting his brother Jules, who was by then Governor General, in 1974. I found myself facing a priest of ascetism but quiet confidence. I couldn't help asking: 'Why is it, Your Eminence, that when I worked with you for a whole week I didn't find it as challenging to photograph you. Now I am finding the task complex.'

'Oh,' he replied, 'that's easy. *Sans mon cadre* – without all the ornaments – I'm more difficult.' Gesturing toward comfortable surroundings, he added: 'Just think of the transition between the work I do in Africa and all this ...'

I ventured to ask with whom, among the saints, he would like to be identified. Perhaps Augustine? 'No,' he answered, 'that's reaching too high,' and he declined to name an alternative. None was needed. Enough that the man before my camera was a servant of humanity who abandoned a life of spectacular luxury to live and work among a remote, tragic people of his own free choice.

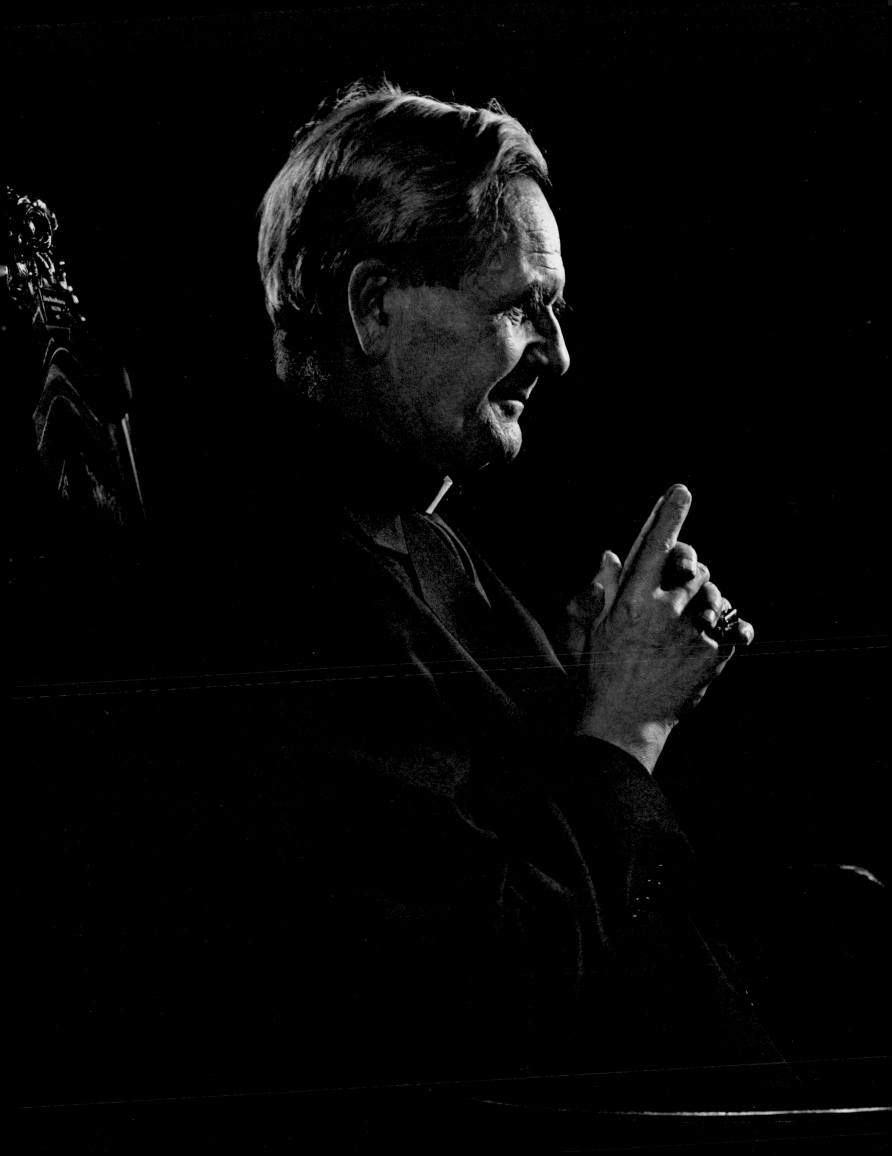

Jean-Paul Lemieux

1977

The work of the painter Jean-Paul Lemieux has always fascinated me and I was eager to photograph him. His lyrical, surrealistic canvases – 'memory emotions' of a Quebec childhood filtered through a simple and sincere imagination – have retained a childlike purity of vision. Visiting him and his wife, Madelaine, herself an artist, in their beautifully understated summer home in Île aux Coudres, and enjoying their warm hospitality, I found that the gentleness which characterizes Lemieux's work might well describe the man as well.

At first he appeared a bit shy but with a quiet inner strength. As we talked about his art he proudly called my attention to a favourite piece of sculpture by Bourgeault, one of the many Quebec carvings he has been collecting all his life, most of them at Île aux Coudres.

His quiet manner belied a subtle sense of humour and a fine appreciation of the ridiculous. Our rambling conversation drifted to his portrait of Queen Elizabeth and Prince Philip – one of his very few portraits, along with that of Governor General and Mme Léger which was soon to be dedicated at Government House.

Madelaine told me the delightful anecdote of their daughter, Anne, who had been introduced to Her Majesty and Prince Philip as 'the daughter of our beloved artist, Lemieux.' Diffidently, but firmly, Anne protested: 'While I'm proud to be the daughter, how nice it would be if I were introduced on my own.' To this Prince Philip quipped: 'And now you can understand how I often feel.'

Over the years, Lemieux's style has evolved from his early struggles as a conventional painter in the Morrice tradition. But as his life-long close friend, Dr Robert Hubbard of the National Gallery, remarked: 'What has not changed is the essential quality of the man, who has remained true to himself and has always been the same in the loyalty of his friend-ships.'

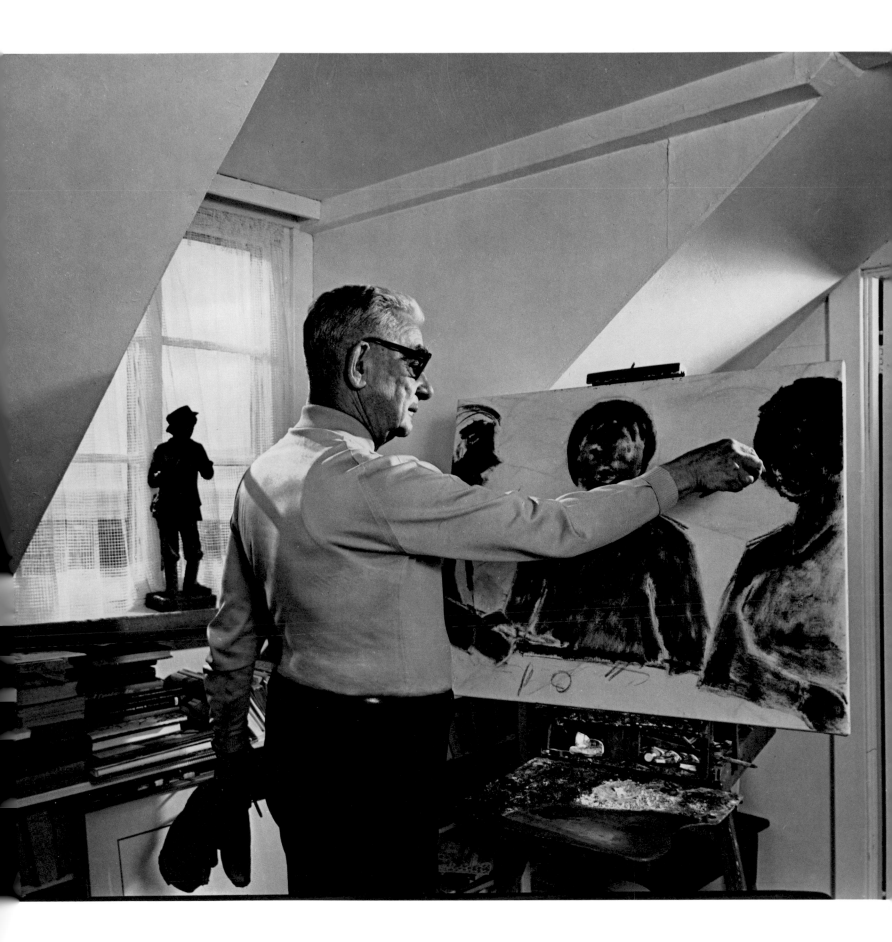

Réne Lévesque

1978

As a Canadian who speaks French and has long admired the riches of French culture, I disagree with Premier René Lévesque's determination to have Quebec separate from the rest of Canada. But portraiture, not politics, brought me to Quebec City in the spring of 1978. There I photographed this extraordinary man, sixteen months after he had been surprisingly swept into the office he, himself, hardly expected to occupy.

Lévesque was already a familiar figure in journalism, television, and politics. He was a second world war correspondent with the U.S. Army. From 1956 to 1959, his talk-show 'Point de mire' enjoyed the highest rating on French television, reaching a popular and universal audience including college professors and taxi drivers. 'In a way,' states the CBC, 'it became the soap opera of current affairs.'

The slight, intense, chain-smoking Premier had thus already been a public personality for a quarter of a century when, ten years ago, he founded the movement which became the basis for the current Parti québécois, dedicated to separating the province from the rest of Canada. 'What does this French Quebec want?' Lévesque has written:'... there are growing possibilities that the answer could very well be independence.'

The dynamism that leaps from the television screen is more subdued in person, but he is incisive, informal, and radiates a restless energy. He invited me to sit in on a cabinet meeting and photograph him as he was engaged in actual decision-making. From this session came a photograph capturing him in a familiar characteristic moment, his eyes darting in one direction, hands eloquently pointing in another, the ever-present cigarette dangling from his lips.

When we visited alone together we shared our personal reading preferences. Lévesque prefers biographies, autobiographies, and historical novels, because they tell of actual events and real people. The photograph here was taken during our moments together as he naturally assumed a stance suggestive of reflective strength.

Lévesque has been called a man who doesn't want to change institutions, but rebuild them. I asked him his highest aspiration for Quebec. 'A bastion of personal liberty and social justice,' he replied, 'and a small French member of the family of western nations, adding a vibrant difference to North America. Such is my hope and forecast for Quebec.'

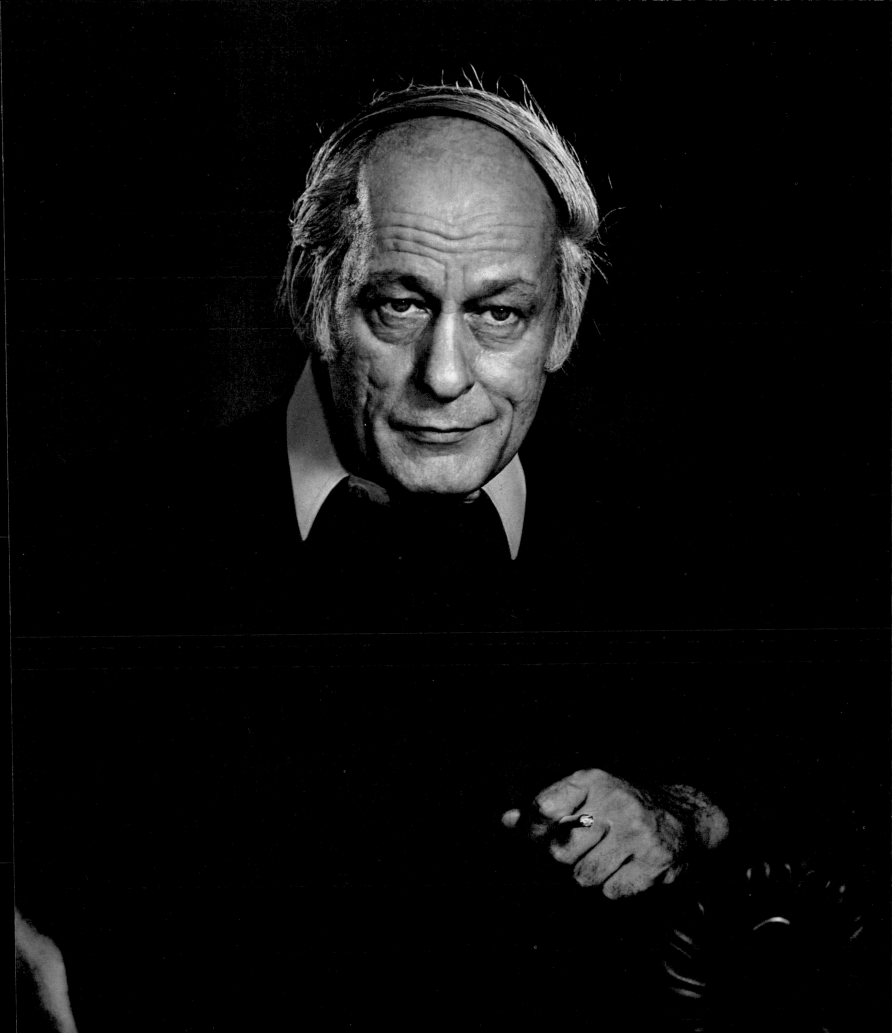

Monique Leyrac

1977

More intimately than any political orator, or any written word, the Quebec chanteuse can evoke the feelings, dreams, and folk memories of the French-Canadian people. Rarely does a singer have such an intimate relationship with her audience, such a common understanding.

This magical form of entertainment, or rather secret communication, has produced many fine interpreters. Among them one of the most enchanting is Monique Leyrac, a woman of intelligence and verve, the Gallic spirit incarnate. She is often compared to the great tragic French chanteuse, Edith Piaf.

The temporary home where I made her portrait was absolutely bare of furniture; her presence filled the room. While I worked she hummed old French tunes, ignoring my camera.

Monique Leyrac began her career as an actress, not a singer, and her roles in the plays of Molière and Brecht were much admired. Even today she could hold an audience with her readings of poetry. But it was the songs of Quebec that brought her recognition far beyond her homeland.

In 1965 she won first prize at the International Song Festival for her passionate rendition of Gilles Vigneault's chanson, *Mon Pays*. The nature of the chanson itself, she says, describes what a chanson is. 'There are lots of kinds. The way to know them is to sing them.'

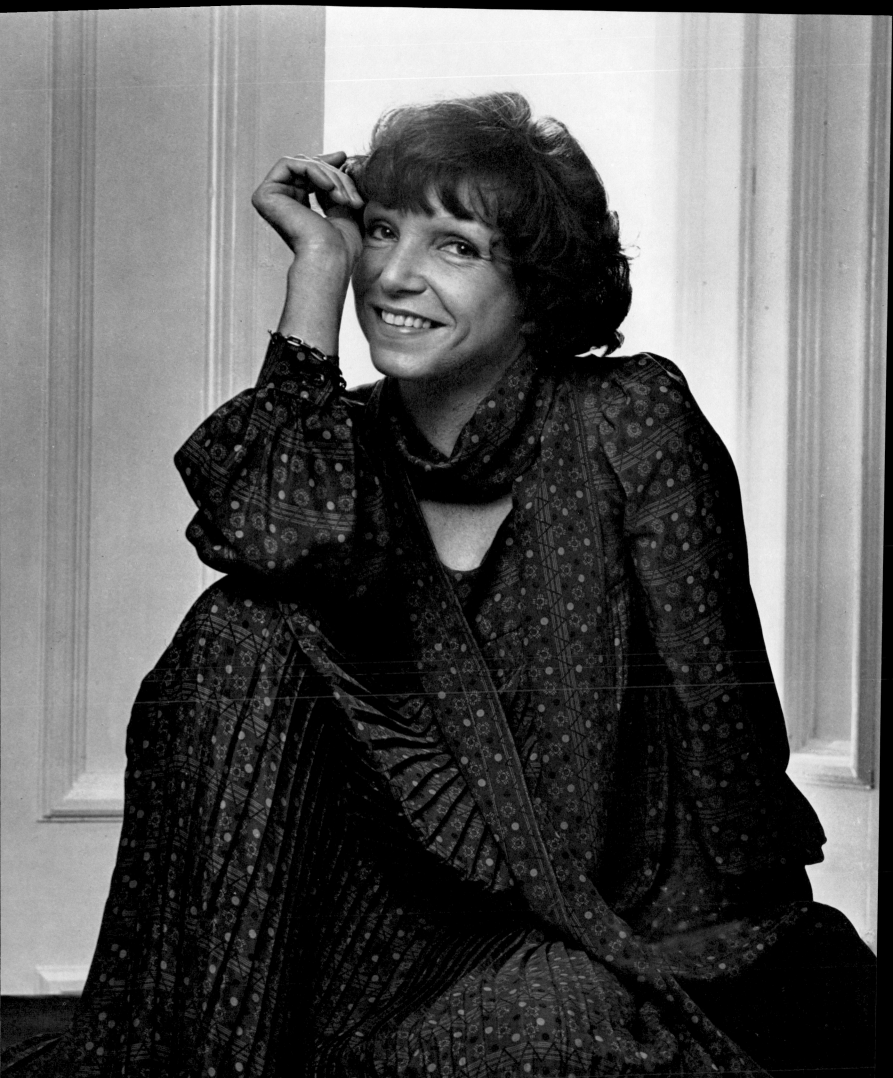

Peter Lougheed

1977

After he had studied at the Harvard Business School, Peter Lougheed brought his knowledge of finance and economics into the government of Alberta. But even when he became Premier, and a power in the nation's affairs, he retained a western ease and directness and the candid manner of his native province.

When he welcomed me to his home in Banff, where he and his family were enjoying a brief holiday, it was almost like meeting relatives for the first time. We hit it off immediately. I was so interested in the man and his ideas that I spent the day with him in conversation, postponing work to the morrow.

The setting for his portrait was chosen with care. Having inspected various possible locations, I decided to photograph Lougheed in one of the rooms of the Banff Springs Hotel. It was a suitable but unlikely choice. As the Premier entered the room he paused and exclaimed: 'What a fortunate coincidence! This is where I attended my first political meeting.'

From that meeting he has gone far, and from our photographic session my friendship with him and his entire family has grown into a relationship cemented by law.

After Estrellita and I had returned the Lougheeds' hospitality in our home, with Estrellita delighting our guests by having wild roses, the official flower of Alberta, as the table centrepiece, a document arrived from Jeanne Lougheed's lawyers. She had taken steps to adopt me as her official uncle. But as in most legal transactions, this one turned out to be rather complicated.

First, although Jeanne had wisely decided to inform my wife of her plan, the adoption certificate arrived three days before her letter to Estrellita. Furthermore the document had not been witnessed, as was necessary, by Peter.

These difficulties were resolved over a subsequent dinner to which we invited not only the Lougheeds but also Norman Green, our mutual friend who had drawn up the document, and the Chief Justice of Canada, Bora Laskin. By the end of the dinner both the Premier and the Chief Justice had appended their signatures to the certificate, making the entire arrangement as legal as one could possibly wish.

Although I have yet to discover exactly what privileges Jeanne can claim as my adoptive niece, our birds already have benefited in a tangible way from a transCanada friendship. One of the feeders in our garden at Little Wings came from Alberta.

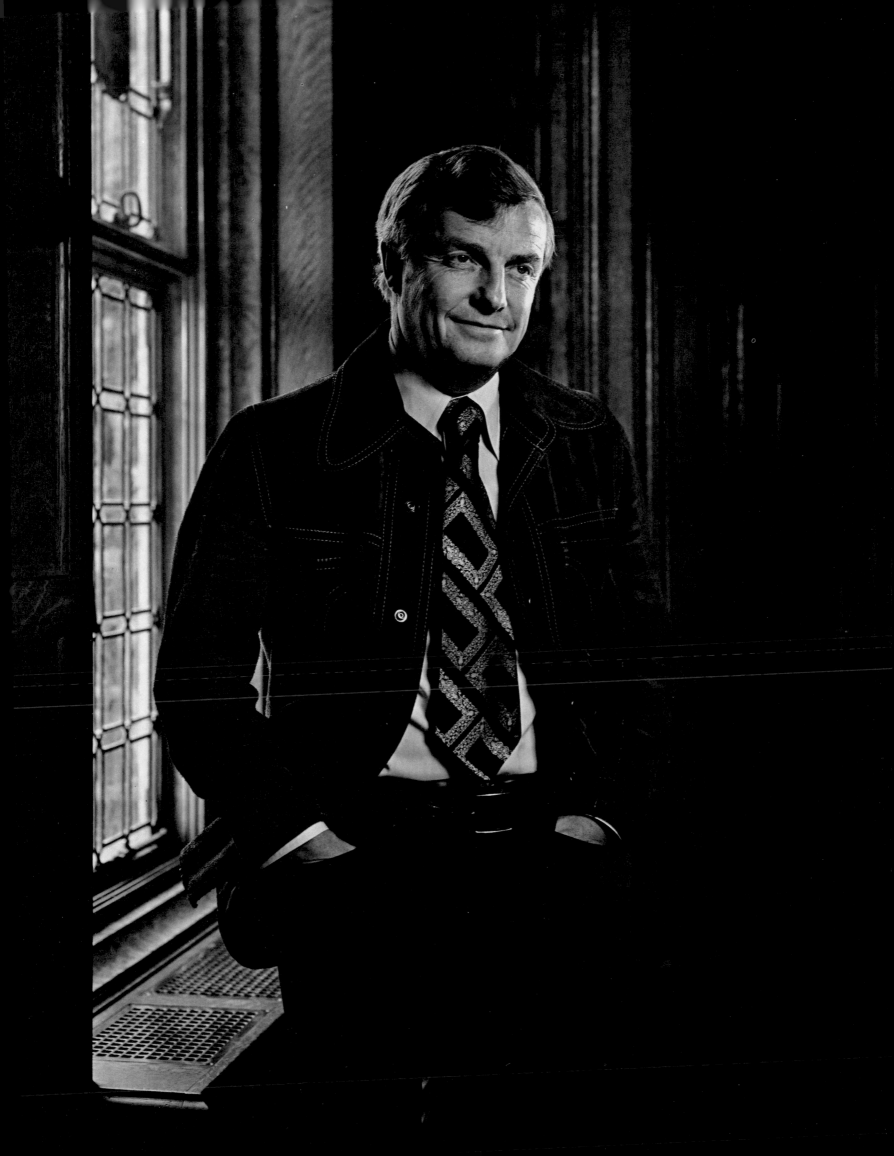

Hugh MacLennan

1947

The times were hard when Hugh MacLennan began his literary career. I had reason to know because I was also beginning mine. But it was much more difficult in those days to be a writer than a photographer. The Canadian who planned to live by his writing had to depend entirely upon himself. The general atmosphere of Canada was still incorrigibly narrow and provincial and the writer could expect no financial support, as he can now.

Unbelievable as it may seem to the present generation, MacLennan's first important novel, *Two Solitudes*, precipitated a furious and absurd controversy. He had dealt with English-speaking and French-speaking families in the years of the first world war, ending with what would nowadays be called a bicultural marriage. All this was innocent enough and it posed, in vivid human terms, the nation's future crisis. But the Presbyterian Church, among other critics, denounced the book as immoral and even responsible for an increase in venereal disease.

Such nonsense is soon forgotten. The novel completed in 1945, two years before I photographed the author, is being made into a film. MacLennan's perceptive insights, his understanding of the Anglo-French relationship, continue to impress themselves on the national consciousness.

Hugh MacLennan is still writing and carrying a full course load as a teacher of literature at McGill University. For the last seven years, his friends tell me, he has worked on a new novel, the first since 1967, and promises that it will be quite different from all his former work.

A shy, modest man, he greatly underestimates a career spanning his long quest for the elusive Canadian identity. 'After all this time and talk, I think, it is simple enough to describe what a "Canadian" writer is,' MacLennan has said. 'He is one who writes some aspect of his own vision of the human experience within the particular context of the society he knows best which is what he grew up with and lived with here in Canada. Every universal writer who ever lived has rooted in his own territory.'

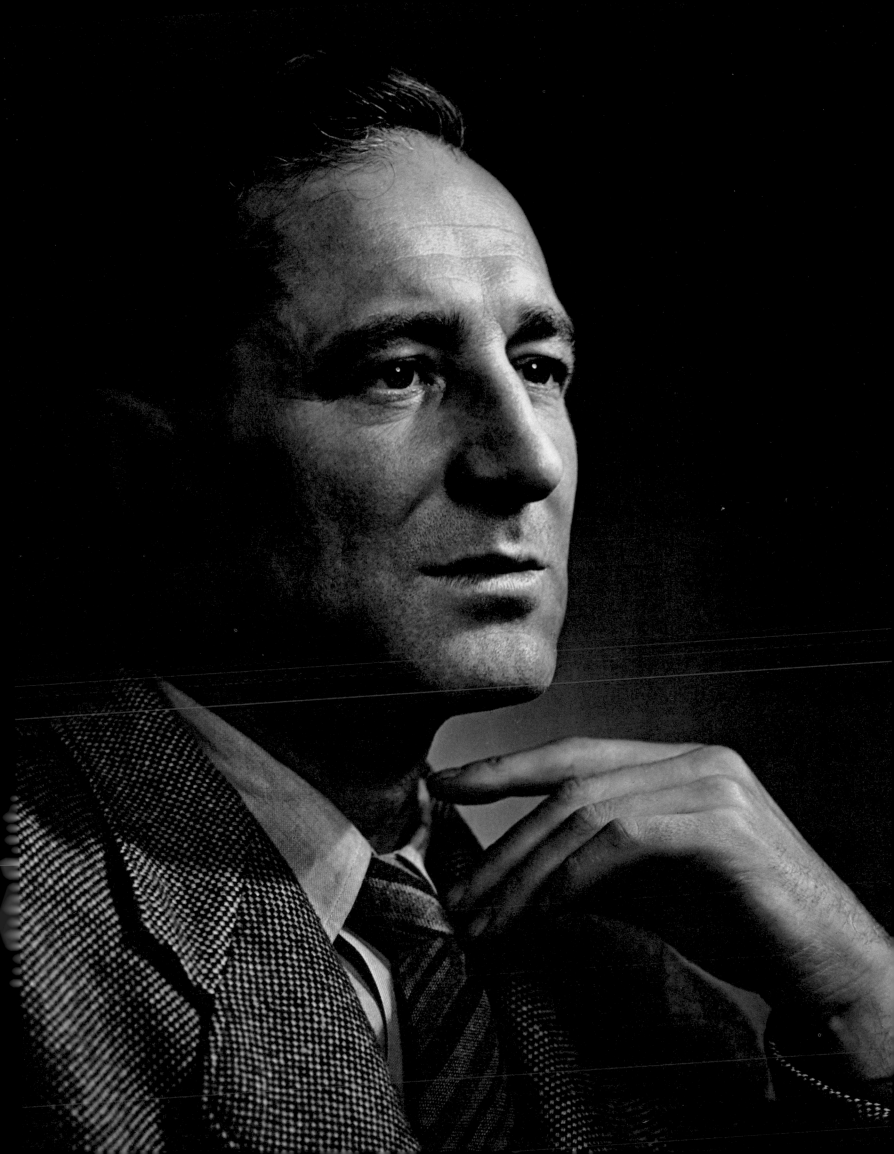

Sir Ernest MacMillan

1943

Because they combine serious work with *joie de vivre*, musical artists of Sir Ernest MacMillan's school have always been favourite subjects for my camera and my admiration.

The urbane gentleman seated beside his piano was a Canadian musical prodigy. At the age of eight, Ernest MacMillan performed publicly on the organ. At ten this precocious boy dazzled an audience in Massey Hall. When the first world war began, he was stranded in Germany and interned. But prison could not long suppress his talents.

Somehow he managed to compose and play original music in the war camp for the entertainment of his fellow prisoners. More important for his career, he smuggled out the necessary papers and compositions that won from Oxford University the degree of Doctor of Music in 1918. He had determination and ingenuity as well as genius.

Sir Ernest seemed infinitely capable of work. His many teaching and conducting positions, with his frequent performances, were proof of an amazing stamina. He subjected not only his art, but life itself, to the most exacting standards and confessed his hatred of telephones, juke boxes, and insipid dinner tunes.

There was another, and lighter, side of his character, as in this portrait. The jaunty look and the rakishly-balanced cigarette hint at his fondness for musical comedy as practised by entertainers like Gracie Fields and, in moments of relaxation, by Sir Ernest himself. Torontonians who attended the popular Christmas Box Concerts might glimpse the comic gifts that the knightly conductor of the Toronto Symphony Orchestra usually kept well hidden from the public eye.

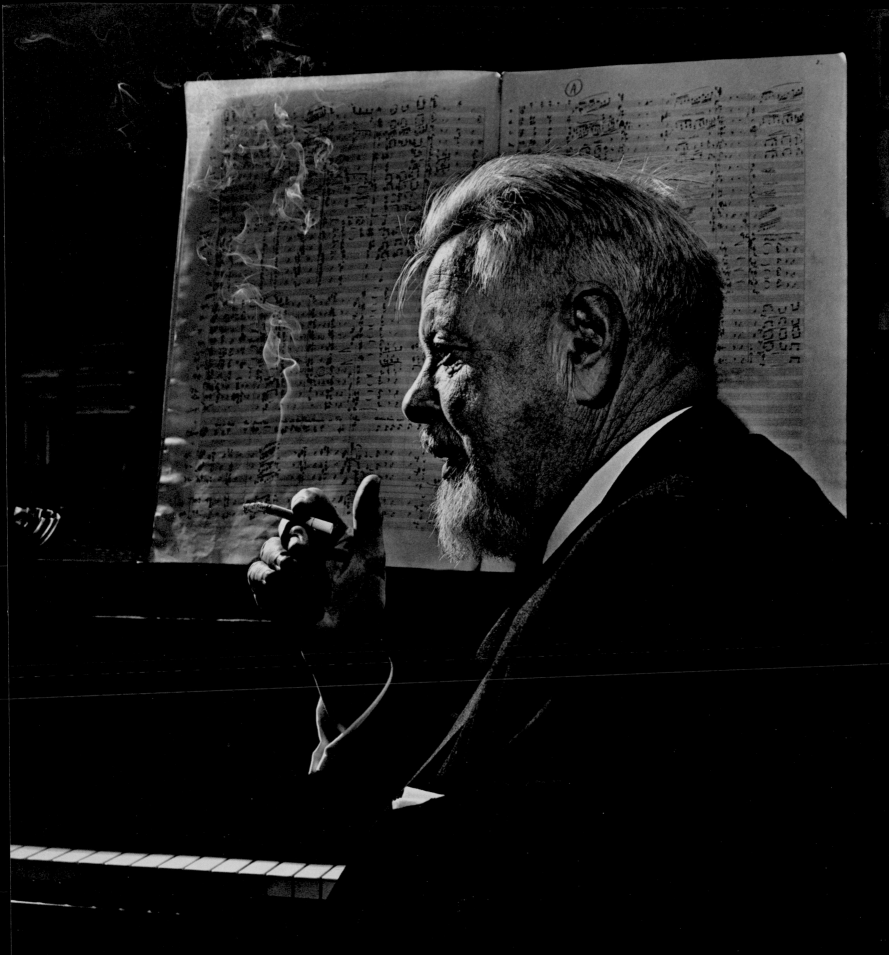

Karen Magnussen

1973

No one who observes Karen Magnussen's radiant smile would guess that the champion figure skater from Vancouver was once told that she could never skate again. But so it happened. In 1969 she suffered stress fractures in both legs while training for the world's skating championships and was forced to abandon the contest. Even that misfortune could not discourage her. She refused to give up.

After bravely completing an arduous rehabilitation program, she regained the Canadian crown in 1970. By 1973, when I photographed her, she had captured three gold medals and the world title at the international games in Bratislava, Czechoslovakia.

Like all who knew of her determination, I was moved by her story of strength and courage. I wished to picture her at the height of her fame, a few months after she had turned professional to join the Ice Capades. Despite the glitter and dazzle of her performance, I found an unspoiled, simple, spontaneous, unpretentious woman. It was my hope that I might thus portray her.

For her portrait, she wore a salmon-coloured chiffon gown from the Greek-American, George Stavropoulos, my wife Estrellita's favourite designer. Its dramatic elegance perfectly suited her natural animation and high spirits.

Our session did not end with one photograph. A manufacturer wanted to make a movie of me testing a new type of film for promotional use, and I chose to carry out the assignment with Karen's help. Attaching a close-up lens to my camera, I sat down beside her, our heads together, and she clicked the shutter. The results, I thought, were fine. Now, whenever people ask me, 'Who takes *your* picture,' I tell them, 'Karen Magnussen.'

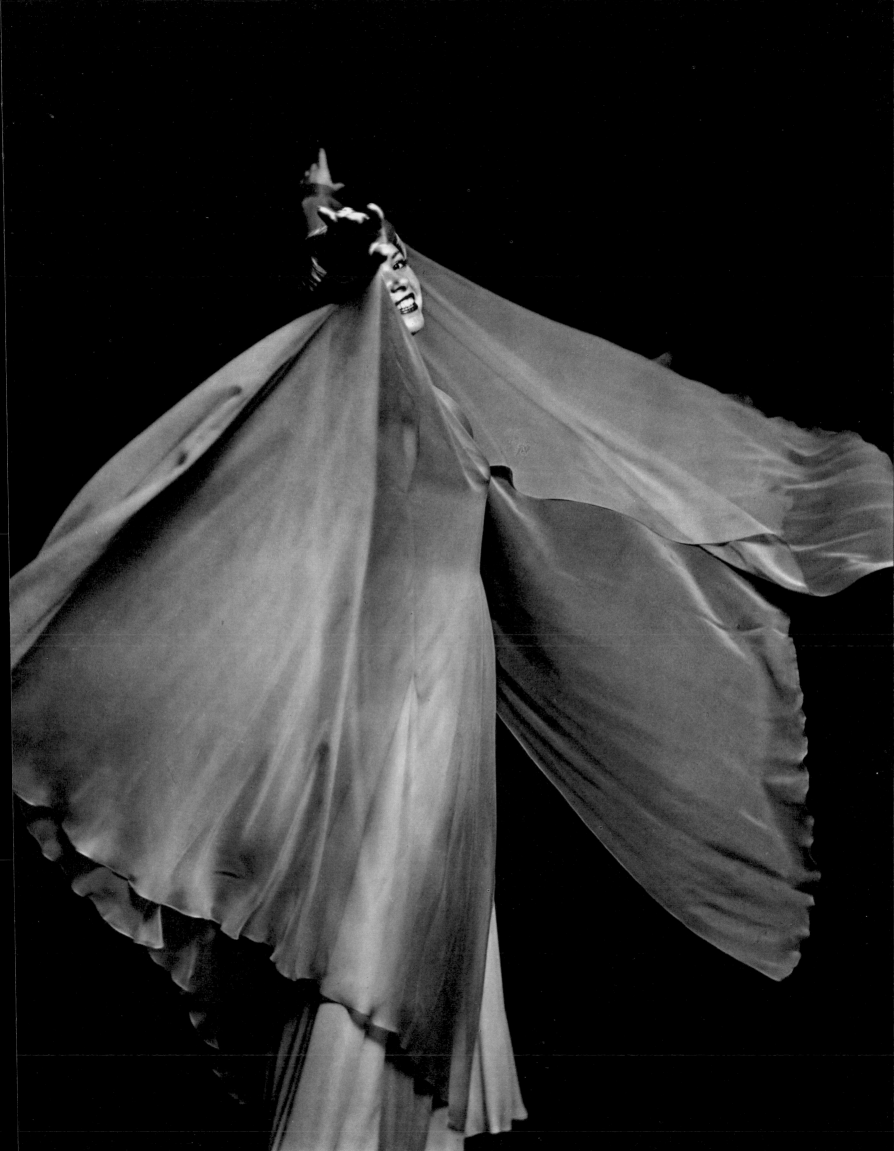

Daniel Makokis

1960

At the age of eighty, Daniel Makokis had been flown from the Saddle Lake reserve to the Charles Camser Hospital in Edmonton for a cataract operation. Meeting him there, I was impressed by the stoic determination of an Indian who had come on a long journey with all his worldly belongings in a sack, his near-blindness indicated by a white cane. I photographed him because he seemed to embody the ancient spirit of his people. This is a portrait of humble endurance and quiet courage in a hard northern land.

Vincent Massey

1952

In the presence of Vincent Massey, it was said, the most civilized man must feel like a savage. This remark, now a part of Canadian legend, contained more wit than truth.

As Governor General, Massey placed a high premium on ceremony and his manner, on public occasions, was always formal. But he was far too intelligent, too experienced in the ways of the world – and too human – to be stuffy. Even when I first met him, he could not have been kinder or more helpful. He was a man easy to like, everywhere respected for the quality of his mind, for the range of his interests, and for his passionate faith in Canada.

In London, in 1943, on my first overseas photographic expedition, I did not expect the overworked Canadian High Commissioner to devote much time to me, engaged as he was in secret wartime affairs. But I ventured to show him a list of the numerous personages whose portraits I hoped to make. To my surprise, he immediately offered his assistance through his wide network of friendships.

My list of subjects was turned over to Campbell Moodie, the able press officer at Canada House, and from then on things moved smoothly. Moodie and I became close friends, dined and wined together and shared each other's anxiety if our pursuit of certain famous photographic subjects did not immediately yield affirmative results. At the end of two months my portfolio was complete, except for the Royal Family. 'Leave it to me,' Massey reassured me, and he proved as good as his word. I photographed the King and Queen and the two little princesses, Elizabeth and Margaret.

I showed the portraits I had made to the High Commissioner; he examined them carefully. When I said my mission would have failed without his help he remarked, with a diplomat's knowing smile: 'It wouldn't have been good for either of us if you hadn't succeeded, but you have.'

After he was appointed Governor General I often saw him at Rideau Hall, where this picture was taken. He never failed to suggest new subjects for my camera, and his advice was invaluable. His sparkling private conversation, behind the required formality and protocol of his office, added much to my knowledge of the nation and its people.

Norman McLaren

1957

The young man of this portrait seems to be looking through a strip of film on which he has painted what I take to be a dancing hen. In fact, Norman McLaren, the prodigy of the National Film Board, is looking through his own private prism at the gorgeous, humorous, and tragic spectacle of life.

The results of that vision are now known and lauded the world over. By painting on film, and scratching the accompanying music on the sound track, McLaren produced a new art form. But over the years he lost neither his modesty, his impetus to experiment with unorthodox cinematic methods, nor his refusal to accept failure.

Having photographed him at the Film Board's Montreal headquarters, I was curious to learn more about the man and the techniques he employed in masterpieces praised everywhere for their startling originality. I expected him to reply briefly and formally, perhaps in technical language I would find difficult to understand. Instead, he wrote me at length, and by hand, a letter which has become a family treasure.

All capital letters are alphabetically legible, but each is a weird drawing of a bird or a beast unknown on land or sea. Amid a jungle of these winged creatures, like animals in a medieval bestiary, he recalled his long search for the ultimate possibilities of the motion picture film.

'It's true,' he explained, 'that I do sometimes make use of the very things that people try to avoid most. In film-making, for instance, scratches and dust are two things that must be avoided at all cost on the photographic negative. But I have often been entranced by the intermittent flickering, fluttering, sputtering, and joggling scratches during the projection of an old, beat-up film. Sometimes, if the film was poor, it was definitely more entertaining to watch the scratches than to watch the film. So I decided to make a whole film with nothing but scratches.' (These scratches, as he calls them, became the classic *Blinkity Blank*.)

Always the bold innovator, McLaren does not hesitate to make use of mere accident. When he was painting the film *Begone Dull Care* one of the wet film strips fell to the floor and, as he first thought, was spoiled. On projecting it, however, he found that the wet dye had receded in a circle from each dust speck to leave a charming pattern.

'From that moment,' he told me, 'we became experts in dust, eagerly collecting it in small packets from all kinds of surfaces and classifying it by the kinds of effects it would produce when sprinkled carefully on wet, dyed film.'

Such daring experiments have won the most prestigious awards for the Canadian documentary film at international exhibitions and have made McLaren the acknowledged master of his art. Never quite satisfied, he continues his search for ever newer methods and finer results.

Marshall McLuhan

1974

No collection of Canadian personalities would be complete without the guru of the electronic age. For more than a decade, through the sixties, Marshall McLuhan was the most discussed, admired, or disparaged academic figure in North America, his name a household word or, at least, a cocktail party cliché. It even spawned a popular adjective, 'McLuhan-esque,' to describe parallels to his theories or, alternatively, his circuitous method of expressing them.

His brilliance of mind and broad classical scholarship produced a startling analysis of our modern society, drastically changed by the electronic media, both 'cool' and 'hot.' Although everyone does not agree with him, McLuhan has influenced our attitude to all the different media of communication, from print to television.

We had arranged to meet in his book-lined office in one corner of the University of Toronto campus where he has long been professor of English. For hours we talked continuously, interestingly, quotably; it was absolutely fascinating. At the end I was exhausted, and proposed that we postpone photography until the next day. Since then we have had more good long walks and talks together, at Toronto and at Fordham University in New York, where he held the prestigious Albert Schweitzer chair for a year.

Such a man will always have an abundance of admirers and critics, as I saw myself when I introduced him to two important international advertising executives. The four of us spent a stimulating evening in friendly argument at his home. Afterwards, one of the executives told me that McLuhan was a towering genius; the other's impression was precisely the opposite. This little incident epitomized the divided opinions certain to surround such a bold, original thinker.

A. G. L. McNaughton

1942

When I first came to know General McNaughton before the second world war, he was president of the National Research Council. I admired this restless, controversial figure who was a scientist, electrical engineer, ballistic specialist – and friend.

His sudden promotion to the highest Canadian military command surprised and fascinated many. The war was ultimately won through science, and in this area McNaughton had made a unique contribution.

When this portrait was made he was under heavy strain, and not given to small talk or frivolity. I did not then know that he was embroiled in disputes on military strategy with his political superiors, although they are now familiar to students of history. I knew nothing of his inner tension when he paused – unconsciously dramatic – in front of my camera. But I could read the anxiety in his troubled gaze and see the impatient cast of his hands.

After this portrait appeared on the front page of *Saturday Night*, Napier Moore, publisher of *Maclean's*, wrote me a note: 'Yousuf, your photograph of General McNaughton is a humdinger.' 'Humdinger' was a new word to me, and I added it to my growing English vocabulary.

When a reporter asked me how I had caught this restless, moody, worried man in the darkest days of war, I explained that I had merely asked the general to walk back and forth across my studio and photographed him. The next day the caption on the reporter's article announced: 'Karsh Puts McNaughton on a Route March.'

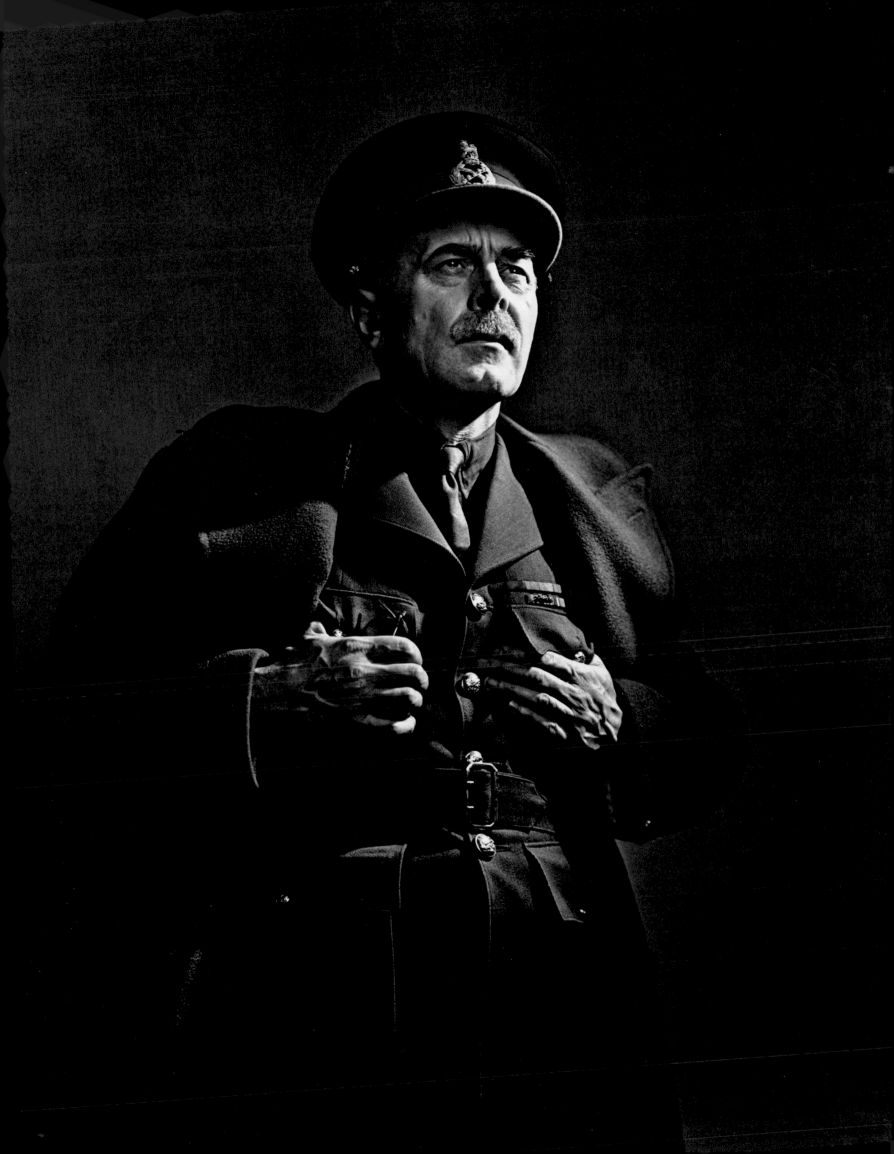

Sir William Mulock

1943

At the age of ninety-nine, Sir William Mulock was the oldest person who has sat before my camera. His vitality and good humour impressed me so much that, meeting H.G. Wells in London shortly afterward, I described the venerable Canadian at some length. His longevity, I informed Wells, was attributed to the consumption of a daily quart of whiskey.

Wells was not entirely convinced. Thrusting his hands into his vest pockets, he reflected: 'Ah, I wonder if future historians will speculate as to how much longer he would have lived if he hadn't touched a drop!'

More important aspects of Mulock's life will interest historians and have already been recorded. During his long political career he was Postmaster General, Minister of Labour, and consistently a leading figure in the Liberal Party. After retiring from politics he was appointed Chief Justice of the Exchequer Division of the Canadian Supreme Court and then Chief Justice of Ontario. Until his death at the age of one hundred and one, he remained in full possession of his faculties, as I discovered when I arrived at his Toronto mansion to photograph him.

Although he was often bedridden by then, I set up my equipment in one of the reception rooms. The photographic appointment had been scheduled on the day of a New Year celebration and a parade of young, uniformed women – for it was wartime – kept filing past to wish Mulock a happy 1943. Having made this portrait, I took his arm and guided him back to his bedroom. With a mischievous twinkle he confided to me: 'Karsh, I'd give anything to be sixty again.'

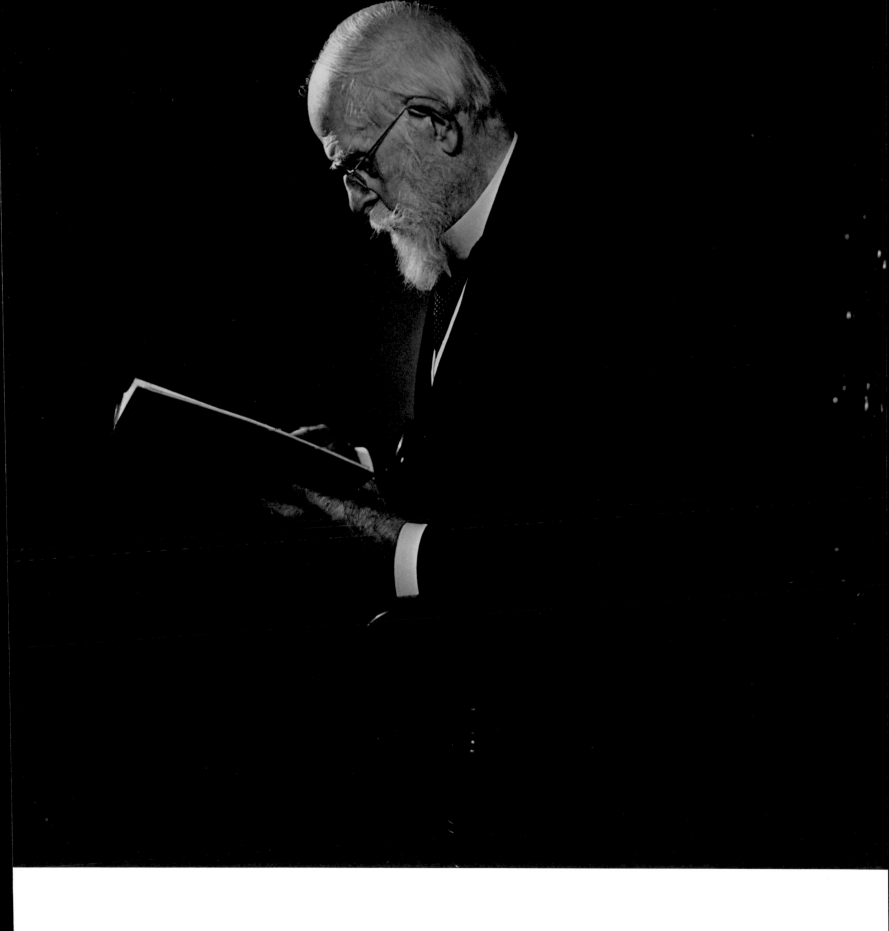

Grattan O'Leary

1938

Someone once said of Grattan O'Leary that he could make a casual comment on the weather sound like Shakespearean prose. Colourful as his speech may have been, in his writing he took great pains to choose his words with careful precision, regarding them as precious, even sacred.

Splendidly opinionated, romantic, and passionately committed to people, he refuted his own theory, that 'we as a nation put no great store in the majesty of speech,' by his incomparable command of the English language. Arthur Meighen, his bosom friend, and indeed the whole Conservative party, knew no more effective spokesman.

Although wonderfully entertaining in print and on the radio, O'Leary was still more candid, sparkling, and reckless in private. I remember in particular one dinner party we gave at our home before I realized the explosive nature of partisan politics, which he relished for its own sake.

My wife and I innocently lighted a political bonfire by inviting guests who were all individually exciting, but worlds apart politically: Joey Smallwood, Napier Moore, George Drew, and O'Leary – sure elements of spontaneous combustion. Soon the atmosphere could not have been hotter if we had served fire crackers as the main course.

I photographed O'Leary in his office at the Ottawa *Journal* where he worked in different capacities, from cub reporter to editor, during an amazing span of fifty-two years. Seated at a desk piled high with books, letters, reports, and documents, he would turn out his inimitable editorial gems amid this cheerful clutter. He assured me that he was a bad correspondent but a good housekeeper – he burned all his unanswered mail every three months.

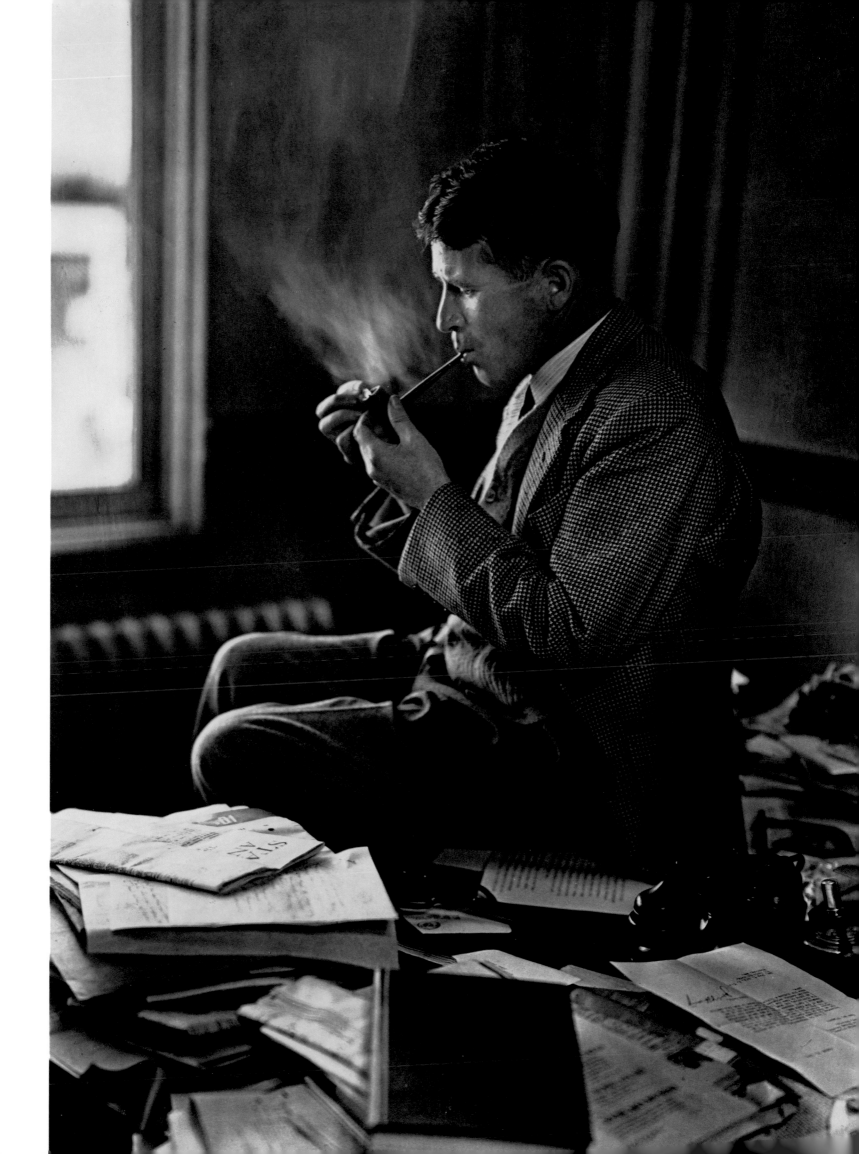

Tom Patterson, Jean Gascon, William Hutt

1973

From the very beginning, Solange and I applauded Tom Patterson's inspired plan to found a Shakespearean festival in his hometown – a plan based on the mere coincidence of the town's name and that of a little river flowing through it: Stratford on Avon, Ontario. When the first season opened in 1953 under the artistic direction of Tyrone Guthrie, we were there at what was to be an historic occasion. In successive summers, we always attended opening nights. Thanks to the fulfilment of Patterson's boyhood dream, we were able to savour the riches of the spoken word as interpreted by some of the finest actors in the world, with Canadians Bill Hutt and Jean Gascon among them.

Gascon's association with the Stratford Festival has been a long and fruitful one. He began by giving memorable performances as an actor when Le Théâtre du Nouveau Monde (the company which he helped found in Montreal) presented three Molière farces at the Avon Theatre in 1956. Later he was appointed director, and finally artistic director, of the Festival. Under him, the company's national and international reputations flourished. He organized tours to Europe and Russia in 1973, and to Australia the winter after. Both times, the leading roles were played by Bill Hutt, the elder statesman of Canadian actors.

Although Gascon has gone on to become artistic director of the National Arts Centre in Ottawa, where he can at last realize his own dream of building a permanent national theatre company in Canada, his fate for many years was bound up with that of Patterson and Hutt. As a tribute to the pleasure which this trio has given audiences for so long, I assembled them at Stratford one windy day for a group photograph.

They are standing on a balcony of the theatre. Against the sky rises a distinctive coronet, a reminder of the large tent in which performances were held until the Festival had money for a permanent building. Below them grows a garden planted with many of the herbs mentioned in the Shakespeare plays.

To my regret, there was no time for leisurely conversation. My only concern was that the strong wind would not topple my camera and add one more tragedy to those already performed at Stratford.

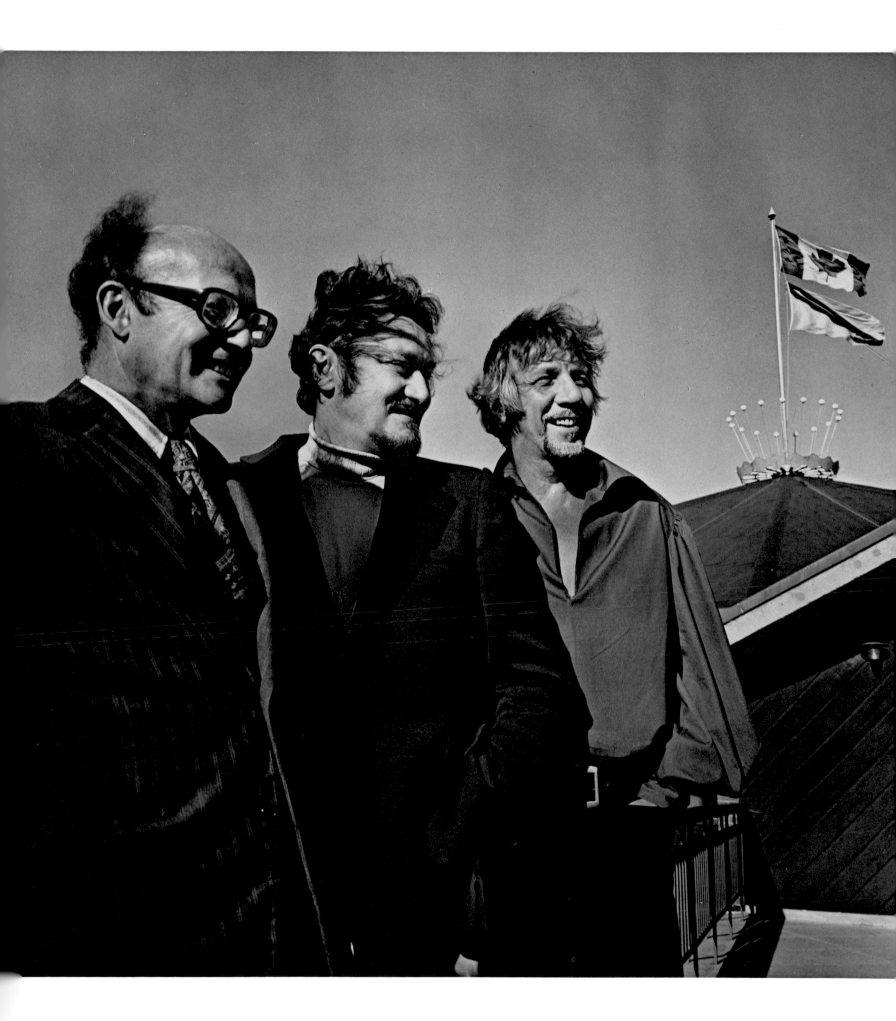

Lester B. Pearson

1957

My first photograph of Lester Pearson was taken in 1944 when he served Canada as Minister Counsellor to Washington. After seeing the portrait, he wrote me a note characteristic of the man known familiarly to everyone as Mike: 'You make me look almost like a statesman.'

My portraits make him look, I hope, like the usually boyish, and sometimes tortured, human being he was. The second adjective may seem strange but I had known Mike too long to miss the clouds that occasionally flecked the sunshine. They were more frequent, of course, once he became Prime Minister.

Estrellita was first exposed to his famous charm at a social evening in Ottawa. He had heard that she came from Chicago and his first words to her were: 'I worked in Chicago, too.' Indeed he had, as a young man, in Swift and Company's meat plant – his 'days of sausage making' as he called them. With my wife, his greeting was followed by a long, serious conversation in which he demonstrated his humour, his vast knowledge of world affairs, and an acute intelligence.

This particular photograph was taken in the House of Commons, shortly after he received the Nobel Peace Prize. The Speaker of the House, Roland Michener, a friend of Pearson's since their student days at Oxford, and a future Governor General, participated in the arrangements.

I had watched from the gallery as Pearson accepted the congratulations of political supporters and opponents alike. His demeanour that day remained in my memory as I took the portrait.

Having talked to him privately over many years, I decided to seek, for the public record, his considered view of international life and Canada's place within it. His reply encompassed the Pearson philosophy from the time he joined the diplomatic service to the end of his career as leader of the Canadian government.

'Canada can always take a disinterested stand, in the sense that she can do what is right irrespective of what anybody else does. This is easier for us because we have no national interests that are continually under examination or challenge at the United Nations. So we do not need to feel superior or smugly virtuous.

'We have also to remember that in cases of doubt as to what is right or wrong – and most international issues involve doubt in this sense – we have always to take into consideration the importance of co-operating with friends. We should never break with them unless we are absolutely sure we are right. On the other hand, if we follow the United Kingdom or the United States automatically, any influence we have with them or in the international community would soon disappear.'

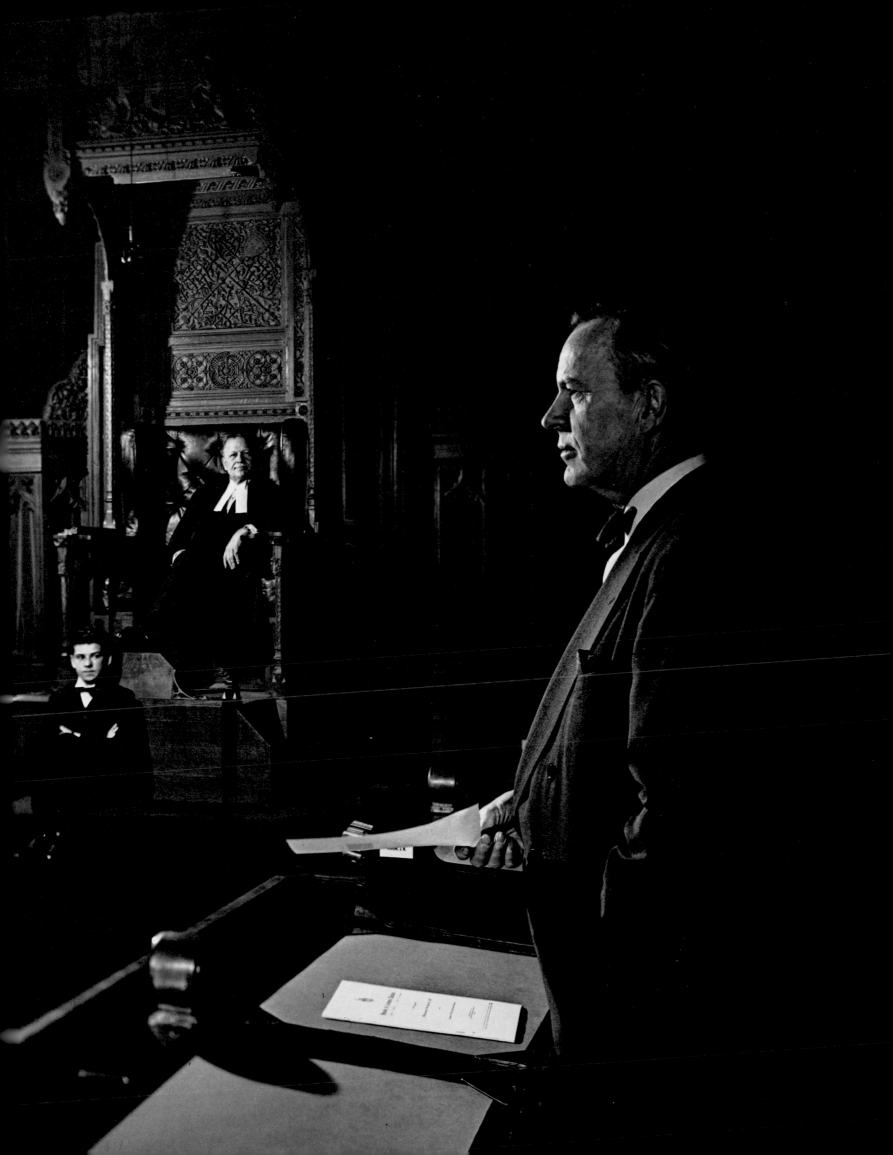

Alfred Pellan

1973

While the Group of Seven was discovering the northern Canadian landscape and painting it in a new, dramatic style, Alfred Pellan sought his inspiration elsewhere. He studied art in Paris, where his talent was quickened by the same atmosphere which had nurtured Fauvism, Cubism, and Surrealism.

Such an artistic climate suited him perfectly. From it came the vivid sensuality of his work. He owed much to the tradition built by artists like Miró, Klee, and Max Ernst. Many people found their imagery distasteful, even disturbing, since it presented the dreams and fantasies of the unconscious mind. Pellan's canvases aroused the same reaction. He was an original, a bold experimenter and, some would say, a heretic.

When he exhibited his Paris paintings in Quebec City and Montreal, after returning to his native Quebec in 1940, they were considered too daring for a public taste moulded on more conventional lines.

This negative reception could not daunt Pellan. Teaching at the École des Beaux Arts in Montreal, he maintained his belief in the non-rational sources of human understanding and encouraged his students to make their own experiments. He actually persuaded some of them to paint blindfolded so that, undeterred by the physical world around them, free of all restraint, they might express their innermost feelings.

His methods brought him into headlong conflict with the academically oriented director of the school who ultimately was forced to resign. In a struggle between the old and the new traditions, Canadian expressionistic art took root.

Pellan is shown here at his home outside Montreal. The masks hanging on the wall are a reminder that he is not only a painter but a brilliant designer of theatrical sets, costumes, and stage properties. As he examines a book about his work, which he had received only that morning, the masks appear to look on with lively interest. And I like to think that the peacock feathers symbolize the romance and colour he has contributed to the art world of Canada.

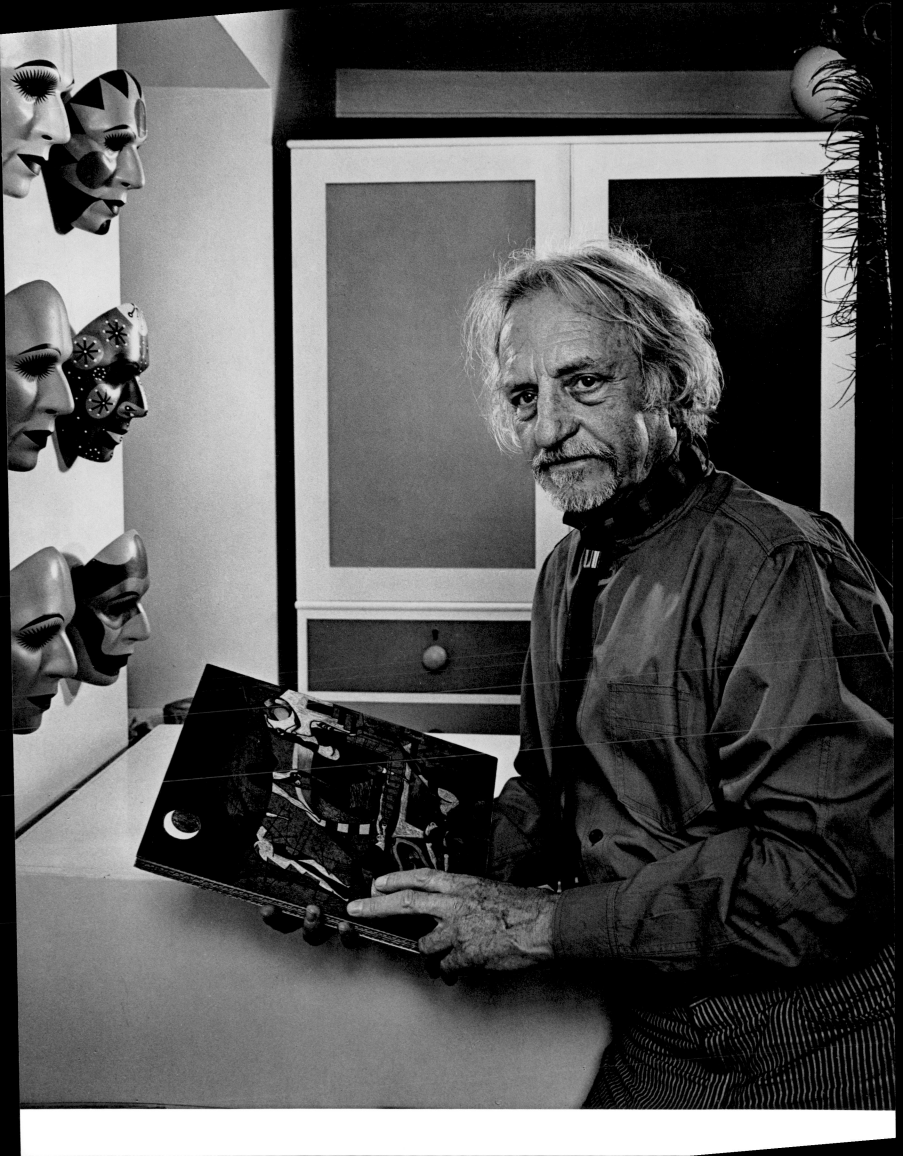

Wilder Penfield

1952

A tragic coincidence explains this unplanned portrait of Wilder Penfield, the world-famous neurological surgeon of Montreal.

I had already taken several photographs of him alone. Now I intended to photograph him with his colleague, Dr William Cone, and his assistants at the Neurological Institute. Just as I completed my arrangements, Dr Penfield was called out of the room. In a few minutes he returned, and I saw at once that he had received bad news.

The favourite orderly of the Institute, a veteran of more than a quarter century, had died suddenly in the building from a heart attack. Photography, I decided, was impossible that day but, by an unconscious reflex, I snapped the camera shutter. The resulting photograph reveals Dr Penfield's love of humanity and his constant desire to preserve life – but also the sorrow common to all doctors when they realize that, in the end, their ancient adversary always wins.

Not all my recollections of Dr Penfield are as somber as the portrait of 1952. Some years later Estrellita and I entertained for the Penfields and Dr and Mrs C.J. Mackenzie (Dean Mackenzie was for many years president of the National Research Council of Canada). Dr Penfield was in Ottawa to lecture at Carleton University on the life of his mentor and friend, Sir William Osler, the Canadian who was perhaps the greatest physician of the last one hundred years. Penfield held him in deep and touching reverence. He was in fact one of the last remaining men who had known Osler personally. After being wounded overseas during the first world war, he had been invited by the then Regius Professor of Medicine at Oxford to convalesce for two months at Sheltering Arms, the Osler home.

Dining with us at Little Wings, Penfield reminisced about the time he had spent so happily with the great pioneer physician. He spoke, too, about his other travels, particularly of his visit to China in 1962. He had been invited there by the Chinese Medical Association and his former Chinese neurology students. On his return he had spoken favourably of what he had seen to the New York Academy of Medicine, and his report, in the then-cold political climate, became the subject of much controversy. But in medicine, he believed, there could be no consideration of national interest or prejudice. Today, as he had hoped, Eastern and Western physicians regularly exchange visits and information.

Penfield brought to Little Wings a memento of still another journey into medical history and another facet of his personality, his fictional biography of Hippocrates, *The Torch*. It was based on several months he had spent on the island of Cos where Hippocrates, the father of medicine, supposedly was born. His inscribed volume is one of the treasures of our library.

When I first photographed Penfield I remarked that he looked not unlike a monk, a man chastened by the human suffering around him. I asked whether doctors in general were pious persons. Somewhat wryly, he answered that piety was not their strongest point. He was perhaps thinking of organized religion, but in his own personal concern he displayed a passionate devotion that transcended dogma.

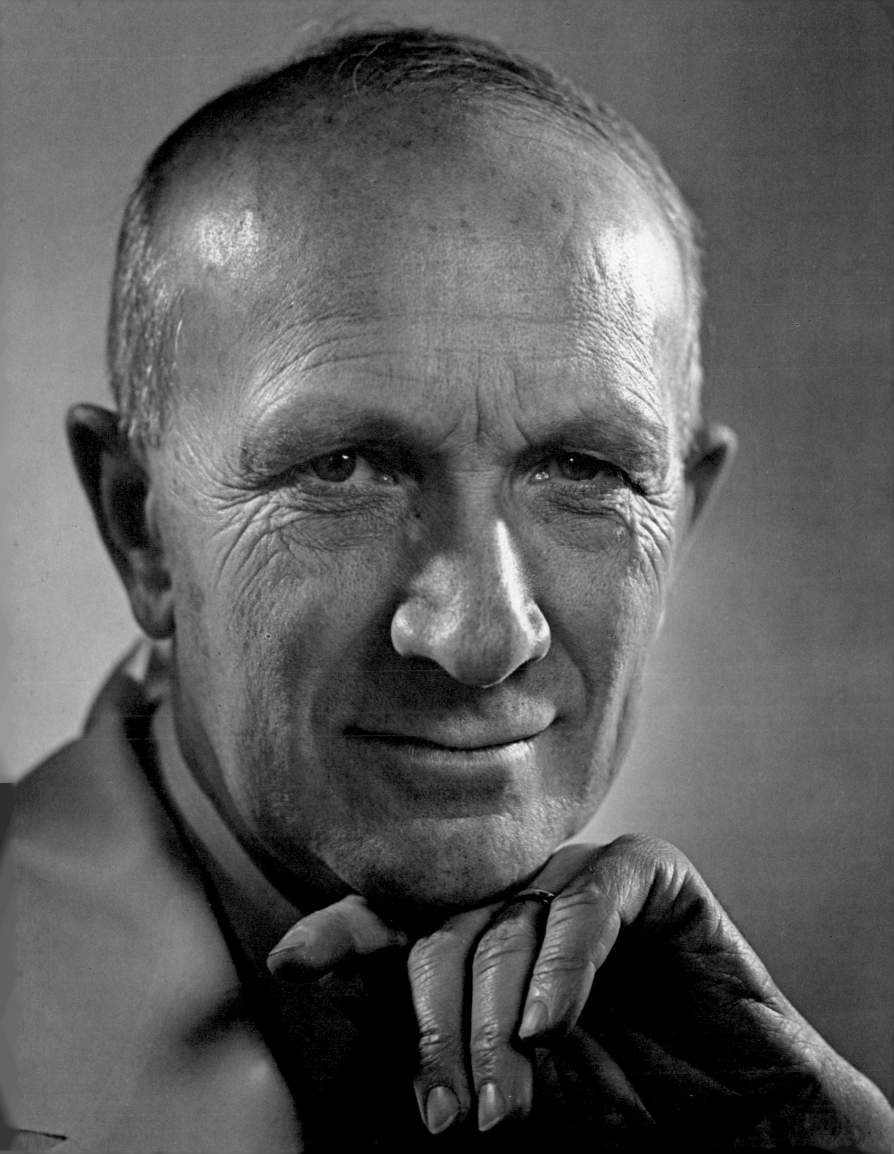

Nadia Potts

1977

Temporary misfortune can sometimes lead to happy consequences, as in taking this portrait of the rising young ballerina, Nadia Potts.

When I arrived at the National Ballet Company's rehearsal rooms in Toronto's St Lawrence Hall, I was told that, because of a back injury, she had been temporarily forbidden to dance. Despite the unhappy news, I wished to make the portrait anyway, and set about finding an atmosphere suitable for her classic romanticism.

I asked her to sit on a red velvet banquette while tying her ballet slippers.

During our session we talked about the growing popularity of the ballet, which Nadia attributed partly to charismatic personalities like Nureyev, who brought glamour and dynamism to the dance, and partly to the public's increasing interest in exercise and physical fitness.

When I asked whether she was eager for stardom, she insisted that her ambition was only to dance as well she could and to continue improving her skill. That, she explained, was more important than immediate reputation: 'I believe in climbing my own ladder upwards and deepening the portrayal of my roles.' Then she quoted the old adage that it takes ten years to make a principal dancer – but she neglected to mention that she had already danced with the National Ballet for almost a decade.

My portrait, capturing her in a mood of repose, suggests perhaps a graceful transition from youthful vivacity to the mature experience of a brilliant artist.

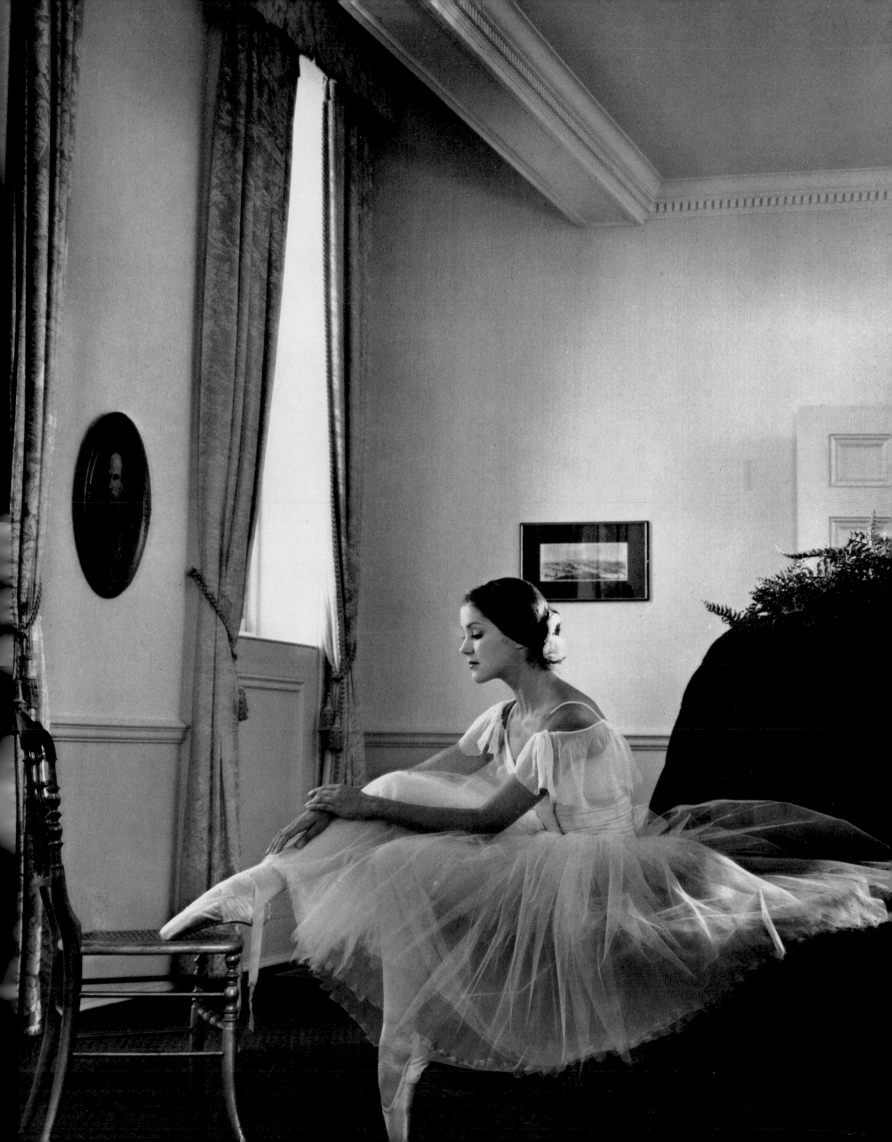

Jean-Paul Riopelle

1965

My first encounter with Jean-Paul Riopelle was a surprise – and a pleasant relief. I had expected to meet a difficult, temperamental artist, but after I had climbed the stairs to his top-floor rooms in the rue Frémicourt, a working class district of Paris, I discovered a natural, robust fellow. There was about him a gallant, courtly quality – a born gentleman in the guise of a rough-hewn cavalier. He welcomed Estrellita and me warmly and hospitably and opened a bottle of wine, prelude to much good conversation.

One of his circular paintings above the fireplace caught my eye; I suggested to Riopelle that it resembled a rosette in a stained-glass window. Always skeptical of established art practices, he treated me to one of his laughing sarcasms: 'I'll tell you why I did that. Because my dealers insist on setting the price of a canvas by the number of square inches in it. For the fun of it, I decided to confuse them and paint one that is round.'

Riopelle's working method is erratic and rapid, like the speed of his Bugatti as he drove me along the narrow, gravel-strewn roads of France. He will go for weeks, or even months, without lifting a brush. Then, of a sudden, will come a period of intense, almost frantic activity when art simply explodes in him. He will paint for weeks; he will not eat; he will not sleep; he will cover canvas after canvas with his highly individual, textured interlacings of bright impasto. Only when the compulsive surge has been fulfilled will his creative labours also subside.

But he is more than a painter. When I met him in 1965, he had been experimenting with a sculpture he had recently completed. It stood beside him while we chatted and I incorporated it into his portrait.

The National Gallery of Canada acquired my portrait of Riopelle in his studio as the first item in its newly formed photographic archives.

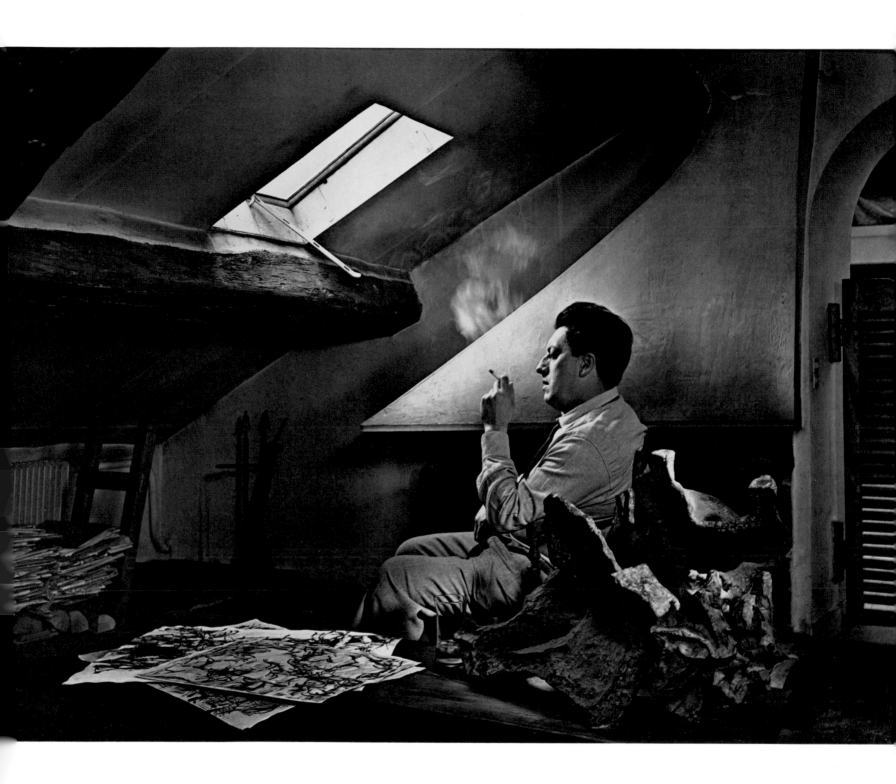

Edgar Ritchie, Gordon Robertson, Arnold Smith, Jules Léger

1973

Throughout my career, I have been generously assisted by the officials who represented Canada in diplomatic missions all over the world. They offered me their time and counsel, not merely from a sense of duty, but spontaneously – from the heart. To me, the four men about to enjoy early morning coffee on the balcony of the Rideau Club in Ottawa, with its magnificent view of the Peace Tower, typify the highest tradition of public service. Although they may seem a closed circle, in practice they have always been accessible and open.

All were liberal with their hospitality. Jules and Mme Léger entertained for Estrellita and me during our honeymoon in Rome in 1962, when he had just become the Canadian ambassador to Italy. The Canadian residence on the Via Appia Antica had once been owned by Carlo Ponti, Sophia Loren's husband. There, in a Roman catacomb which had been converted into a dining room, Estrellita attended her first Canadian diplomatic dinner. Five months after this photograph was taken, Jules Léger was appointed Governor General.

We met Edgar Ritchie while he was ambassador to the United States. When Estrellita and I flew to Washington for the gala opening of my exhibition, 'Men Who Make Our World' – which had been chosen to mark the one hundredth anniversary of the Corcoran Art Gallery in 1968 – the Ritchies invited us to be their guests at the embassy residence. Immediately Edgar and Gwen Ritchie welcomed us. They have a wonderful knack of making the most formal occasion informal and relaxed, and in their hands, protocol loses its traditional rigidity.

The same might be said of Arnold Smith, who capped a most distinguished career by serving as Canadian ambassador to the USSR and then as the first Secretary of the Commonwealth. He was ambassador to Egypt at the time that Bishop Sheen and I were there collaborating on a book, *This is the Holy Land*. Our first encounter took place under rather unusual circumstances. One Sunday, a party made up of our publisher, Kenneth S. Giniger, the South African writer H. V. Morton, who wrote the text, and I were driving to the Great Pyramids at Geza. Suddenly the Canadian ambassador's car sped by; we recognized it by the flag. I immediately enlisted the aid of a camel driver to overtake the car. When he returned, the exhausted driver held out his hand for more baksheesh. 'I almost killed my camel,' he explained, 'but I succeeded.' Arnold Smith rewarded our resourcefulness by inviting us to tea later that afternoon in one of the most exotic teahouses imaginable – a tent he shared with the American ambassador, pitched in a cool shadow of the Pyramid of Cheops.

Not everyone pictured here has developed a public profile. Gordon Robertson, a sensitive human being with a great appreciation of the history of Canada, works his diplomatic skills largely behind the scenes, studiously avoiding the limelight. For the last few years, in his capacity as Secretary to the Cabinet for Federal Provincial Relations, he has been assigned the mission of advising the provincial premiers on constitutional matters.

This collective portrait is my way of expressing affection for all of them, and for their many colleagues with whose acquaintance I have been blessed.

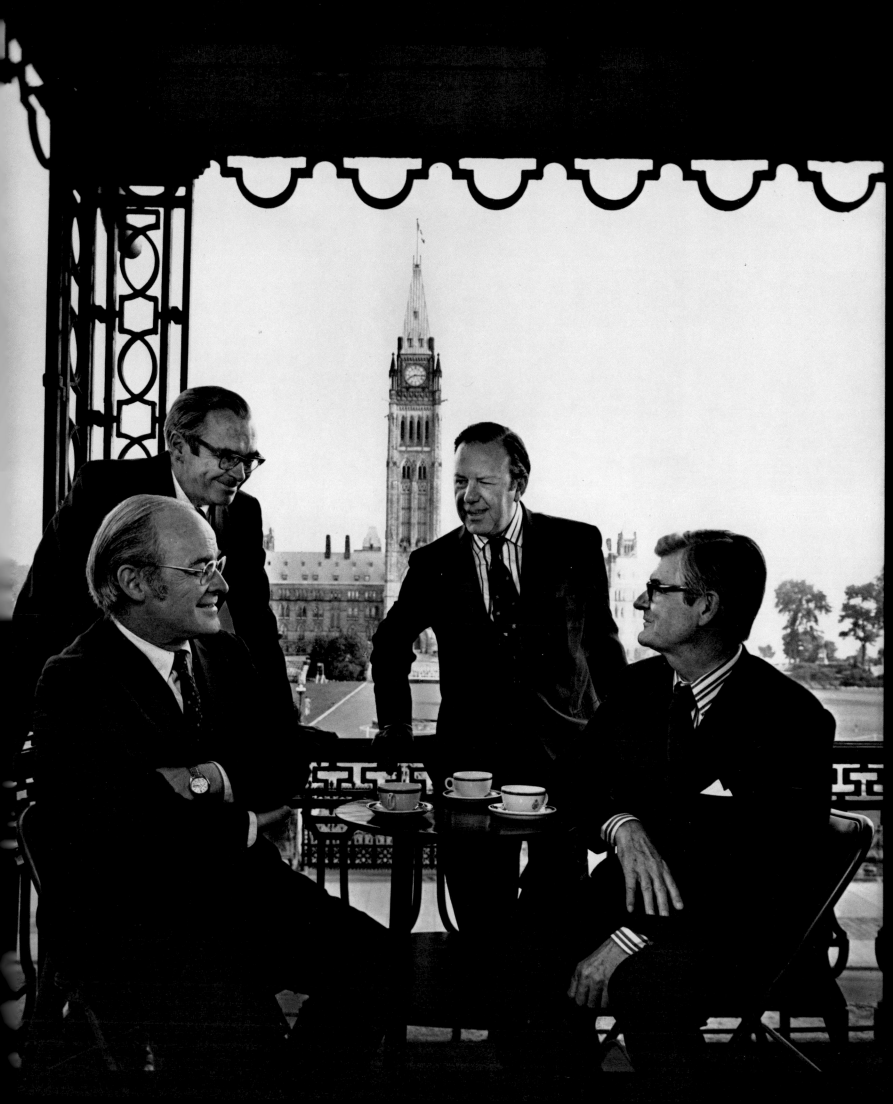

Claude Ryan

1977

This portrait was made at a watershed in the career of Claude Ryan and, as it turned out, of Canadian politics. Since then he has become, by general consent, one of the most important figures in our country.

For many years the premiers of Quebec, especially Robert Bourassa, had consulted Ryan, publisher of the influential newspaper *Le Devoir* and a Montreal editor respected from coast to coast. His look of moral earnestness, his unquestioned integrity, and those deep-set eyes under the shaggy brows, reflected deep meditation and a formidable intellect. But the cartoonists, a playful breed, found in him an easy subject for caricature, and often drew him as the Canadian Pope.

Arriving on a Sunday morning in 1977 at his home, where I had been invited to have coffee with him and his family, I knew nothing of his latest plans. When he told me that he was on the brink of resignation from *Le Devoir*, I asked whether the politicians were persuading him to run for the leadership of the provincial Liberal Party. He admitted that he was considering such a possibility and I was brash enough to suggest that the pen was mightier than the sword.

He thanked me for my gratuitous advice but didn't take it. Although at first he refused to enter the leadership race at a party convention, a torrent of letters and phone calls from fellow citizens throughout Quebec – as well as the crisis posed by the election of a separatist government – forced him to change his mind. Ryan is more than a great French Canadian; he is a citizen of all Canada and has put aside his journalism, along with the satisfactions of private life, to preserve the nation he loves.

As he wrote in his last editorial in the newspaper which he served so brilliantly over a period of more than fifteen years: 'Of all the forms of action, political action is, after religious service for the faithful, the most universal and the most important by its objectives. It is also the most demanding and, these days, the most decisive.'

That editorial had not been written, and Ryan had not yet made his final decision, when I photographed him in the old *Le Devoir* building on St Sacrement Street with back issues of newspapers from all over the world stacked behind him. His face clearly reveals the pressures he was then undergoing. Three months later, he left the editorial tower to fight for Canada's unity in the ruthless arena of politics.

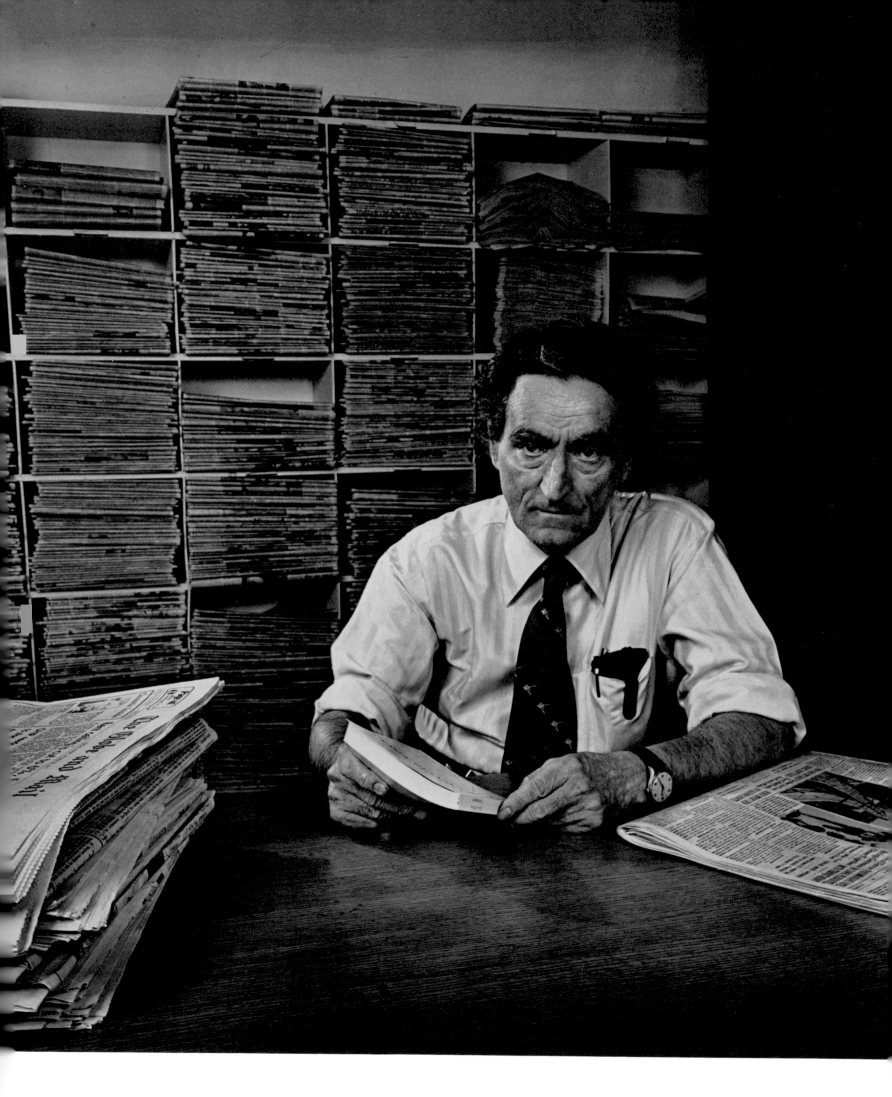

B. K. Sandwell

1939

For a young photographer seeking to establish himself in a new country, encouragement and understanding are as important as air itself. No one could have given me greater moral support, when I most needed it, than B.K. Sandwell.

The editor of *Saturday Night* liked my portraits. Fortunately his respected weekly magazine was published in a large format, on paper of good quality – exactly the favourable medium any photographer covets.

Not only had Sandwell become celebrated as a writer, but he was, by turn, Toronto's philosopher, or gadfly. I, on the other hand, was a novice, just having undertaken the rather frightening responsibility of a studio of my own.

I had read and admired B.K.'s urbane editorials. When he arrived in Ottawa to address the Canadian Club – his speech, as always, filled with humour and insightful comment on the nation's affairs – I made it a point to meet him. Our friendship began at once.

He shared my conviction that there is more to making a portrait than mere technical mastery. The photographer should be sensitive to the total personality of the subject. Soon, my latest portraits were being dispatched regularly to him. Every time he published one, often allowing it a full page, he would write a brief note of congratulation and further encouragement.

Our relationship was more than professional. We shared a fondness for Persian cats. B.K., I learned, felt it obligatory to spend four or five minutes each morning carefully massaging the tummy of his magnificent pet with the soft felt sole of his slipper. When he came to Little Wings, however, our own Persian did not welcome him. She was jealous of the attention we were giving to our guest. After dinner he stroked and spoke to her in cat language. Presently she was crawling on the keys as he played the piano.

'Conquest! Conquest!' B.K. shouted, and a new friendship was cemented.

This portrait was taken in 1939. A couple of years later I took my well-known portrait of Winston Churchill in the Parliament Buildings. To give *Saturday Night* the first Canadian rights to it, and to subsequent portraits, seemed inadequate repayment for the patronage of the great editor and one of the most civilized of Canadians.

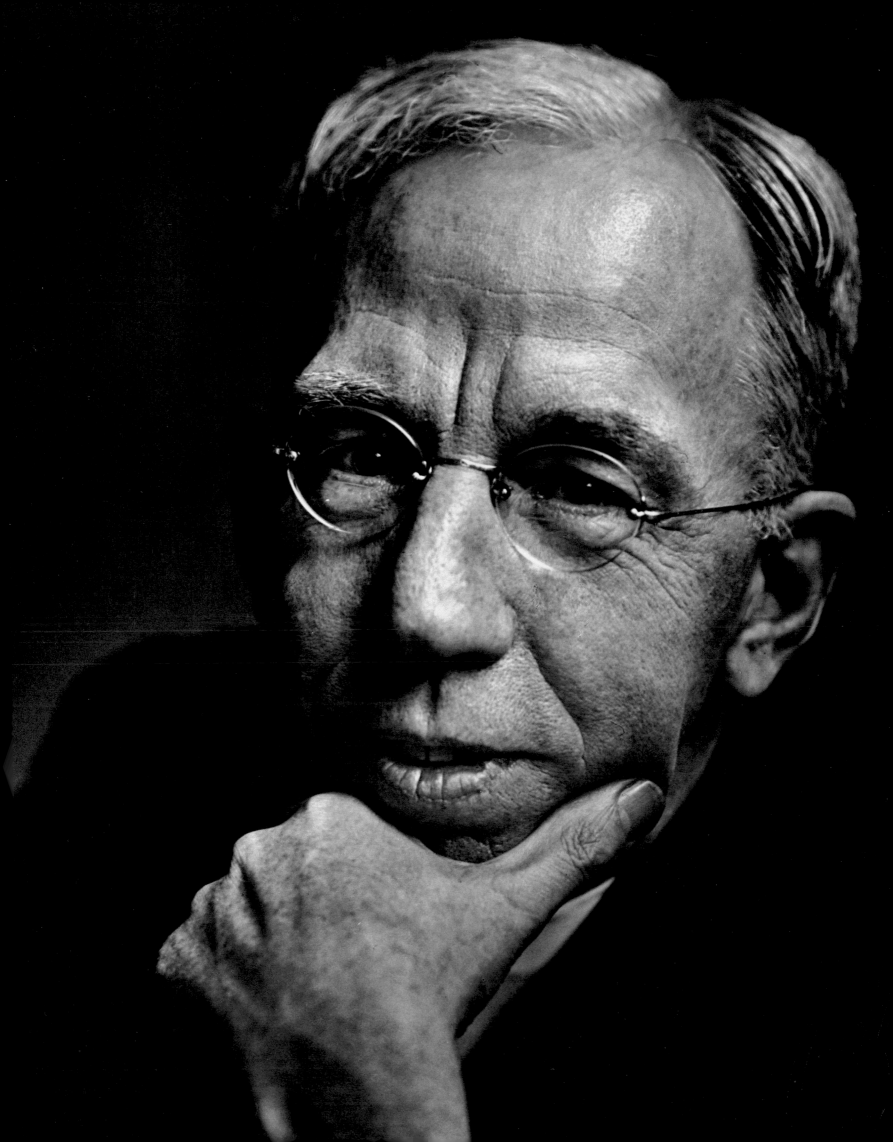

Sir Charles Saunders

1934

The genius who developed the Marquis strain of wheat enriched the Canadian nation. Unlike many others, this strain thrived in the harsh prairie climate, ripened early, and greatly increased the yield per acre. But unknown to the farmers or the general public, Sir Charles Saunders paid a terrible price for his achievement.

In his experiments he tested specimens of Canadian and foreign wheat by grinding a few grains between his teeth. Thus he determined the colour of the flour and the quality of the bread that each variety would produce. Over the years, he reckoned that he had chewed his way through more than a hundred varieties. Before he was ready to select the best of them he developed a condition almost similar to tuberculosis and suffered acute difficulty in breathing.

When I came to know him, his thin, pinched look was the result of these tests. But he remained cheerful and a strong bond was forged between the Saunders and the Karshes. My late wife, Solange, and he both spoke exquisite French and shared a keen interest in encouraging its use. At every opportunity Solange and her mother, Mme Héloise Gauthier, met at Saunders' home for lively French conversation, mostly about music.

Saunders was delighted by their sessions and, in memory of them, left a gift to Solange in his will. For her part, Solange preserved all his letters written in French. The fond feelings that existed between them, as if they were father and daughter, always touched me. In 1934 I photographed Solange's venerable friend, the multi-faceted knight and the nation's benefactor.

Barbara Ann Scott

1946

Today's youth may idolize the stars of rock and roll but back in the forties it was a figure skater, hardly more than a child herself, who captured Canada's adulation. Even Mackenzie King adored Barbara Ann Scott, and her fresh face, and pert little flowered hat, filled the newspapers – while her mother hovered constantly around her.

It is a miracle, indeed, that Barbara was able to reach her goal, for nothing less than perfection could satisfy her. The spectators watched her skate without the least sign of effort. But they had not witnessed her long apprenticeship, the hours and years of practice and experimentation. In those days, perfection in performance was enough – the world did not want the personal exhibitionism of so many current sports idols.

At the age of sixteen, Barbara won the North American skating championship and then went on to win both the European and world titles. She was repeatedly chosen as Canada's most outstanding athlete and ranked above the Prime Minister as the most newsworthy person of 1947.

When she was leaving for the Olympics the next year, aged only nineteen, Solange and I sent her a telegram: 'Go and conquer!' Barbara quoted our message to the press and promised not to disappoint the Canadian people. That promise was well kept. She won the gold medal at St Moritz. After such a crowning success, it was natural for her to turn professional, replacing Sonja Henie in the Hollywood Ice Revue.

In Barbara's Chicago home – her married name is King – in the hallway is a prized memento, a license plate struck for the canary-yellow Buick presented to her by the city of Ottawa, at a time when excellence seemed more important than show business.

Duncan Campbell Scott

1933

When I became interested in Ottawa's Little Theatre, almost half a century ago, Duncan Campbell Scott was its president. He had surrounded himself with a coterie that deeply influenced my private and professional life, always with happy results.

At the theatre I met my first wife, Solange, who was starring in *La Belle de Haguena*. I also met Madge Macbeth, that vivacious hostess, John and Jean Aylen, Mr and Mrs D.P. Cruikshank, Colonel Henry Osborne, and many other lively spirits. Their plays improved my exposure to the riches of the spoken word; my photographic technique gained much from exploring the possibilities of the lighting effects used on their stage. The Theatre was strictly an amateur enterprise, but the spontaneity of its productions excited me and seemed to forecast the cultural climate of modern Ottawa.

I soon made Scott's acquaintance and photographed him in 1933, my second year in the capital. Already in his seventies, he was withdrawn, thoughtful, austere and, I thought, rather shy. Yet he was a ready patron of all the arts, who gave freely of his advice and experience to the young. Only a year earlier, he had retired as deputy superintendent general of the Department of Indian Affairs which he had joined in his youth, giving a lifetime of devoted service to the Indian people.

He is remembered best, however, as a poet of the so-called 'Confederation Generation.' This group included the distinguished Archibald Lampman (a fellow civil servant who inspired Scott to write), Charles G.D. Roberts, and Bliss Carman. Scott never achieved the popularity of the others but his poetry had the true ring and quality of the Canadian north, a land he knew and loved.

As a newcomer to Canada, I was struck especially by some lines still echoing his northern vision: 'All wild nature stirs with the infinite, tender / Plaint of a bygone age whose soul is eternal, / Bound in the lonely phrases that thrill and falter / Back into quiet.'

Frank R. Scott

1966

'The lawyer should not only be a legally learned man, he should also be a broadly cultivated man.' No one personifies this statement better than the lawyer who made it; few Canadians are more broadly cultivated than Frank R. Scott.

For many years he was a respected professor of constitutional law at McGill University, but his interests ranged beyond his profession. As a spare-time hobby, he made himself a distinguished poet whose work has been described by critics as sparse, lean, observant, witty, and humane – and sometimes fractious, too, his satire as biting as any ever written in Canada.

When we met for this portrait I had already known of him as a champion of individual freedom, to which he devoted himself with knowledge and talent, and a burning passion. In Quebec, he was a vigorous defender of the Jehovah's Witnesses, an opponent of that province's notorious 'Padlock Law,' and, in British Columbia, a spokesman for the Japanese interned in the second world war. While he fought these battles in the courts, he argued that a good play or novel might do more to free men's minds from prejudice than any new legislation.

Scott struck me as a sensitive man deeply concerned about the fate of his country. I sensed that his holistic viewpoint had not been achieved without secret anguish.

Only this year, a collection of Scott's writings on constitutional law won the Governor General's Award for non-fiction. In a short preface to that volume he looked back over four decades of struggle and wove together the two main threads of his own career. 'Changing a constitution,' he wrote, 'confronts a society with the most important choices, for in the constitution will be found the philosophical principles and rules which largely determine the relations of the individual and of cultural groups to one another and to the state. If human rights and harmonious relations between cultures are forms of the beautiful, then the state is a work of art that is never finished. Law thus takes its place, in theory and practice, among man's highest and most creative activities.'

CIVIL LIBERTIES

ENGLISH POETRY IN QUEBEC

english in Quebec

McGILL

Hans Selye

1973

'Fight for your highest attainable aim, but do not put up resistance in vain.' This quotation was written on a card which Dr Hans Selye had tucked into a pre-publication copy of his forthcoming book, *The Stress of Life*, before he gave it to me.

Having photographed him at the Institute of Experimental Medicine and Surgery of the University of Montreal, I went home, opened the book to find these words, and read the inscription to my wife, Estrellita, who is a medical writer. Selye knew she would be fascinated by the book, the first explanation of his complex theory of disease in language that the ordinary reader could understand.

In a general way even I could understand Selye's concept of stress and see why it has profoundly influenced the entire world of medicine. But it was that exhortation, 'fight for your highest attainable aim,' that had been the essence of our conversation in 1973 as he took me through the laboratories where he and his assistants, using experimental animals, examined 'the syndrome of being sick.'

He recalled the early days when, as an enthusiastic young investigator, he had vainly tried to interest older colleagues in the study of the 'non-specific damage' to body organs accompanying all diseases. Most of his friends urged him to abandon the project, now the ruling passion of his life. But he was determined to pursue the search for the mechanism by which nature fights disease and other injuries to the body.

So he went ahead with little help or money until, quite unexpectedly, Sir Frederick Banting paid him a visit. The co-discoverer of insulin saw at once the possibilities of Selye's work and undertook to secure financial backing for it. 'I often wonder,' Selye told me, 'whether I could have stuck to my guns without that encouragement.'

His research convinced him that stress comes not only from physical illness and the reaction to bad news. Happy emotions, too – as when a person finds an exciting job, for example, or falls in love – can be stressful. Then, by a minor accident, I suddenly found the great doctor himself under stress.

In the hallway outside his laboratory he had hung photographs of scientists and humanists who had inspired him (for in an era of scientific iconoclasts he was still a refreshing hero worshipper). Pointing to the pictures of Louis Pasteur and Sir William Osler, he added: 'Here is one of my favourites, your portrait of Albert Einstein ...' His voice trailed off in mid-air. The portrait was missing!

I promised to relieve his stress and, as soon as I arrived back in Ottawa, sent him a replacement for the lost photograph of his hero.

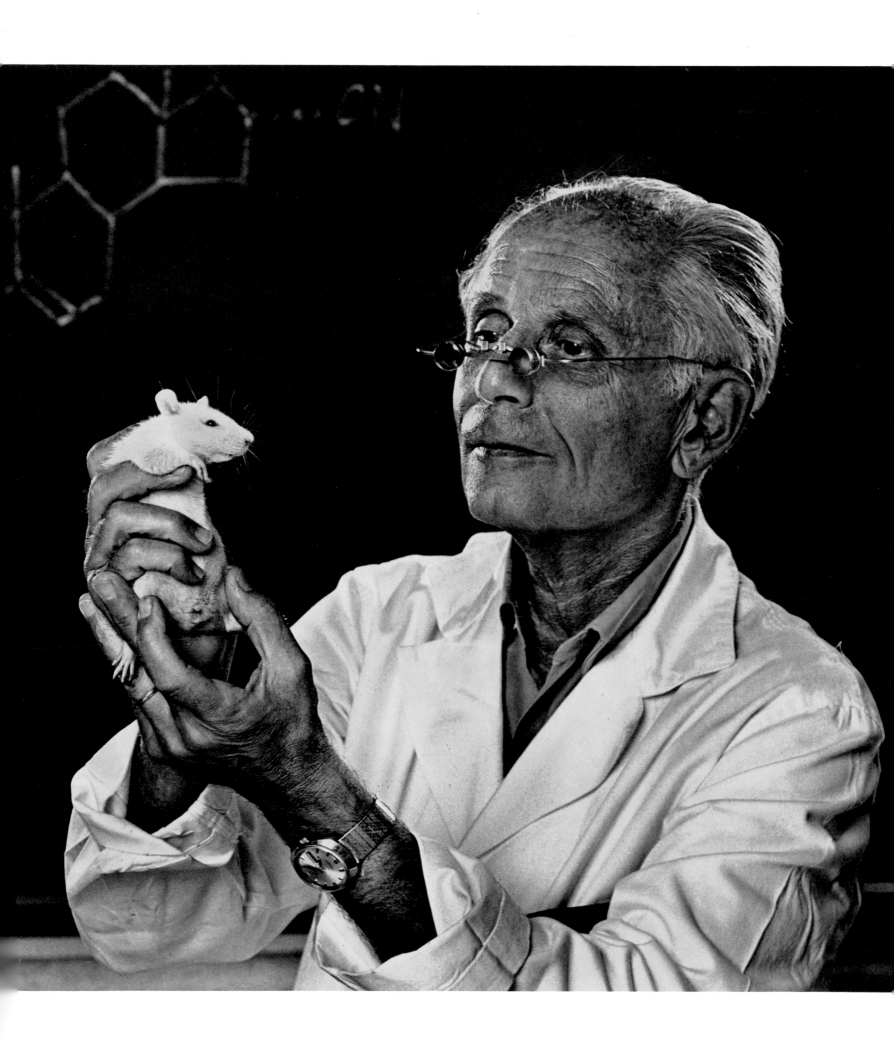

Gordon Sinclair

1974

Perhaps Gordon Sinclair is musing in this photograph about the time he embarrassed me, quite deliberately, on national television. I had agreed to appear on 'Front Page Challenge' before realizing Sinclair's mischievous streak. The program had scarcely begun when he asked: 'Karsh, how much do you charge?' I tried to make light of his indelicacy by suggesting that commercials should not interrupt a serious interview. He persisted in his questioning. What I finally said to Sinclair, I now forget, but I heard later that the unflappable Scot had also asked Pierre Trudeau how much money the Prime Minister was worth. So, at least, I had the satisfaction of being placed in good company.

Sinclair's obsession with people's earnings, his own included, is his trade mark and a highly profitable enterprise. By articulating questions that most people are too polite to ask, he has made himself one of Canada's best-known media personalities, almost a folk hero. Twice daily he airs his views about everything and anyone over the radio in a slot appropriately named 'Let's Be Personal.' But he has strong views on larger questions. In 1973, in his news commentary, he delivered a paean of admiration for the American Red Cross that as a record sold millions of copies. Sinclair contributed the proceeds to charity.

During our portrait session he reminded me – tongue-in-cheek – that he was uneducated and often used slang. Although it is tempting to take Sinclair's self-generated mythology of ignorance at face value, he is intelligent and shrewd. His penchant for the vernacular, he said, had brought some amusing responses, as when a prospective publisher sent him an odd request: 'You are indeed the man we want, for slander and purposefully bad grammar are all right, as long as they are not patently offensive.'

Here he is seen in the home he designed for himself in Mississauga, outside Toronto. Behind him is evidence of his busy life as a journalist and newscaster. Service in the 48th Highlanders during the first world war may account for his beret, but his entire ensemble bespeaks the cocksure eccentricity marking one of the few survivors of the flamboyant heyday of Toronto journalism.

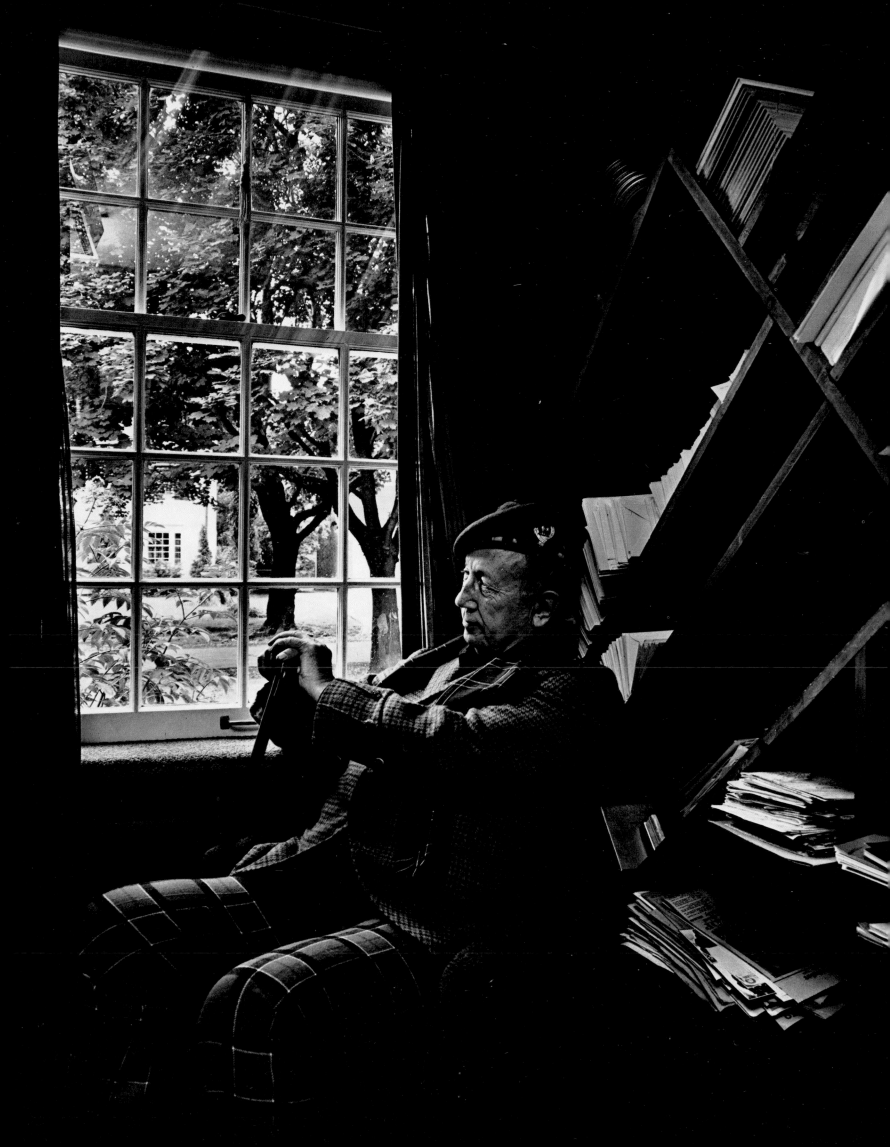

Joseph R. Smallwood

1949

It has been said that Prime Minister Louis St Laurent lured Newfoundland into Canada by waving an Eaton's catalogue and the promise of baby bonuses. Nowadays this may sound whimsical, but not to anyone familiar with the hard life of the average Newfoundlander in 1949.

This I saw for myself at first hand early that year when I was commissioned to photograph some twenty people, headed by Joey Smallwood who, more than any other man, had persuaded his people, in a narrow vote, to make Newfoundland the tenth Canadian province (and himself, as he likes to think, the last remaining Father of Confederation).

At the time of my arrival, feelings were running high both for, and against, the colony's decision. But as a fairly new Canadian myself, I had no doubt that life for the people would be improved through membership in a rich, transcontinental nation. And a story told me by Dr William Roberts, another portrait subject, showed how desperately such improvement was needed.

Dr Roberts had attended the wife of a lighthouse keeper who supported his family of five on a salary of three hundred dollars a year. After performing a series of operations, the doctor summoned the husband to take his wife home from the hospital.

The lighthouse keeper, full of gratitude, said he must pay for the operations. The doctor, knowing the man's pitiable income, refused to accept a fee. The keeper insisted and, not wishing to offend him, the doctor finally agreed. 'Here's your money, doc, and you jolly well earned it!' the man exclaimed triumphantly, producing the fee from his pocket. It was a single dollar.

As for Smallwood himself, I found him exuberant and colourful, a gifted story teller, a former journalist and a subtle politician. But in several meetings with him since 1949 I noticed that, with all his bubbling talk, he gave away few secrets. Indeed, I have discovered that it is the mark of most successful politicians that they never reveal too much of themselves, even before the camera.

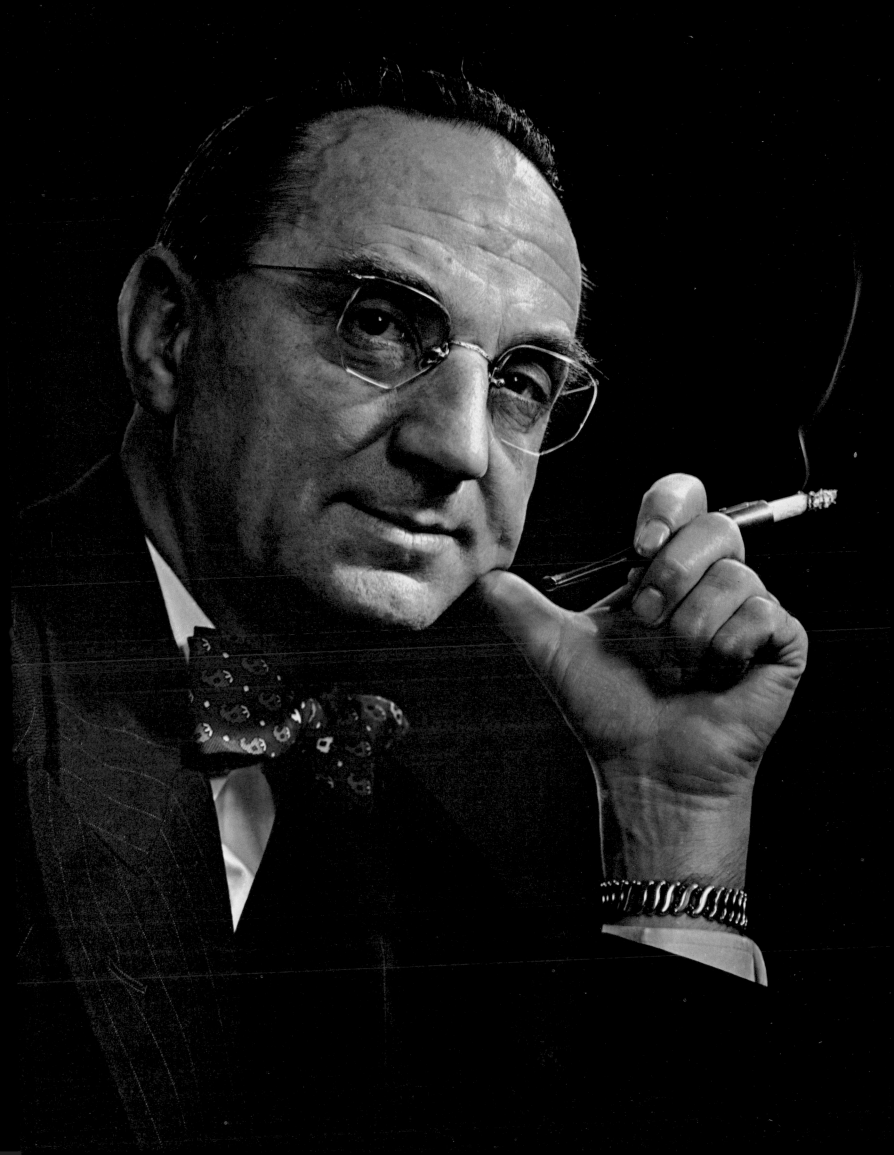

P. A. Taverner

1939

The invisible background of this portrait is a pleasant domestic tale. At first, the little house that Solange and I built beside the Rideau River in 1941 had no name. But thanks to the many birds visiting our property, for we were located on a migratory route, it did not remain nameless for long. We christened our home, Little Wings. We erected feeders and Solange began her practice of recording, in a log, the birds seen each day. Over the years she counted one hundred and twenty-six different species, including such unusual varieties as mourning doves, snow geese, and blue heron.

Solange's authority on birds was P.A. Taverner's *Birds of Canada*, a book that is an exquisite synthesis of poetry and precision. Like everything Taverner wrote, it is lucid and accessible, for the author, though a learned scholar, had never been academically trained as an ornithologist and did not confuse the reader with technical language.

Architecture had been his original profession but could not engage him completely: he had spent most of his time studying birds in the field, in museums, and in taxidermists' shops. In 1931, despite his lack of official credentials, he was invited by the National Museum in Ottawa to take charge of its new bird exhibits. What Marius Barbeau was to folklore, Taverner was to birds. In a period of thirty-one years, he built a magnificent study collection of 35,000 specimens.

The portrait was planned as a tribute to a great Canadian naturalist but, to my dismay, my first attempt to capture on film this unassuming man was a failure. Both Solange and I were shocked when we viewed the proofs. Taverner appeared positively diabolical, the very opposite to what we knew to be his true character. On a later visit to Little Wings he sat before my camera a second time. This time I was relieved to find the thoughtful familiar features of the bird lover who had enriched our knowledge and appreciation of nature.

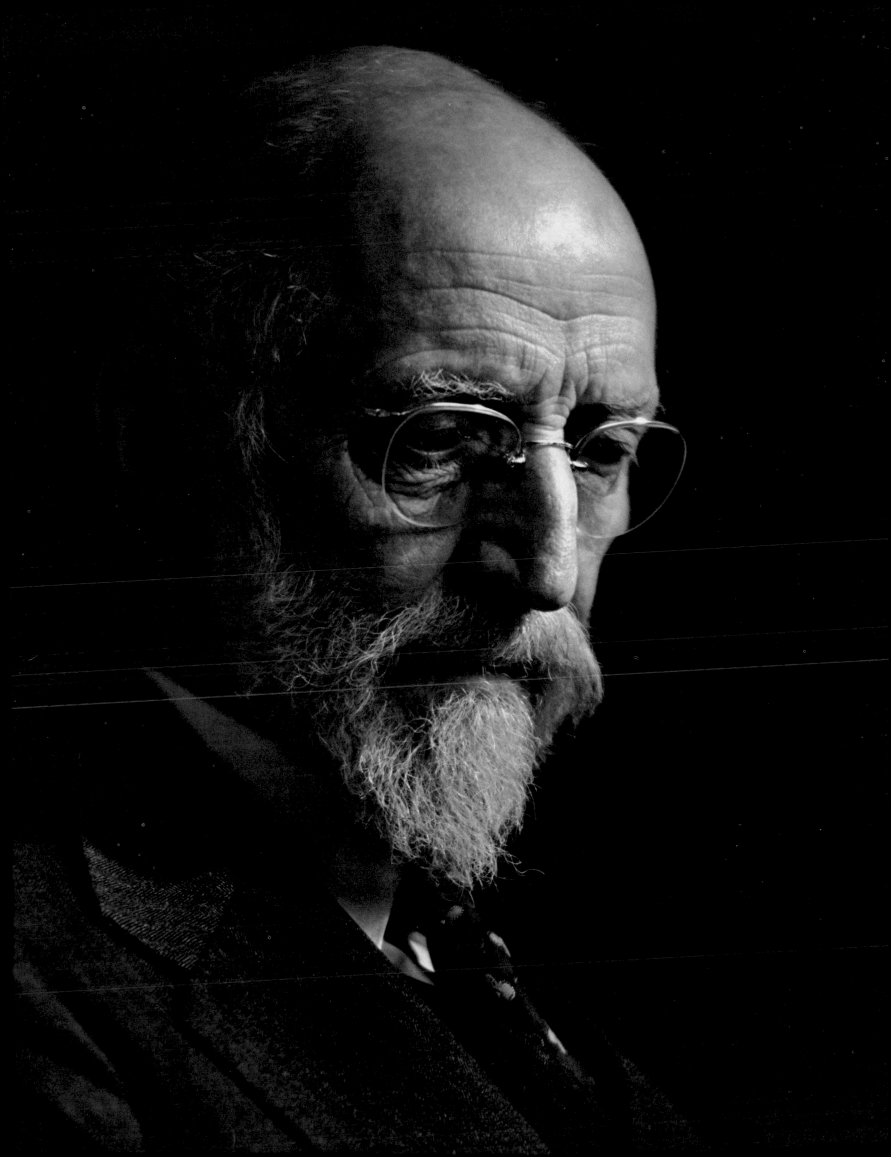

E. P. Taylor

1944

For Canadians, E.P. Taylor has long symbolized the power and mystery of high finance – a handsome, elegantly dressed man, friendly in manner, direct and candid in speech.

When this portrait was made in 1944, he had already become one of the world's most influential financiers. As a wartime 'dollar-a-year' servant of the government, he successfully managed the British Supply Council and the British Purchasing Commission responsible for moving supplies from North America to Britain.

After the war a 'new' E.P. Taylor seemed to emerge. With the asset of his diplomatic experience, and a broad knowledge of international affairs, he began to expand his business, acquiring numerous corporations at home and abroad to combine them into larger, more efficient units. This approach was the beginning of the Argus Corporation, which he founded in the year after I took this photograph.

His business acumen served many philanthropic projects, as when he headed the Toronto General Hospital campaign for funds in 1962, and raised enough money for six new buildings. His leisure interest, centred on race horses, made him a world-renowned breeder. (Northern Dancer, from his stables, was the first Canadian winner of the Kentucky Derby.) He was responsible for the building of Toronto's new Woodbine Race Track and a general upgrading of the sport.

Over the years, Taylor never lost his fascination with big business. He is now the world's largest house builder, who has made low-cost housing available in many developing countries. As he describes his guiding principle, 'I've always found it difficult to refrain from embarking on a business venture which appeared to be constructive, which would fill a need, and which, in a reasonable period of time, could be successful in an economic sense.'

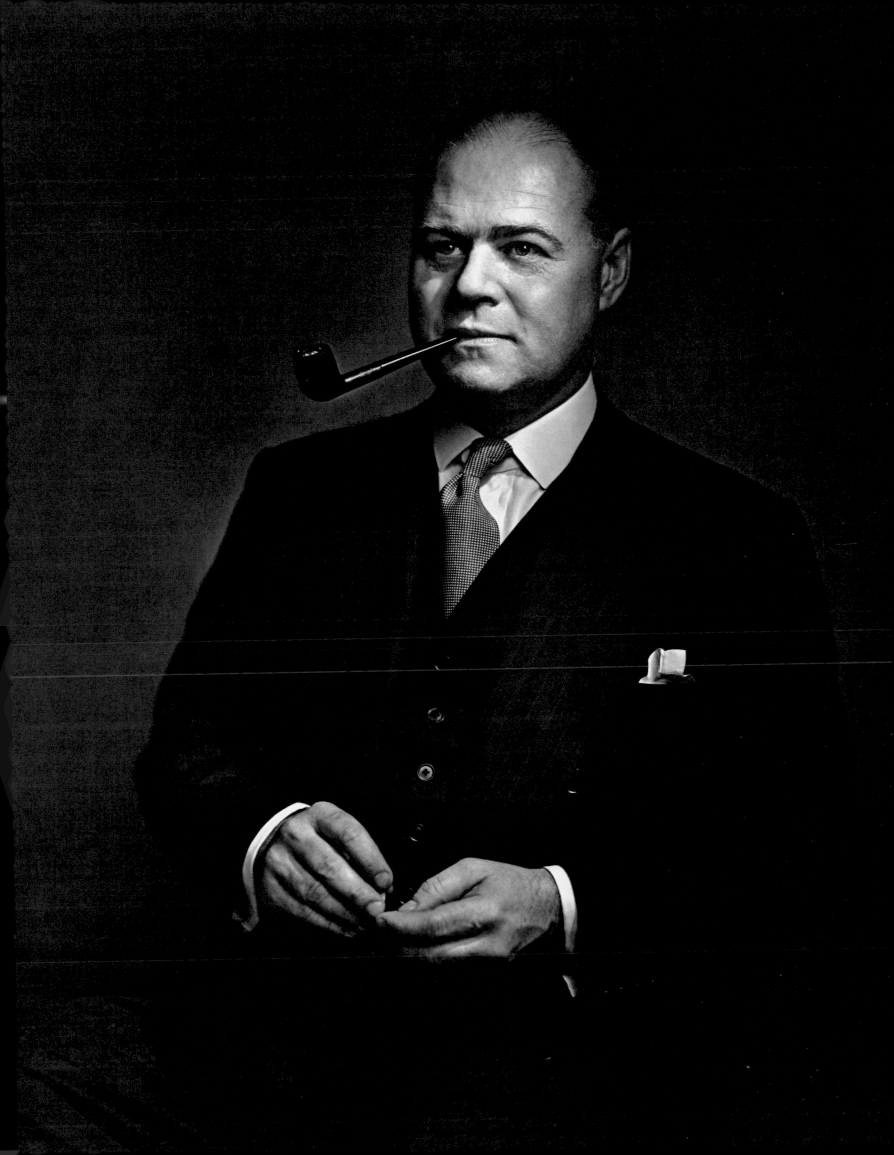

Harold Town

1967

Towards the end of January 1967, I took Marshall McLuhan's son along as my photographic assistant and paid a visit to Harold Town. We went to his working quarters in the historic Studio Building, constructed in Toronto in 1914 by Lawren Harris and Dr James MacCallum expressly for the artists of the Group of Seven.

I was immediately struck by Town's restless intelligence. He proved an entertaining host – witty, opinionated, iconoclastic. I could see in his smouldering eyes, pursed lips, and confident manner traces of the *enfant terrible* who, in the fifties, championed the cause of Abstract Expressionism, challenging the artistic mores of Canada.

Everywhere in his studio were signs of his constant experimentation. The styrofoam blocks behind him were part of a public school project on which he was working, pressing what is normally a 'throw-away' material into the service of art.

I appreciate the style of his most recent piece of writing – the text for a lavishly illustrated biography of Tom Thomson, wherein Town sees Thomson as the paradigm of the romantic artist.

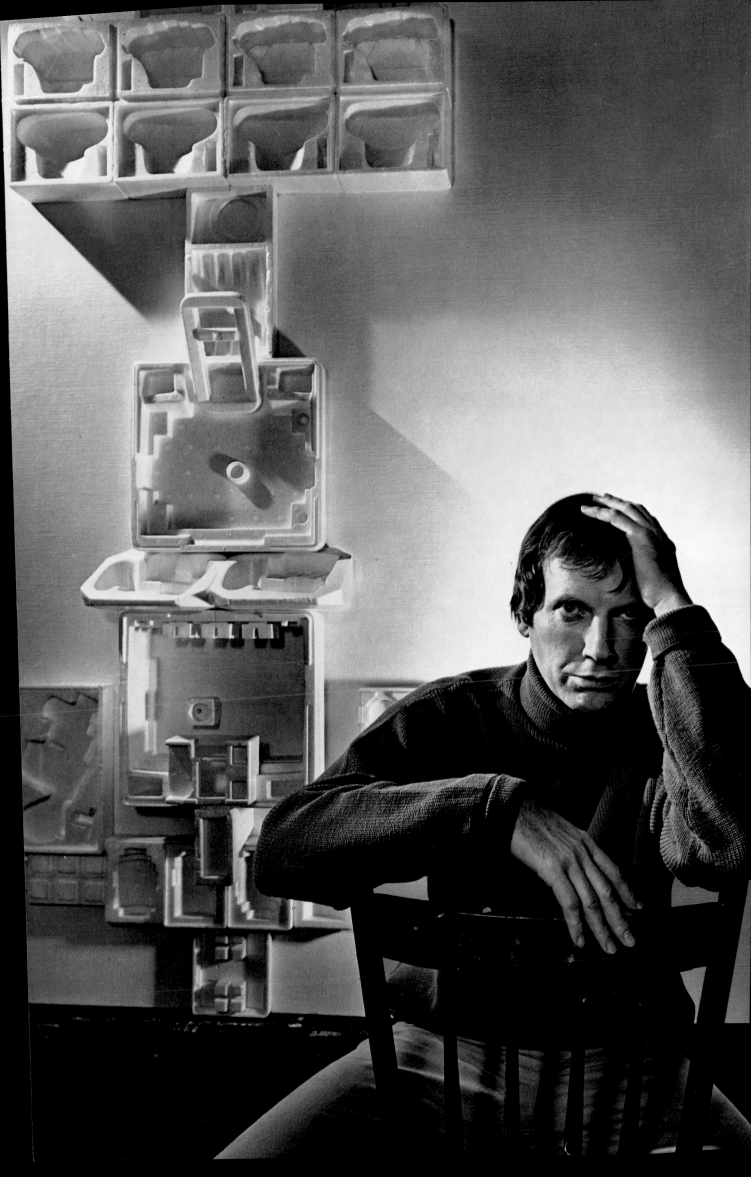

Pierre Elliott Trudeau

1968

When I photographed Prime Minister Pierre Elliott Trudeau, soon after he took office in 1968, the voters already had found him compelling and charismatic but not yet controversial. The discovery of his many-faceted nature was to come later – a partial discovery, I suspect, because the Canadian people may never fully understand him.

Before our photographic session at his official Ottawa residence, 24 Sussex Drive, we lingered and talked over dessert and coffee. The new head of government was very relaxed, very natural and, above all, candid. Seldom had I met a politician who spoke so freely, yet he weighed his words as they pertained to national affairs. He also had a lively sense of humour, an ironic wit, a sharp memory for persons and events. If he speaks directly to you, the force, as well as the charm, of his personality helps to explain his place in current politics.

Political life at the summit can never be without strain, of which a minor episode reminded me. I was present on the day when Koran, the Catholicos (head) of the Armenian Church, visited Ottawa to confer the Church's highest honour on Trudeau. A political debate was under way and the Prime Minister could not receive the Catholicos until six o'clock in the evening. He looked absolutely exhausted. But, accepting the beautiful medal with a weary smile, he remarked: 'It was particularly welcome on this hard day to have some spiritual consolation. It helps one forget the trials and tribulations.'

These trials and tribulations had scarcely begun as I took several photographs. Trudeau was most pleased and wished to make one of them his official portrait.

The portrait reproduced here seems to capture both sides of him: his celebrated fondness for logical argument and flashing repartee is almost belied by the introspective cerebral quality of his features, suggesting perhaps more than cool detachment. Underneath his smiling public appeal or sudden gusts of anger, Pierre Trudeau must be one of the most private men who ever played so great a part in the nation's life.

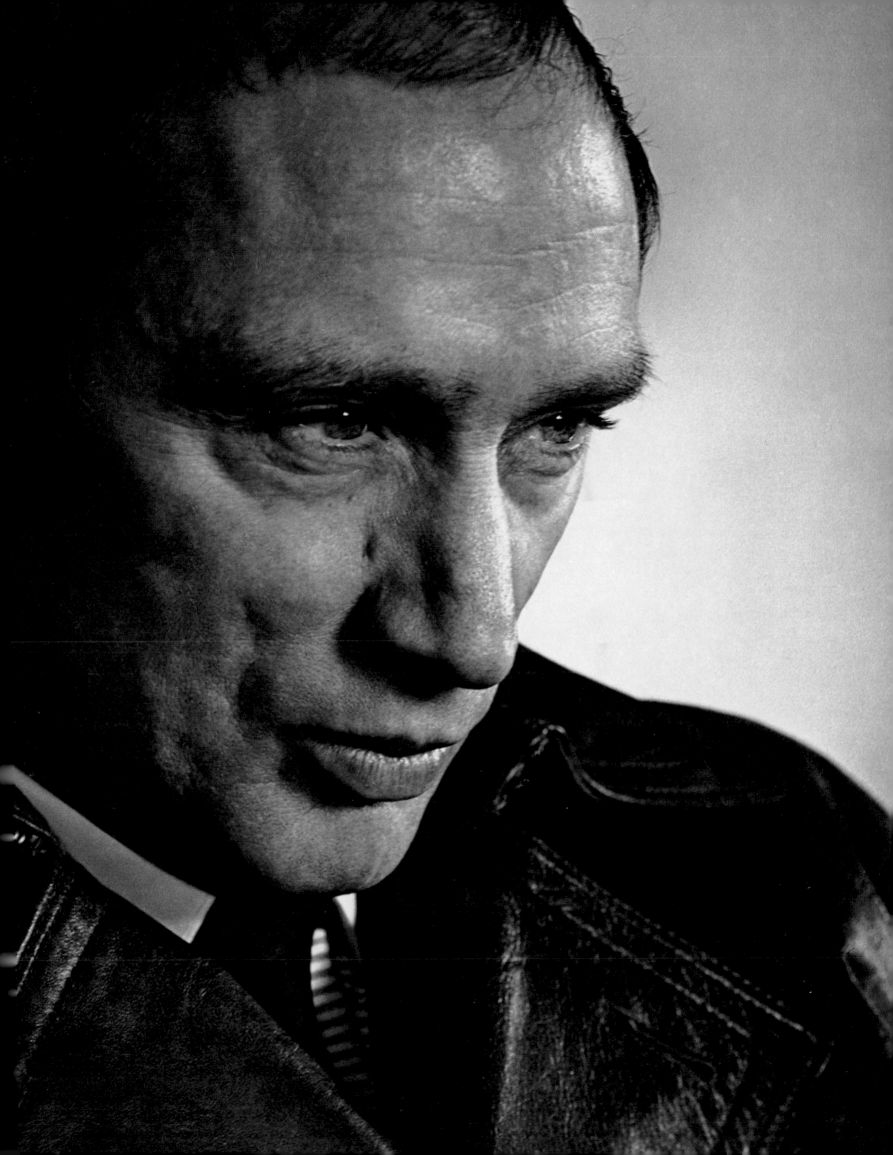

Pauline Vanier

1949

Thanks to Pauline Vanier's beauty, intelligence, and warmth, an appointment with her was always a delight for me as photographer and friend. The meeting which produced this portrait proved no exception. It took place in Paris, during Georges Vanier's term as Canadian ambassador to France.

Although I had intended to make an individual portrait of his wife, chance intervened to change my plan. While I was considering various attitudes, Mme Vanier's son, also named Georges, whispered something to his mother. 'Ah,' I exclaimed, 'that's a picture!' And I slightly re-arranged my two subjects so that Georges was reflected in the long mirror by his mother's side.

After she became the chatelaine at Rideau Hall, I photographed her again and I remember how solicitous she was about my health. I had fallen ill as a result of a marathon photographic journey to Washington, and when I appeared at the vice-regal residence she remembered my temporary indisposition. After our photographic session and a delicious lunch, she accompanied me upstairs to one of the guest bedrooms, turned back the bedsheets herself, and insisted that I take a half hour's nap.

Her kindness did not surprise me. Concern for others has always been a part of this noble woman's life. In the first world war she worked with the St John Voluntary Aid Department and throughout the second represented the Canadian Red Cross in France. With her husband – a lawyer, soldier, diplomat, and beloved public figure even before he became Governor General – she established the Vanier Institute of the Family.

But her busy and fulfilling life in Canada was not to be the end of her compassionate story. After Georges Vanier's death, she sold many of her possessions and moved to a small village north of Paris where her son, Jean, manages the headquarters of L'Arche, the splendid organization that provides homes and treatment for the mentally retarded. As Jean proudly told me when I telephoned him: 'Mother is the mother of them all.'

Frederick Varley

1964

Frederick Varley was not born a Canadian; like me, he freely chose the country of his future. Growing up in England, he studied art at Sheffield and Antwerp and was over thirty years old when he reached Canada in 1912. He became the finest portrait painter our country has ever known. But his temperament did not always fit those of his subjects and some of these encounters are legendary and hilarious.

Among the Group of Seven, Varley alone seemed to feel that the human being was more important than the inanimate landscape. His paintings of the embattled Flanders scenery when he was an official Canadian military artist during the first world war exemplified this attitude. With him, humanity always remained uppermost. His tragic depiction of a shattered cemetery, for instance, is entitled *Some Day the People Will Return.* There spoke the man of passion even more clearly than the artist.

It is hardly surprising that his later work, after he left the Group to teach and paint in Vancouver, glows with mysticism, although his drawings are sensuous. Varley was a bohemian – kind and generous, often short of cash. National honours came to him relatively late in life. It was in connection with one of them, the Canada Council Medal, that I was asked to photograph him.

Estrellita and I drove to meet him in Unionville, a village northeast of Toronto, where he lived his final years with close friends, Donald and Kathy McKay. They had a lovely old board and batten house, festooned with 'gingerbread' and built nearly 150 years earlier by one of Mrs McKay's ancestors, the son of a pioneer settler. Varley was now over eighty years of age. The fiery red hair had faded and so had the mercurial temper. But not the generosity.

While I set up my equipment, Estrellita amused herself by looking through a pile of his drawings and paintings. She stopped at a watercolour – only a spontaneous quick sketch and yet vividly alive. It could have illustrated a children's story about an enchanted tree. Varley presented it to her and it hangs today in our home.

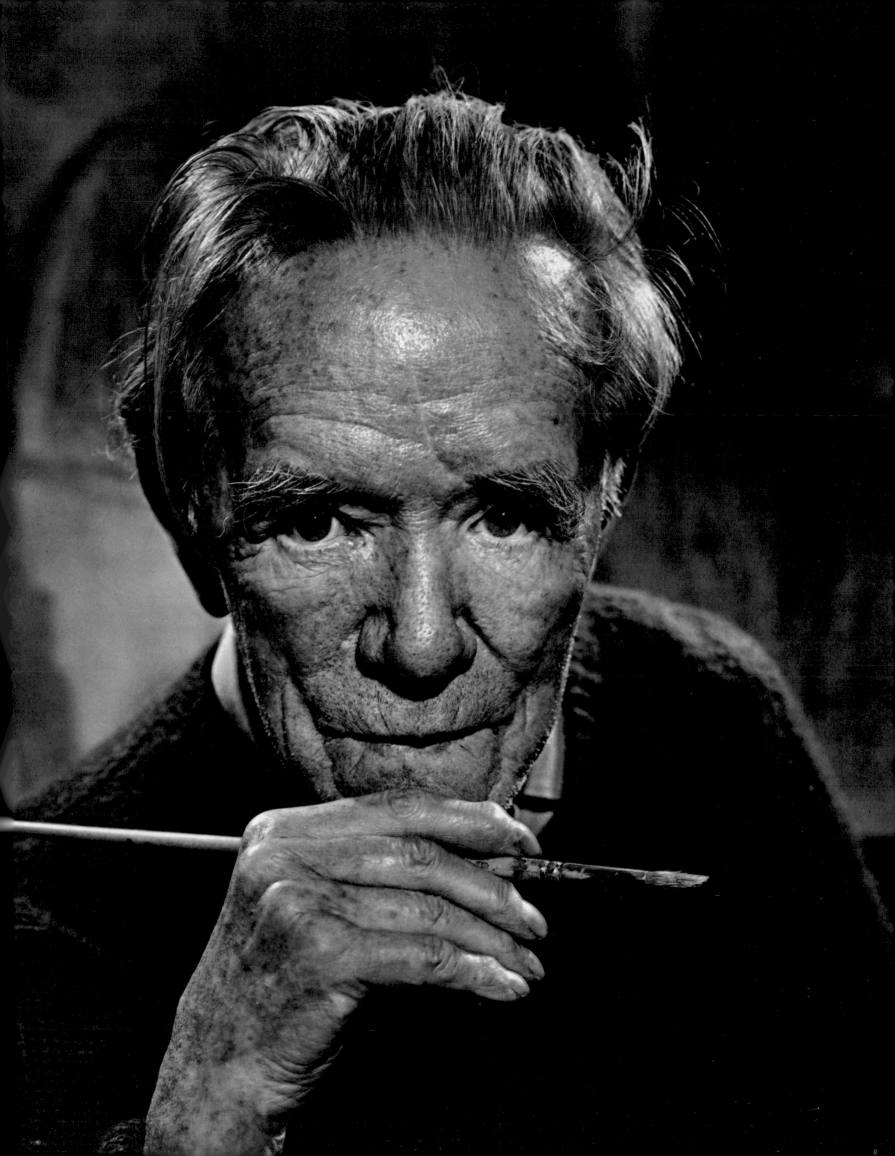

Healey Willan

1952

As his philosophy of life, Healey Willan resolved to take his work seriously but never himself. So he did with results known throughout the English-speaking world. 'Music,' said the distinguished organist and composer, 'has been my chief delight and if at any time I have been able to share it with others I am content.'

This endearing gentleman had good reason for contentment – and many honours to justify it. Soon after he came from England to head the theory department of the Royal Conservatory of Music, his fame spread as the organist and choirmaster at St Mary Magdalene Church in Toronto, and his liturgical music was adopted by countless North American churches.

When our mutual friend, B.K. Sandwell, urged me to photograph him for *Saturday Night* magazine, British royalty had just singled him out for special recognition. One of his anthems was to be incorporated in the Coronation ritual of Queen Elizabeth II, and this had led to a second royal commission, an anthem for the Festival of St Cecilia.

On meeting Willan I saw at once a mischievous sense of humour in the twinkling eyes and slightly mocking expression. It did not surprise me to learn that he wrote limericks as readily as he composed fugues. For many years he was organist at the graduation ceremonies of the University of Toronto and, while degrees were being conferred, would exchange instant verses with the equally poetic president, Claude Bissell.

Although his works are well known and admired among musicians everywhere, Willan's influence on an entire generation of music students is less understood but it has been prodigious. Altogether, his career is classical in its sweep and impact.

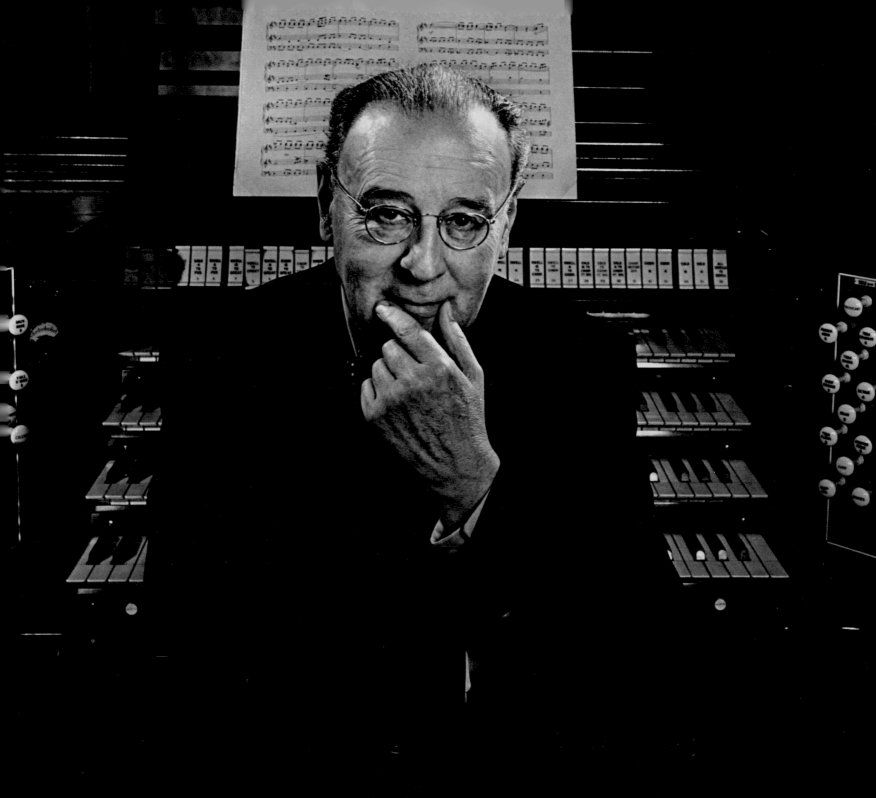

J. S. Woodsworth

1938

The strongest critic of his economic and social views would not deny that J.S. Woodsworth was the conscience of Parliament. Even when, standing alone, he voted against Canada's declaration of war in 1939, respect for his integrity was not diminished, but increased. While all his followers in the House of Commons supported the declaration, they deserted his policy but never his ideals. Prime Minister Mackenzie King, in fact, was the first to praise him for his brave defence of convictions as sincere as they were impractical.

That vote ended Woodsworth's leadership of the Co-operative Commonwealth Federation, which was mainly his creation. Some years earlier, members of his party had asked me to photograph him with his daughter, Grace MacInnis, and M.J. Coldwell, his eventual successor. Intrigued by his looks – for he resembled a prophet of the Old Testament – I invited him to pose for my camera on a later occasion.

He greeted me in his parliamentary office, which was not only a centre of active political business but a kind of sanctuary. There his admirers from all parts of Canada sought his advice and, with it, always received the help and compassion of a man who had suffered much without losing his faith in mankind.

Some poignant mementoes of his struggle to reform Canadian society could be seen in this small room – a steel billhook used by the frail young Woodsworth as a longshoreman in Vancouver; the half neck yoke employed as a weapon by the special police in the Winnipeg strike of 1919 when he was arrested for his editorials in the *Western Labour News*; and on the walls a gallery of press cartoons, most of them ridiculing him but touching his ready sense of humor.

My portrait conveys, I hope, the visage of a truly Christian gentleman, but only his life, and his profound effect on the nation's future, can measure his lonely achievement. Although he had left the Methodist ministry for the secular world of politics and sought reform in the now rather than the hereafter, he remained a visionary, an ascetic and, as his friends judged him, a saint.

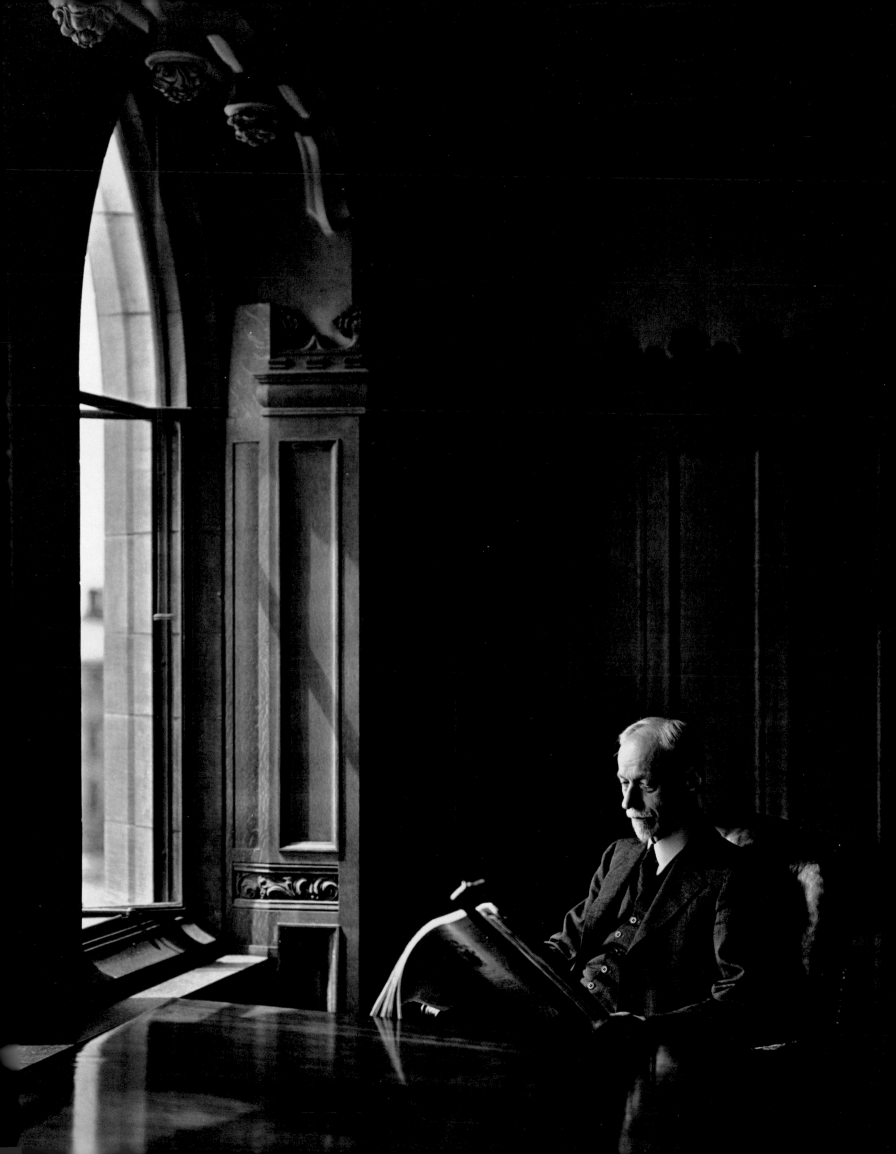

Young Canada

1977

The international reputation of the National Ballet School, founded and directed by Betty Oliphant, is well deserved. Her devotion and inspiration have already produced such international stars as Karen Kain and Veronica Tennant.

This photograph of Ava and Eva, two current students of the National Ballet School, ends my thanks-offering to the people of Canada with a salute to the men and women of its future. The splendid nation that is their heritage will remain, I know, united, strong and free, welcoming the newcomer in its midst as it welcomed me.

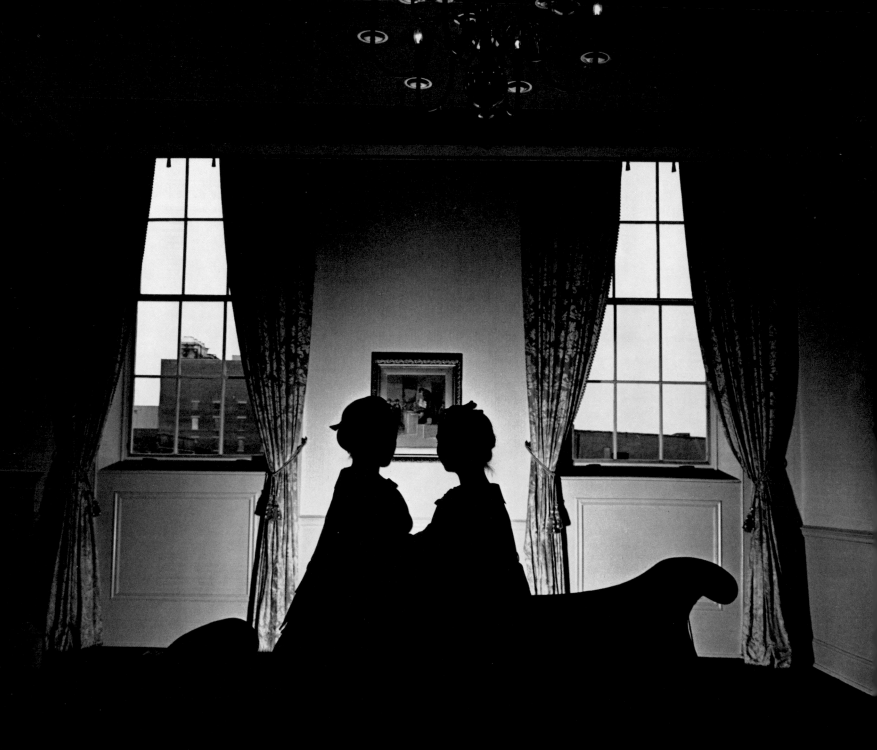

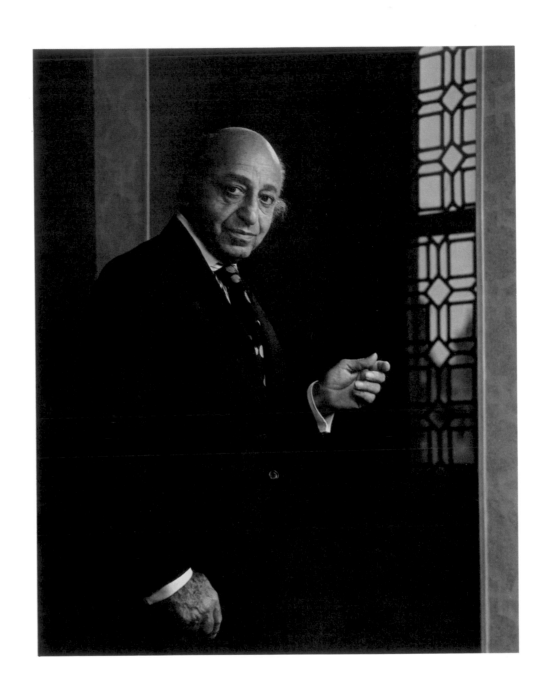

Biographical Notes

MARGARET ATWOOD (1939–), poet, novelist, critic. Born in Ottawa. Her parents moved to Toronto when she was seven but the family spent several months a year in the bush of Quebec and Ontario. Educated at the University of Toronto, Radcliffe College, and Harvard University. *Double Persephone* was published in 1961; other books of poetry include *The circle game* (1966); *The journals of Susanna Moodie* (1970); *Procedures for underground* (1970); *Power politics* (1971); *You are happy* (1974) and *Selected poems* (1976). Has won many prizes for poetry including the Governor General's Award in 1966. Her first novel, *The edible woman*, was published in 1969, followed by *Surfacing* (1972) and *Lady oracle* (1976). *Survival: a thematic guide to Canadian literature* (1972) and *The dancing girls and other stories* (1977), are other prose works. Her first children's book, *Up in a tree*, was published in 1978.

MARIUS BARBEAU, CC, FRSC (1883–1969), author, poet, lecturer, scholar, anthropologist, authority on Canadian folk music. Born in Ste Marie de Beauce, Quebec; attended Collège Ste Anne de la Pocatière and Laval University; was the first French-Canadian student to be awarded a Rhodes Scholarship; studied at Oxford University, the Sorbonne, and University of Montreal. From 1911 to 1958, was Ethnologist and Folklorist of the National Museum of Canada, responsible for collecting and recording French-Canadian, Indian, and Eskimo folklore, including songs and native tales. Among his books are *Folk songs of French Canada* (1925); *Come a-singing* (1947), and *Alouette* (1946). Lorne Pierce Medal of the Royal Society of Canada for literature, 1950; Canada Council medal, 1961–2; among other honours, vice-president of the International Folk Music Council of Unesco.

LORD BEAVERBROOK (1879–1964), financier, politician, newspaper publisher. Born William Maxwell Aitken, clergyman's son, in Maple, Ontario; at his death controlled one of the greatest newspaper empires in the English-speaking world. Studied law at the University of New Brunswick but left to seek his fortune in Montreal, where he quickly built a reputation for business acumen and engineered the merger of three companies into the Canada Cement Company. In 1910, moved to England and for six years represented Ashton-under-Lyne in Parliament as a Conservative. Appointed 'Eye-Witness' to the Canadian Expeditionary Force, 1915, Canadian Government Representative at the Front, 1916, and Officer in Charge of Records, responsible for organization and distribution of war films for the British War Office, 1917. Created Baronet, later peer, and took his title from Beaverbrook, a small stream near his early New Brunswick home. Chancellor of the Duchy of Lancaster and Minister of Information, 1918. Bought a controlling interest in the London *Daily Express* in 1916 and built its circulation to well over four million a day; subsequently founded the *Sunday Express* and acquired the London *Evening Standard*. During the second world war, served as Minister of Aircraft

Production, Minister of State, Minister of Supply, and Lord Privy Seal. After war, dropped out of political life but as a newspaper owner campaigned relentlessly for free trade and crusaded against Britain's entry into the Common Market. Chancellor of the University of New Brunswick, 1947–53.

MARIO BERNARDI, CC (1930–), pianist and conductor. Born in Kirkland Lake, Ontario, where his father had immigrated to work in the mines. At six, was sent back to Italy with his mother, brother, and sister to live with an uncle, a priest, in Treviso. At 17 received his diploma in piano, organ, and composition from Benedetto Marcello Conservatory, Venice, with perfect marks. Returned to Canada in 1948 as scholarship student at Royal Conservatory of Music, Toronto. Made his debut with the Canadian Opera Company in 1957 and conducted it regularly until 1962, when he was awarded a Canada Council grant and began work with the Sadler's Wells Opera Company as opera coach. Opera conductor of that company, 1963–6, and musical director, 1966–9. Also conductor at the Stratford, Ontario, Festival, 1961, Vancouver Opera, 1962–8, and Opera Guild, Montreal, 1965–7. Since September 1969 has been conductor of the National Arts Centre Orchestra, Ottawa; also musical director of the National Arts Centre.

PIERRE BERTON, O.C. (1920–), author and broadcaster. Born in White-horse, Yukon; worked in Klondike mining camps while at University of British Columbia; in four years in the army, rose from private to captain/instructor at Royal Military College, Kingston. Began newspaper career with Vancouver *News Herald* and at 21 was youngest city editor on any Canadian daily. At 31 was named managing editor of *Maclean's*. Joined Toronto *Star* as associate editor and columnist, 1958. In 1968 began own television program, 'The Pierre Berton Show,' which ran until 1973. Is host of two weekly Canadian television programs, 'My Country' and 'The Great Debate,' is seen weekly on 'Front Page Challenge' on which he has appeared since it began in 1957, and is heard daily on Toronto radio. Has written 24 books and is the only Canadian to win three Governor General's Awards for non-fiction – for *The mysterious north* (1956), *The Klondike* (1958), and *The last spike* (1972). Stephen Leacock Medal for Humour for *Just add water and stir* (1960). Wrote and narrated documentary film *City of Gold*, which won more than 30 awards including the Grand Prix at Cannes in 1958.

CHARLES H. BEST, CC, CH, CBE, FRSC (1899–1978), scientist, co-discoverer of insulin. Born in West Pembroke, Maine, but moved to Toronto as a youth. Educated University of Toronto, University of London. In 1921, while still a student, collaborated with Frederick G. Banting in the discovery of insulin, which has prolonged the lives of over three million diabetics around the world. Subsequently engaged in rich career in medical re-

search, holding senior positions at the University of Toronto, including professor of physiology and director of the Banting and Best Department of Medical Research. In second world war initiated project for securing dried human serum for military use; joined Royal Canadian Navy as director of Medical Research Unit in 1942 and produced a pill 75 per cent effective against seasickness. Scientific director, International Health Division, Rockefeller Foundation, 1941–3 and 1946–8. Research embraced studies of heparin as an anti-coagulant drug and the dynamics of the metabolism of fat. Received many honours, awards, medals.

WILLIAM AVERY BISHOP, VC, DSO, DFC, MC (1894–1956), Canada's greatest world war flying ace. Born at Owen Sound, Ontario, and educated at Royal Military College, Kingston. Went overseas in first world war as cavalry soldier and transferred to Royal Flying Corps as observer. After four-month tour in France, 1915, was sent back to England for pilot training. Returned to France in March 1917 and within a few weeks had downed 20 enemy aircraft. On 2 June 1917, decided to make a single-handed surprise attack on a German aerodrome, destroyed two of seven planes ready to take off, and when attacked in the air managed to shoot down one more and badly damage another. For this, became first Canadian airman to win the Victoria Cross. In May 1918 formed his own squadron, the 85th, 'Flying Foxes.' At 24 years of age, was appointed to Canadian General Staff, with record of 72 official kills plus 23 'probable but unconfirmed' kills, the Victoria Cross, Distinguished Service Order and bar, Distinguished Flying Cross, Military Cross, Legion of Honour, and Croix de Guerre with Palm. Between two world wars, lectured, experimented in commercial aviation, invented a formula for quick drying paint, and became vice-president of McColl-Frontenac Oil Co. Ltd. In 1936, promoted to Air Vice-Marshal, in 1938 to Air Marshal, and during second world war to Honorary Air Marshal. After war, resumed business career and recruiting. Books include *Winged warfare* (1918) and *Winged peace* (1944).

SIR ROBERT BORDEN, GCMG, FRSC (1854–1937), Prime Minister of Canada 1911–20. Born in Grand Pré, Nova Scotia. Educated at Acadia Villa Academy, Nova Scotia, and studied law. President of Barrister's Society of Nova Scotia, 1893–1904. Elected to House of Commons from Halifax, 1896. Chosen leader of the Conservative opposition, 1901; defeated in Halifax, 1904; elected from Carleton, 1905; elected from Halifax, 1908–17, and from King's County, 1917–21. Became Prime Minister in 1911 with defeat of Liberal government of Sir Wilfrid Laurier; led Canada through first world war and peace negotiations. Canadian delegate at the Washington Conference, 1921–2. Chancellor of McGill University, 1918–20, and of Queen's University, Kingston, 1924–30. After retiring from political life published two volumes of lectures, *Canadian constitutional studies* (1922) and *Canada in the Commonwealth* (1929).

WILLIAM BOYD, FRSC (1885–), pathologist and author of numerous texts on pathology. Born in Portsoy, Scotland and educated in Scotland and England. Professor of pathology, University of Manitoba, 1915–37 and Pathologist, Winnipeg General Hospital, 1919–37. Professor of pathology, University of Toronto, 1937–51, and University of British Columbia, 1951–4. Honorary Fellow of the Royal College of Physicians (London), president of the American Association of Pathologists and Bacteriologists, president of the American and Canadian Section of the International Association of Medical Museums. Best known as author of textbooks that have passed through many editions and served generations of medical students, including *Pathology for the surgeon*, *Pathology for the physician*, *Textbook of pathology*, and *Introduction to the study of disease*.

LEONARD BROCKINGTON, CMG (1888–1966), lawyer, administrator, broadcaster; known as Canada's 'orator laureate.' Born in Cardiff, Wales; educated at the University of Wales. Came to Canada in 1912 and after periods as a journalist and civil servant began studying law in Calgary. City Solicitor for Calgary, 1921–35, and General Counsel for the Northwest Grain Dealers Association, Winnipeg, 1935–9. First chairman of the Canadian Broadcasting Corporation, 1936–9. Special wartime assistant to the Prime Minister of Canada, 1940–1; advisor on Commonwealth affairs to the British Minister of Information, 1942–3. Thereafter returned to Canada, practised law in Ottawa, acted as chairman of many labour reconciliation boards and as government arbitrator in a number of law disputes. Also served on corporate boards. From 1947 until his death, was rector of Queen's University, Kingston. Honorary Bencher of the Inner Temple, London; Honorary Life Member of the Canadian and U.S. Bar Associations; Honorary Counsel for the Boy Scouts Association of Canada; many other honours. To many Canadians, is best remembered for broadcasts over CBC and BBC networks. Also spoke over U.S., Australian, and New Zealand networks and the Canadian, U.S., and British short-wave services.

JACK BUSH, OC (1909–1977), abstract artist. Born in Toronto; studied in Montreal and at Ontario College of Art. First exhibited in Toronto in 1944: early work reflected the Group of Seven landscape tradition, but later he adopted a more abstract style. Supported his painting by working as a commercial artist and began exuberant colour-field abstractions full-time only in last years of his life. Founding member of Painters Eleven, and one of the few of that group to establish himself internationally without leaving Canada: New York *Times* critic Hilton Kramer called Bush 'one of our best living painters.' One-man show at the Boston Museum of Fine Arts, 1972. Art Gallery of Ontario organized major retrospective exhibition of his work in 1976 which subsequently toured to Vancouver, Edmonton, Montreal, and Ottawa.

MORLEY CALLAGHAN (1903–), author. Born in Toronto, educated at University of Toronto and Osgoode Hall Law School, Toronto. Reporter for Toronto *Star*, 1923–8. Admitted to Ontario Bar, 1928. Lived in Paris, 1929, and New York, 1930. By 34, had produced eight novels, two books of short stories, numerous articles for magazines. Works include *Native argosy* (1929), *Broken journey* (1932), *Such is my beloved* (1934), *Luke Baldwin's vow* (1948), *The loved and the lost* (1951), *The many-coloured coat* (1960), *A passion in Rome* (1961), *A fine and private place* (1975), and *Close to the sun again* (1977). Governor General's Award, 1951; *Maclean's* Fiction Award, 1955; Lorne Pierce Medal for Literature of the Royal Society of Canada, 1960; Molson Award of the Canada Council, 1966–7; Royal Bank of Canada Award 1970.

MONSIGNOR MOSES MICHAEL COADY (1882–1959), priest and educator. Born in Margaree, Nova Scotia, and died at Antigonish, Nova Scotia. Educated at St Francis Xavier University, Acadami di D. Thomaso and Urban College, Rome. Instructor, 1910–25, at St Francis Xavier High School and University, Antigonish. Professor of Education, St Francis Xavier University, 1925–8. First Director of St Francis Xavier's extension program, 1928–52. Pioneered adult education among the fishermen of Maritime Provinces, and helped organize co-operatives and credit unions. Wrote about the Antigonish Movement in *Masters of their own destiny* (1939). Carnegie Award for Adult Education, 1936. Vice-president, American Association for Adult Education, 1944–5. President, Canadian Association for Adult Education, 1949–51.

TOLLER CRANSTON (1949–), figure skater believed by many responsible for revolutionizing the sport with his unique and balletic blend in movement. Born in Hamilton, Ontario; grew up in Kirkland Lake, Ontario, and suburbs of Montreal. Entered first skating competition in Stratford, Ontario, at age of nine and at 14 won the Canadian Junior Skating Championship. Six-time winner of the Canadian Senior Men's Championship. First in free-style division, World Championships, 1972 and 1974. Bronze medallist, 1974 World Championships and 1976 Olympic Games. Turned professional in 1976. Studied at École des Beaux Arts, Montreal; his kaleidoscopic paintings have been exhibited and bought worldwide. *A ram on the rampage*, illustrated by himself, was published in 1977.

THOMAS S. CULLEN (1868–1953), surgeon. Born in Bridgewater, Ontario. Graduated in medicine from University of Toronto. Specialized in gynaecology at Johns Hopkins University under the legendary Dr Howard A. Kelly, and subsequently himself became professor of gynaecology at that university. Wrote and taught extensively on embryology, anatomy, and diagnosis and treatment of clinical gynaecological conditions. Was first to recognize a number of diseases and their physical signs (e.g., Cullen's sign for ruptured ectopic pregnancy). His work on gynaecology

was the standard textbook for many years. Member and officer of medical, surgical, and gynaecological societies. Trustee and president, Enoch Pratt Library, Baltimore. Chairman, Chesapeake Bay Authority.

ROBERTSON DAVIES, CC, FRSC (1913–), author and educator. Born in Thamesville, Ontario; educated at Queen's University and Oxford. Joined the Old Vic Repertory Company in 1938 and later taught drama at the Old Vic Theatre School, England. After returning to Canada, became literary editor of *Saturday Night* in 1940, and in 1942 became editor and later publisher of the Peterborough *Examiner*. Early books include *Tempest-tost* (1951); *Leaven of malice* (1954), and *A mixture of frailties* (1958) as well as *Diary of Samuel Marchbanks* (1947). More recent books include the trilogy *Fifth business* (1970), *The manticore* (1972), for which he won the Governor General's Award, and *World of wonders* (1975); and *One half of Robertson Davies* (1977). Plays include *Fortune, my foe* (1949) and *Question time* (1975). Stephen Leacock Medal for humour, 1955. Lorne Pierce Medal for Literature of the Royal Society of Canada, 1961. Since 1961, has been Master of Massey College and Professor of English, University of Toronto.

YVON DESCHAMPS (1936–), monologuist and actor. Grew up in the poor St Henri district of Montreal, leaving school at eleven to work in the CBC record department. Later began taking acting lessons and during the next decade worked in theatre and television, played drums, opened a restaurant which went bankrupt. Presented his first monologue in 1968 and later that year performed at Place des Arts, Montreal. Produced his first album in 1969 and did 310 stage shows. Since 1968 has recorded 10 albums in French (average sales 40,000 each) and has performed in more than 1,200 live shows, mostly in Quebec and usually sold out. English debut, 1976, on the TV program '90 Minutes Live'; since then has acquired a manager in Los Angeles.

PAUL DESMARAIS, OC (1927–), industrial executive. Born in Sudbury, Ontario; educated at University of Ottawa. Took over Sudbury bus company in 1951 and within five years had it financially sound. In early 1960s acquired control of Gelco Corporation and shortly afterward bought control of Imperial Life Assurance Company of Canada. In 1965, sold other interests and eventually achieved control of Power Corporation of Canada Ltd, of which he is chairman and chief executive officer. Corporate interests include French-language daily newspapers, Canada Steamship Lines Ltd, Hilton of Canada Ltd, and Standard Brands Ltd.

RT HON. JOHN G. DIEFENBAKER, PC, CH (1895–), statesman and Prime Minister of Canada, 1957–63. Born in Neustadt, Ontario, but family moved to Saskatoon in 1903. Graduated from University of Saskatchewan. Elected to House of Commons for Lake Center, 1940, re-elected, 1945 and 1949; has represented Prince Albert since 1953. Leader of Conservative

Party of Saskatchewan, 1937–40. Elected leader of Progressive Conservative Party of Canada, 1956. Prime Minister, 1957–63. Leader of Her Majesty's Loyal Opposition, 1963–7. Honorary Freeman of the City of London, 1963. Has received numerous civic awards and honorary degrees. Three volumes of memoirs, *One Canada*, were published, 1975–7.

CYRUS EATON (1883–), financier and philanthropist. Born in Pugwash, Nova Scotia. Graduated from McMaster University. Went to U.S. and became active in operation of public utility properties, 1906–12. Organized Continental Gas and Electric Corporation, controlling a group of public utility companies in the Midwest, and thus came in contact with banking house of Otis and Co., of which he has been a director since 1915. Became interested in steel business in 1925 and after series of mergers formed Republic Steel Corp. Initiated Pugwash Intellectual Life Conferences, 1956, and International Pugwash Conferences of Nuclear Scientists, 1957. Lenin Peace Prize, 1960. Author of several books including *Financial democracy* (1941), *The professor talks to himself* (1942), *A capitalist looks at labor* (1947), *Canada's choice* (1959). Fellow, American Academy of Arts and Sciences.

ARTHUR ERICKSON, OC (1924–), architect. Born in Vancouver. Studied at University of British Columbia and McGill University. Served in Canadian Army Intelligence Corps in second world war in India and Malaya. Archaeological research in Mid-East, Mediterranean, Scandinavia, Britain, 1950–3. Taught at University of Oregon, 1955–6, University of British Columbia, 1956–64. Partner in Erickson, Massey since 1963. Numerous awards for architectural design of major buildings and residences. With Geoffrey Massey, won competition for design of Simon Fraser University, 1963. Major commissions also include MacMillan Bloedel Building, Vancouver; Man in the Community and Man and His Health, Expo 67, Montreal; Canadian Pavilion at Expo 70, Japan; Bank of Canada Building, Ottawa. Shared Molson Award of Canada Council, 1967. Royal Bank Award, 1971. Auguste Perret Award, International Union of Architects, 1975.

JOHN KENNETH GALBRAITH (1908–), economist and author. Born at Iona Station, Ontario. Studied at Ontario Agricultural College, University of California, Cambridge University. Taught economics at Harvard and Princeton universities. Deputy administrator, U.S. Office of Price Administration, 1941–3. Editor, *Fortune* magazine, 1943–8. Director, U.S. Strategic Bombing Survey, 1945. Director, Economic Security Policy, U.S. Department of State, 1946, and other government posts. Warburg Professor of Economics, Harvard University, since 1949. U.S. Ambassador to India, 1961–3. U.S. Medal of Freedom and President's Certificate of Merit. Author of numerous articles and several books, including *Modern competition and business policy* (1938), *A theory of price control* (1952), *The affluent*

society (1960). *The Scotch* (1964), *The new industrial state* (1967), *Economics and the public purpose* (1973), *Money* (1975) and *Age of uncertainty* (1977).

JEAN GASCON, CC (1920–), actor and director. Born in Montreal. Abandoned plans for a medical career, received a scholarship in dramatic art from the Government of France, and studied at École de Vieux Colombier. Founded Théâtre du Nouveau Monde, Montreal, 1951. Co-founder and director, National Theatre School, Montreal, 1960. Appointed associate director, Stratford Festival, Ontario, 1964, and artistic director, 1967. Recently appointed director of theatre at the National Arts Centre, Ottawa. Won Molson Award (for promoting better understanding between Canada's two founding cultures); Royal Bank Award, 1974.

GRATIEN GÉLINAS, OC, FRSC (1909–), producer, author, director, actor. Born at St Tite near Three Rivers, Quebec. Studied at Collège de Montréal and École des Hautes Études Commerciales, Montreal, before working in a department store and as insurance company accountant. In late 1930s established his reputation as author-star in French-language radio as 'Fridolin.' After 1941, devoted himself to theatre. His play *Tit-coq* opened in Montreal in 1948 and in two years broke all Canadian box office records; a movie of it was named best Canadian feature film of 1953. *Bousille et les justes* (1958) also was translated and well received by Canadian and U.S. audiences. Played Henry V at Stratford Shakespearean Festival and Edinburgh Festival, 1956. Founding member, National Theatre School of Canada, 1960; president, Canadian Theatre Institute, 1959–60; president, Association canadienne du théâtre amateur, 1950–61; vice-president, Greater Montreal Arts Council, 1957–62. Chairman, Canadian Film Development Corporation, 1969–78.

DONALD GORDON, CC, CMG, KGStJ (1901–1969), banking and transportation executive. Born in Old Meldrum, Scotland and educated at public schools in Scotland and Canada. Joined Bank of Nova Scotia in 1916, took extramural courses from Queen's University, eventually passed Canadian Bankers Association examinations. Secretary of the Bank of Canada, 1935, and deputy governor, 1938. Appointed chairman, Wartime Prices and Trade Board, responsible for rationing and price control in Canada, 1941. Returned to Bank of Canada, 1947, and in 1948 was made executive director, International Bank for Reconstruction and Development. Director of the Industrial Development Bank, 1944–9. Chairman and president of Canadian National Railways and director of Air Canada, 1950–66.

GLENN GOULD (1932–), pianist and composer. Born in Toronto; could read music at three years of age and at 11 entered Royal Conservatory of Music in Toronto, studying piano, organ, and composition. Received degree of Associate of the Royal Conservatory at 12 and was hailed as one of the most promising child pianists in North America. Made debut as

soloist with Toronto Symphony Orchestra in 1947, U.S. debut in Washington in 1955, and European debut in 1957 with Berlin Philharmonic. First North American pianist to appear in the Soviet Union, 1957. Bach Medal for Pianists, 1959. Molson Prize of the Canada Council, 1968. Has performed in over 30 recordings. Also writes on music, and has written and produced television and radio programs.

GREY OWL (Archibald Belaney) (1888–1938), author and conservationist. Born in Hastings, England. Emigrated to Canada about 1907 and (apart from war service in France, where he was wounded) for almost twenty years worked as trapper and guide in northern Ontario. Lived mainly with Indians at this time, was taken into their tribe, and adopted the name 'Grey Owl.' Later claimed to be part Indian and was publicly accepted as such, although no supporting evidence exists. Became ardent spokesman for conservation movement. Published in 1931 *The men of the last frontier*, followed by *Pilgrims of the wild* (1934), *The adventures of Sajo and her beaver people* (1935), *Tales of an empty cabin* (1936), and *The tree* (1937). Made two successful tours in England during which he performed before the King. Made a film starring two beavers, Jelly Roll and Rawhide. In final years lived in a cabin at Ajawaan Lake, Saskatchewan, as park warden.

LAWREN HARRIS (1885–1970), artist. Born in Brantford, Ontario. After one year at University of Toronto, studied art in Europe. Worked as illustrator for *Harper's* magazine but decided to devote himself entirely to painting. Helped plan and finance the Studio Building on Severn Street, Toronto, completed in 1914 as a workshop for the Group of Seven, of which he was a founding member, and other Canadian artists. First president of the Canadian Group of Painters, 1933, and one of the principal organizers and president of the Federation of Canadian Painters, 1944. First living artist to have a major one-man exhibition at the Art Gallery of Toronto, 1948. Always experimented with technique and subject matter; in later years adopted an abstract style. Best known paintings include *Above Lake Superior* (1922), *The ice house, Coldwell, Lake Superior* (1923), *North shore, Lake Superior* (1926), *Lighthouse, Father Point* (1930), *North shore, Baffin Island* (1930), *Equations in space* (1936), and *Composition #1* (1940).

GERHARD HERZBERG, CC, FRSC, FRS (1904–), physicist and Nobel Prizewinner. Born in Hamburg, Germany. Studied at Darmstadt Technical University and universities of Göttingen and Bristol. Taught at Darmstadt 1930–5, but with worsening political situation decided to emigrate to Canada. Research professor, University of Saskatchewan, 1935–45. Professor of spectroscopy, Yerkes Observatory, University of Chicago, 1945–8. Joined National Research Council, Ottawa, in 1948: director, Division of Physics, 1949–55; director, Division of Pure Physics, 1955–69; distinguished research scientist, 1969. Elected Chancellor, Carleton University, 1973. Author of over 200 scientific articles. Is considered world's

foremost molecular spectroscopist. Honours include Henry Marshall Tory Medal, Royal Society of Canada, 1953; Faraday Medal, Chemical Society of London, 1971; Linaus Pauling Medal, American Chemical Society, 1971. Awarded Nobel Prize in Chemistry, 1971, for 'his contributions to the knowledge of electronic structure and geometry of molecules, particularly free radicals.' (Free radicals are fragments of molecules which have extremely short lifetimes, measured in millionths of a second.)

CAMILLIEN HOUDE, CBE (1889–1958), mayor of Montreal for 18 years. Born in Montreal on a street so poor it was nameless. Started working at 11 in a butcher's shop, but also attended Collège de Longueuil and proved a brilliant student. In ten years after graduating rose from clerk to bank manager, then went into business for himself, trying several lines unsuccessfully. Represented St Mary's as Conservative in Quebec Legislative Assembly, 1923–7. In 1928, defeated 'invincible' Médéric Martin for mayoralty of Montreal, an office he held almost continuously until 1954. During second world war advised compatriots to ignore National Registration Act and was interned 1940–4. On release was greeted by cheering, weeping crowd of 100,000. Elected as Independent to House of Commons, 1949, but took little interest in federal politics and retired in 1954.

BRUCE HUTCHISON, OC (1901–), author and journalist. Born in Prescott, Ontario; raised and educated in Victoria, BC. Worked for Victoria *Daily Times* 1920–36, returning as editor, 1950–63. Associate editor, Winnipeg *Free Press*, 1944–50. Editorial writer and columnist for Vancouver *Sun*, 1938–44, returning in 1963 as editorial director. Considered one of Canada's foremost authorities on politics and economic affairs, a prolific writer of magazine articles, novels, and books. Governor General's Award for non-fiction, 1942, for *The unknown country*. Other books include *The incredible Canadian* (1952); *Canada: tomorrow's giant* (1957); and *Canada: a year of the land* (1967). President's Medal, University of Western Ontario, 1953. Lorne Pierce Medal, 1955. First winner of award for distinguished journalism in the Commonwealth, given by Royal Society of Arts, London. Elected member of Canadian News Hall of Fame, 1968.

WILLIAM HUTT, CC (1920–), actor and director. Born and educated in Toronto. Acting career began in Hart House Theatre, University of Toronto, and professional career began in Bracebridge, Ontario, with summer stock in 1949. Joined Stratford, Ontario, Shakespearean Festival Company in 1953 and next year was first actor to win Tyrone Guthrie Award. Made several tours with the Canadian Players; has acted on Broadway and in England, Europe, and Australia. Appointed associate director of the Stratford Festival, 1970. Earl Grey ACTRA award for best TV performance, 1975, for portrayal of Sir John A. Macdonald in 'The National Dream.'

A.Y. JACKSON, CC, CMG (1882–1974), longest lived artist of the original Group of Seven. Born in Montreal. Worked in lithographing as a youth and studied art at evening classes; later studied in Paris at Julien Academy and in Chicago at Art Institute. In 1913, his painting *The edge of the maple wood* brought him to the attention of other 'Group' painters and he became the link between Toronto-based and Montreal-based members. Served in first world war with Canadian infantry and later as an official artist for Canadian War Memorials. Painted landscapes all over Canada including many trips to the Arctic. Paintings include *A lake in Labrador* (1930), *Algoma rocks* (1923), *Gem Lake* (1941), *Arctic summer* (1952), *Islands, Georgian Bay* (1954). His autobiography, *A painter's country*, was published in 1958.

NORMAN JEWISON (1926–), producer and director. Born in Toronto; worked his way through University of Toronto, then moved to London where he wrote scripts and acted for the BBC. On return to Toronto became leading director of CBC TV programs, 1952–8. Directed CBS TV musical-variety shows in New York, 1958–61, featuring such performers as Judy Garland, Frank Sinatra, Danny Kaye, Harry Belafonte, Andy Williams. Success led to contracts with Universal Studios, MGM, and United Artists and Mirisch Corporation. Directed Academy Award winning *In the heat of the night* (1967); produced and directed *Fiddler on the roof* (1971), *Jesus Christ Superstar* (1974), *Rollerball* (1975), and *F.I.S.T.* (1978). Has won Emmy Award (1960), TV Directors Award (1961), Golden Globe Award (1966).

CLAUDE JUTRA (1930–), actor and film-maker. Born in Montreal; graduated in medicine from University of Montreal but never practised. Instead became student actor at Théâtre du Nouveau Monde, Montreal, and then at Cours Simon, Paris. His first film, *Mouvement perpetuel* (1949), received Canadian Film Award, amateur category, in 1949 and a prize at the Cannes Film Festival, 1950. His TV series *L'École de la peur* (1950) won the Prix Frignon. In 1955, began work with the National Film Board of Canada, and there made several prize-winning films including *Les mains nettes* (1958), *À tout prendre* (1963), and *Comment savoir* (1966). *Mon oncle Antoine* won eight Etrogs at the Canadian Film Awards in 1971 and was judged best picture at the Chicago Film Festival. *Kamouraska* followed in 1975. An ardent Quebec cultural nationalist and separatist, Jutra declined in 1972 the award of Officer of the Order of Canada. The same year he was awarded the Victor Morin Prize by the St Jean Baptiste Society in Montreal for competence and wide influence on the part of professionals of stage, film, or theatre.

KAREN KAIN, OC (1951–), ballerina. Born in Hamilton, Ontario. Entered National Ballet School at age of 11; graduated to corps de ballet, National Ballet of Canada, 1969. Became principal dancer in her second season on undertaking role of Swan Queen in *Swan Lake*. Danced Aurora in *Sleeping*

beauty, 1972; *Giselle*, 1974. At Moscow International Ballet Competition, 1973, won silver medal for women soloists and, with Frank Augustyn, first prize for pas de deux. Has appeared with Rudolf Nureyev several times, and has performed in England, Australia, U.S., and France. With Augustyn, danced *Giselle* at Bolshoi Theatre, Moscow, 1977.

KENOJUAK, CM (1927–), printmaker, artist, sculptor. Born near Cape Dorset. Moved constantly from camp to camp as a child with her three sisters and many brothers. Spent five years in sanitorium and lost eleven of her fourteen children. Her images are usually of animals – owls, birds, bears – full of life, laughing, dancing, even kissing. One of her most famous sculptures is *Two bears kissing*.

RT HON. WILLIAM LYON MACKENZIE KING, PC, CMG, OM (1874–1950), Prime Minister of Canada, 1921–6, 1926–30, 1935–48. Born in Berlin (Kitchener), Ontario; educated at University of Toronto and Harvard University. First Canadian deputy minister of labour, 1900–8. Elected to Parliament 1908 and served as Canada's first Minister of Labour, 1909–11. Director of industrial research for the Rockefeller Foundation, 1914. Elected leader of the Liberal Party of Canada, 1919, and won the 1921 election. Except for a few months in 1926, and the period 1930–5, he remained in power until his retirement in 1948, thus holding power longer than any previous prime minister in the British Commonwealth. First Canadian to receive the Order of Merit, 1947. Writings include *The secret of heroism* (1906), *Industry and humanity* (1918), *The message of the carillon and other addresses* (1927), *Canada at Britain's side* (1941).

MARGARET LAURENCE, CC (1926–), author. Born in Neepawa, Manitoba; educated at United College, Winnipeg; first writing job was as reporter and book reviewer with Winnipeg *Citizen*, 1947. Has lived in England, Canada, Somaliland, Ghana, Greece, Crete, Palestine, India, Egypt, Spain. First works reflected her sojourn in Africa. Best known books are *The stone angel* (1964), *A jest of God* (1966), and *The diviners* (1974): last two both earned Governor General's Awards. Also wrote *The fire dwellers* (1969), *A bird in the house* (1970), and *Jason's quest* (1970). Has won several other awards and in 1975 was a co-winner of the Molson Prize. *Jest of God* was produced as a film, *Rachel, Rachel*, in 1968.

STEPHEN LEACOCK, FRSC (1866–1944), political economist, humorist. Born in Swanmore, England. Came to Canada at an early age and was educated at University of Toronto and University of Chicago. Taught at Upper Canada College, Toronto (where he had gone to school), 1889–99. Joined McGill University, Montreal, 1903, and headed its Department of Economics and Political Science, 1908–36. Wrote more than sixty books, including such serious works as *Elements of political science* (1906) and *The British Empire* (1940), but received greatest recognition as a humorist for

works including *Literary lapses* (1910) and *Sunshine sketches of a little town* (1912). Has been translated into many languages including Gujarati and Japanese. Also wrote two biographies of humorists, *Mark Twain* (1932) and *Charles Dickens* (1933).

HIS EXCELLENCY RT HON. JULES LÉGER, CC, CMM (1913–), diplomat, and since 1974 Governor General and Commander-in-Chief of Canada. Born in Saint-Anicet, Quebec, and attended University of Montreal and University of Paris. Editor, Ottawa *Le Droit*, 1938–9. Joined Department of External Affairs, 1940. Professor of the history of diplomacy, University of Ottawa, 1939–42. Posted in Chile, 1943–7, and in London as first secretary, 1947–8. Advisor to the Canadian delegation to the UN General Assembly, 1948. Executive assistant to the Prime Minister, 1949–50. Assistant Under-Secretary of State for External Affairs, 1951–3. Ambassador to Mexico, 1953–4. Under-Secretary of State for External Affairs, 1954–8. Permanent Representative to the NATO Council, 1958–62. Ambassador to Italy, 1962–4. Ambassador to France, 1964–8. Under-Secretary of State with responsibility in the field of arts, bilingualism, education, and citizenship, 1968–73. Ambassador to Belgium and Luxembourg, 1973–4.

HIS EMINENCE, PAUL-ÉMILE CARDINAL LÉGER, CC, KHS (1904–), priest. Born in Valleyfield, Quebec. Educated in Montreal and Paris. Ordained 1929 as member of the Sulpician Order. Taught philosophy at Sulpician Seminary, Fukuoka, Japan (which he founded), 1933–9, and at Sulpician Seminary, Montreal, 1939–40. Vicar-General of the Diocese of Valleyfield, 1940–7. Rector of Pontifical Canadian College, Rome, 1947–50. Archbishop of Montreal, 1950–67. On 12 January 1953, Pope Pius XII created him Cardinal, the sixth in Canada. Served on the central preparatory commission to the Second Vatican Council, 1962–5. Left Canada for Africa in 1967 to begin missionary work with lepers. Royal Bank of Canada Award for service to humanity, 1969. Returned to Canada in 1974 and was re-appointed a parish priest in the Montreal parish of Ste Madeleine Sophie.

JEAN-PAUL LEMIEUX (1904–), artist and illustrator. Born in Quebec. Educated at Collège Loyola, Montreal, Colarossi and Grand Chaumière academies, Paris, and École des Beaux-Arts, Montreal. Taught at École du Meuble, Montreal, 1935–6, and École des Beaux-Arts, Quebec, 1937–64. One-man shows at Palais Montcalm, Quebec (1953); Roberts Gallery, Toronto (1963); Montreal Museum of Fine Arts (1967). Seventy of his paintings toured Moscow, Leningrad, and Paris in 1974. Group exhibitions at Musée d'Art Moderne, Paris (1946), São Paulo Biennial, Brazil (1957); Brussels International Exhibition (1958); Venice Biennial (1960), Musée Galliera, Paris (1960). Awards include Prix Brymner, 1934; Prix Philippe Hébert of the Saint-Jean-Baptiste Society, 1971; Molson Prize of the Canada Council, 1973.

HON. RENÉ LÉVESQUE (1922–), journalist and politician. Born in the Gaspé. Educated at Laval University. Stopped study of law to work as radio announcer; joined CBC International Service and covered Korean War, 1951. Director, news service, Radio Canada. Became freelance, 1956, and with his program 'Point de mire' became Quebec's best known and most outspoken broadcaster. Elected as Liberal to Quebec legislature for Mont-réal-Laurier, 1960; Minister of Public Works 1960–61; Minister of Natural Resources, 1961–6. Resigned from Liberal Party, 1967, and following year was elected leader of the new Parti québécois. In 1968, his book *Option Québec* was published. Defeated in 1970 provincial election and returned to journalism while remaining active as PQ leader. In 1976, the Parti québécois was elected the government of Quebec with him as Premier.

MONIQUE LEYRAC, CC (1932–), chanteuse. Born in Montreal. Trained in elocution and studied theatre with Jeanne Maubourg in Montreal; made her debut as actress in 1944 as Ste Bernadette on CBC radio. In 1955, Jean Gascon invited her to join Théâtre du Nouveau Monde, where she acted until 1966: performed in *Three-Penny Opera*, *Le Malade Imaginaire*, and *Bérénice*, among others. Called 'Piaf of Canada'; is probably country's best known chanteuse. In 1965, won first prize for her rendition of Gilles Vigneault's song *Mon pays* at the International Song Festival, Sopot, Po-land, and first prize at another contest in Ostend, Belgium. Has made countless radio and television appearances and recorded for Columbia Records.

HON. PETER LOUGHEED (1928–), statesman. Born in Calgary and educated at University of Alberta and Harvard Business School. Played professional football for two years with Edmonton Eskimos. Practised law in Calgary, 1955–6. Joined Mannix Company Ltd, construction firm, 1956, and was named vice-president in 1959 and director in 1960. Started private legal practice, 1962. Elected leader of the Progressive Conservative Party in Alberta, 1965 and represents the constituency of Calgary West. Since 1971 has been Premier of Alberta.

HUGH MacLENNAN, CC (1907–), novelist and university professor. Born in Glace Bay, Nova Scotia; educated at Dalhousie, Oxford, and Princeton universities. Head of Classics Department, Lower Canada College, Montreal, 1935–45, part-time associate professor of English at McGill University, 1951–64, appointed full-time in 1966. Won Governor Gener-al's Awards for fiction for *Two solitudes* (1945), *The precipice* (1948), and *The watch that ends the night* (1959); Governor General's Awards for non-fiction for *Cross-country* (1949) and *Thirty and three* (1954). Other books include *Barometer rising* (1941), *Each man's son* (1951), and *Seven rivers of Canada* (1961). Lorne Pierce Medal for Literature, 1952; Molson Prize, 1966.

SIR ERNEST MacMILLAN, CC, KT (1893–1973), conductor, composer, statesman of Canadian music. Born in Mimico, Ontario. Studied at University of Toronto, in Edinburgh and Paris; Doctor of Music, Oxford University. Became Associate of the Royal College of Organists at 13 and Fellow of that body four years later, receiving Lafontaine prize for highest marks awarded. Principal of the Toronto Conservatory of Music, 1926–42. Conductor of the Toronto Symphony Orchestra, 1931–56, and conductor of the Toronto Mendelssohn Choir, 1942–57. Dean, Faculty of Music, University of Toronto, 1927–52. President of the Canadian College of Organists, 1927–8, of the Canadian Music Council, 1947–66, of Jeunesses musicales du Canada, 1961–3, and of the Canadian Music Centre, 1959–70. Editor of *Music in Canada* 1955, and author of numerous essays and musical textbooks as well as being teacher, lecturer, and adjudicator. First person in the Commonwealth, outside United Kingdom, to be knighted for services to music, 1935. Fellow of the Royal College of Music, 1931; Honorary Member of the Royal Academy of Music, London, 1938.

KAREN MAGNUSSEN, OC (1952–), world champion figure skater. Born and educated in Vancouver. Canadian Junior Singles Champion, 1965; Canadian Senior Ladies Singles Champion, 1968, 1970, 1971, 1972, 1973; North American Singles Champion, 1971. Silver medallist in 1972 Olympics, Sapporo, Japan. World Women's Singles Figure Skating Champion, 1973, Bratislava, Czechoslovakia. In 1973, turned professional and joined the Ice Capades as the highest paid performer in the show's history. Retired in 1977. Canada's Female Athlete of the Year, 1971, 1972, 1973, and in 1972 also won the Vanier Award for Canada's Outstanding Young Canadian and the Special Achievement Award, Sons of Norway of America.

RT HON. VINCENT MASSEY, PC, CC, CH (1887–1967), statesman and Canada's first native-born Governor General. Born in Toronto. Studied at University of Toronto and Oxford. Taught history at University of Toronto, 1913–15. Associate secretary to the War Committee of the Cabinet, 1918. President of the Massey-Harris Co., 1921–5. Returned to Ottawa in 1925 to serve as Minister without portfolio. Attended Imperial Conference, 1926. First Canadian Minister to the United States, 1926–30. High Commissioner of Canada in the United Kingdom, 1935–46, during which time he became a trustee and later chairman of the National Gallery and a trustee of the Tate Gallery. Chairman of the Royal Commission on National Development of the Arts, Letters, and Sciences, 1949–51. Chancellor of the University of Toronto, 1947–53. As Governor General from 1952 to 1962, travelled about 200,000 miles across Canada by all means from planes to dog sled. His memoirs, *What's past is prologue*, were published in 1963.

NORMAN MCLAREN, OC (1914–), film-maker and animator. Born in Stirling, Scotland. Studied interior design at Glasgow School of Fine Art, but by 1935 interests had switched to film. Made several independent films and served as cameraman for a Spanish Civil War documentary. Directed with British General Post Office Film Unit, 1937–9. In 1941, on invitation of John Grierson, joined National Film Board of Canada and until 1943 was engaged in building its animation unit. Unesco sent him to China in 1949 to determine the usefulness of films for teaching health rules, and to India in 1952–3 to train film workers for educational programs. Award winning films include *Begone dull care* (1949), *Neighbours* (1952), *Blinkity-blank* (1955), *Chairy tale* (1957), *Pas de deux* (1968) which won more than 17 prizes, *Ballet adagio* (1971), and *Narcissus* (1974). Has won 147 awards for short films, more than any other film-maker in screen history. Awarded first medal of Royal Canadian Academy of Arts, 1963; Molson Prize, 1971.

MARSHALL MCLUHAN, CC (1911–), author, university professor, communications specialist. Born in Edmonton; educated at University of Manitoba and Cambridge University. Professor of English at University of Toronto since 1946, and director of Centre for Culture and Technology there since 1963. Works include *The mechanical bride* (1951), *The Gutenberg galaxy* (1962), *Understanding media* (1964), *The medium is the massage* (1967), *War and peace in the global village* (1968), and *Culture is our business* (1970). Has received numerous awards and honours including the Governor General's Award (1963); Carl-Einstein-Preis, West Germany, 1967; Canada Council Award for outstanding achievement in the social sciences, 1967; Gold Medal Award from the President of the Italian Republic, 1971; Creative Leadership in Education Award, University of New York, 1977.

A.G.L. MCNAUGHTON, PC, CH, CB, CMG, DSO, CD (1887–1966), scientist and soldier. Born at Moosomin, Saskatchewan. Studied engineering at McGill University. Lectured in that subject there. Joined Royal Canadian Artillery, 1910, and was Major at outbreak of war. By 31 was Brigadier commanding Canadian Artillery. Chief of Canadian General Staff, 1929–35. President, National Research Council of Canada, 1935–44. In 1939 appointed Major General commanding 1st Division, Canadian Overseas Force, during period of intensive training that led to Canadian service in Italy and Northwest Europe. Returned to Canada as Minister of National Defence, 1944. Chairman, Canadian section, Canada-U.S. Permanent Joint Board on Defence, 1945–59. Canadian representative, United Nations Atomic Energy Commission, 1946–9, and president, Atomic Energy Commission of Canada, 1946–8. Chairman, Canadian section, International Joint Commission, 1950–62.

SIR WILLIAM MULOCK, PC, KCMG (1843–1944), statesman and judge. Born in Bond Head, Ontario; attended Newmarket Grammar School and University of Toronto. Quickly became a leading Ontario lawyer, and in 1882 was

elected as a Liberal to represent North York in the House of Commons – a seat he held without a break until 1905. As Postmaster-General of Canada, 1896–1905, was responsible for 'imperial penny postage' within the British Empire. First Canadian Minister of Labour, 1900. Chief Justice of the Exchequer Division of the Supreme Court of Canada, 1905–1923. Chief Justice of Ontario, 1923–36. Vice-chancellor of the University of Toronto, 1881–1900, and Chancellor, 1924–44.

GRATTAN O'LEARY (1889–1976). Born at Percé, Quebec. Formal education ended with elementary school; worked in an iron works and in a hardware store. Joined Saint John *Standard*, 1909, as reporter, and Ottawa *Journal*, 1911. Covered world events including sinking of *Titanic*, 1921 Disarmament Conference, 1945 Potsdam Conference. Member of Ottawa Press Gallery, 1911–25; contributed to Canadian, U.S., British, Australian publications. President of The Journal Publishing Company Limited, 1957–62. A staunch Conservative, he was appointed in 1962 to the Senate, where he advocated Senate reform. Chairman, Royal Commission on Publications, 1961. Retired as editor of Ottawa *Journal* in 1963 and in 1966 was named editor emeritus. Canadian News Hall of Fame, 1967. Rector of Queen's University, 1967–8. His memoirs, *Grattan O'Leary: recollection of people, press and politics*, were published posthumously, 1977.

TOM PATTERSON, OC (1920–), theatrical director. Born in Stratford, Ontario. After graduating from University of Toronto, negotiated with Stratford's civic administration and local citizens and in 1952 founded the Stratford Shakespearean Festival based on a boyhood dream of an international festival in his home town. As the Festival expanded and developed, held a series of posts including general manager, planning consultant, and director of public relations. Left the Festival in 1969 but was retained as consultant. With actor-director Douglas Campbell, formed Canadian Players Ltd in 1954 and formed Canadian Theatre Exchange Ltd in 1960. Now permanent consultant to Sarnia Ontario Arts Foundation, consultant to Dawson City Festival Foundation, and Governor of the National Theatre School.

RT HON. LESTER BOWLES PEARSON, PC, CC, OBE (1897–1972), Prime Minister of Canada 1963–8, Nobel Prizewinner, world statesman. Born in Newtonbrook, Ontario. Studies at University of Toronto were interrupted by first world war in which he served as stretcher bearer and later in Royal Flying Corps. Completed studies at Toronto and Oxford. Taught modern history, University of Toronto, 1924–8. Joined fledgling Department of External Affairs, 1928. Served in office of High Commissioner for Canada in London, 1935–8. Assistant Under-Secretary of State for External Affairs, 1941–2. Minister at Canadian Legation in Washington 1942–5; Ambassador to the United States, 1945–6. Under-Secretary of State for External Affairs, 1946–8. Elected to Parliament (Liberal) from Algoma

East, 1948. Secretary of State for External Affairs, 1948–57. Chairman of the NATO Council, 1951–2. President of the United Nations General Assembly, 1952–3. Nobel Peace Prize, 1957, for his efforts in the formation of the UN Emergency Force that ended the military intervention of Britain and France in the Suez dispute between Egypt and Israel. Leader of the Liberal Party, 1958–68, and Prime Minister 1963–8. Chairman of the World Bank Commission on International Development, 1968–9. Chancellor of Carleton University, 1969–1972; Chancellor of Victoria University, Toronto, 1951–8. Honours included 48 honorary degrees; Human Relations Award of the National Conference of Christians and Jews, 1963; Temple University Peace Award, 1965; Family of Man Award, New York, 1965; Victor Gollancz Humanity Award, 1972. Books include *Democracy in world politics* (1955), *Diplomacy in the nuclear age* (1959), *The four faces of peace* (1964), *The crisis of development* (1970), *Words and occasions* (1970), and three volumes of memoirs entitled *Mike* (1972–5).

ALFRED PELLAN, CC (1906–). Artist, sometimes called Canada's first truly modern painter. Born in Quebec. Educated at École des Beaux-Arts, Montreal, École Supérieure des Beaux-Arts de Paris, Grand Chaumière and Académie Colarossi, Paris. Remained in France until 1940. Associated with Picasso, Léger, Miró. Returned to Canada and taught at École des Beaux-Arts, Montreal, 1943–52; his ideas caused considerable reform in teaching methods. Official representative of Canada at the Chicago Art Institute, Illinois. Full scale retrospective exhibit of his work in Quebec City, Montreal, Ottawa, 1972–3. Honours include first prize, First Great Exhibition of Mural Art, Paris, 1935; National Award in Painting and Related Arts, University of Alberta, 1959; Canada Council Medal, 1965; Molson Prize of Canada Council, 1972; and Prix Philippe Hébert of the St Jean Baptiste Society, 1972.

WILDER PENFIELD, CC, OM, CMG, KStJ, FRS, FRSC (1891–1976), neurologist. Born in Spokane, Washington. Educated at Princeton, Johns Hopkins, and Oxford universities; postgraduate work throughout Europe. Held posts at Columbia University, Presbyterian Hospital, New York, New York Neurological Institute, and Vanderbilt Clinic before coming to Canada in 1928. Founded Montreal Neurological Institute, one of most highly regarded centres for brain surgery in the world, and directed it 1934–60. Neurosurgeon, Royal Victoria and Montreal General Hospitals, Montreal, 1928–60. Professor of Neurology and Neurosurgery, McGill University, 1933–54. President, Vanier Institute of the Family, 1965–8. Author of numerous medical books plus two successful novels, *No other gods* (1954) and *The torch* (1960), and a collection of essays, *The second career* (1963). Many honours included Lister Medal, Royal College of Surgeons, 1961; Jacoby Medal, 1953; Starr Award, Canadian Medical Association, 1965; The Society of the Family of Man Award for Science, 1967; Gold Medal, Royal Society of Medicine (London), 1968.

NADIA POTTS (1949–), dancer. Born in England, but came to Canada when she was four and started classes with the National Ballet School when she was seven. In 1966, her first season with the National Ballet company, was chosen to dance the difficult third variation in *Bayaderka* and in her second season danced leading roles in *The nutcracker* and *Cinderella*. Promoted to soloist in 1968 and to principal in 1969. With Clinton Rothwell won prize for best pas de deux at International Ballet Competition at Varna, 1970, and received bronze medal for solo dance. Danced with Baryshnikov in 1975 and as Giselle with Nureyev, 1976.

JEAN-PAUL RIOPELLE, CC (1923–), painter. Born in Montreal, but has lived in Paris since 1947. One-man shows in Paris, New York, and London; chosen for the Younger European Painters Exhibition at the Guggenheim Museum, New York, 1953–4. In 1961 his paintings were selected for showing at the 42nd Pittsburgh International Exhibition (inaugurated by Andrew Carnegie to show 'old masters of tomorrow'); his works are in the Tate Gallery of London, the National Gallery of Canada, and in many private collections. Canada Council Medal, 1966.

EDGAR RITCHIE, CC (1916–), diplomat. Born in Andover, New Brunswick; educated at Mount Allison University and Oxford. Ministry of Economic Warfare Mission (British Embassy), 1942–4. Joined Department of External Affairs, 1944; posted in Washington 1944–6. Special assistant to the Assistant Secretary-General, Economic Affairs Department, UN, 1946–7, and special assistant to the Executive Secretary of the UN Preparatory Committee and Conference on Trade and Employment, 1947–8. Served in Canadian High Commissioner's Office, London, 1948–52. Assistant Under-Secretary of State for External Affairs, 1959–64; Deputy Under-Secretary, 1964–6. Ambassador to the United States, 1966–9. Under-Secretary of State for External Affairs since 1970. Regent of Mount Allison University.

GORDON ROBERTSON, FRSC (1917–), civil servant and diplomat. Born in Davidson, Saskatchewan; attended University of Saskatchewan, Oxford University, and University of Toronto. Joined Department of External Affairs, 1941. Assistant to the Under-Secretary of State for External Affairs, 1943–5. Secretary to the Office of Prime Minister, 1945–9. Member of the Cabinet Secretariat (Privy Council Office), 1949–51; Assistant Secretary to the Cabinet, 1951–3. Deputy Minister of Northern Affairs and National Resources and Commissioner of the Northwest Territories, 1953–63. Clerk of the Privy Council and Secretary to the Cabinet, 1963–75. Secretary to the Cabinet for Federal-Provincial Relations since 1975. Vanier Medal of the Institute of Public Administration of Canada.

CLAUDE RYAN (1925–), journalist, publisher, politician. Born in Montreal. Attended University of Montreal and Pontifical Gregorian University,

Rome. General secretary of Action catholique canadienne, 1945–62. Joined Montreal *Le Devoir* in 1962 as editorial writer; in 1964 became publisher, and managing director of Imprimerie Populaire Ltée. President, Institut canadien d'éducation des adultes, 1955–61. Human Relations Award, Canadian Council of Christians and Jews, 1966. Elected to Canadian News Hall of Fame, 1968. In January 1977, resigned from *Le Devoir* to seek successfully the leadership of the Liberal Party of Quebec.

B.K. SANDWELL, FRSC (1876–1954), author and editor. Born in Ipswich, England, but came to Canada as a child. Educated at University of Toronto. Joined staff of Toronto *News*, 1897. Drama editor, Montreal *Herald*, 1905–11. Editor, *Financial Times*, Montreal, 1911–18. Taught economics at McGill University, 1919–23. Head of Department of English, Queen's University, 1923–5. Best remembered as editor of *Saturday Night* magazine, Toronto, 1932–51. First secretary of Canadian Authors Association, 1920. Author of *The privacity agent, and other modest proposals* (1928), *The Molson family* (1933), *The Canadian people* (1941), and *The diversions of Duchesstown, and other essays* (1955).

SIR CHARLES SAUNDERS, FRSC (1867–1937), cerealist. Born in London, Ontario, and educated at University of Toronto, Johns Hopkins University, and Sorbonne. Also studied singing in Toronto and New York. Dominion cerealist at the Experimental Farms, Ottawa, 1903–22. There he developed Marquis Wheat in 1904, working on a cross developed in 1892 by his brother, Dr Percy Saunders. Millions of acres in the west were seeded with it in following years: an improved variety bears his name. Also developed Ruby, Garnet, and Reward wheats for special prairie conditions. Retired from civil service in 1922 for reasons of health. Awarded Royal Society of Canada's first Flavelle Medal, 1925. Keen student of French; wrote *Essais et vers* (1928).

BARBARA ANN SCOTT (1928–), figure skating champion. Born in Ottawa. At 11 was youngest skater to win Canadian Junior Championship; held Canadian Senior title, 1944–8. Also youngest continental ice champion, winning North American title, 1945 to 1948. World and European figure skating championships, 1947 and 1948, and Olympic gold medallist, St Moritz, 1948. Lou Marsh Memorial Trophy for the Outstanding Canadian Sports Competitor in 1945, 1947, 1948. Canadian Press named her Canada's Outstanding Athlete of the Year, 1947. Turned professional in 1948 and succeeded Sonja Henie in the Hollywood Ice Revue, 1951–5. Married Tom King in 1955 and now lives in Chicago. Competes often in U.S. horse shows.

DUNCAN CAMPBELL SCOTT, CMG, FRSC (1862–1947), author and poet. Born in Ottawa and educated there and at Wesleyan College, Stanstead. Entered civil service aged 17 in Department of Indian Affairs as clerk. Chief

accounting clerk, 1893–1909; superintendent of Indian education, 1909–13; deputy superintendent general, 1913–32. Contributed to 'At the Mermaid Inn,' column in Toronto *Globe*, 1892–3. Started writing in 1882, and in 1893 his first collection of poems was published, *The magic house and other poems*. Eight further volumes of poetry followed, and two collections of short stories and a book of prose and verse. President of the Royal Society of Canada, 1921–2, and winner of its Lorne Pierce Medal, 1927. President, Canadian Authors Association, 1931–3. President, Ottawa Drama League, 1925. Served on the board of Canadian Writers Foundation and Dominion Drama Festival. Fellow of the Royal Society of Literature of Great Britain.

FRANK R. SCOTT, CC, FRSC (1899–), educator and poet. Born in Quebec and educated at Bishop's College, and Oxford, McGill, and Harvard universities. After two years of practice with a Montreal law firm, joined McGill University in 1928 teaching federal and constitutional law, rising to professor of civil law in 1934 and dean of the Faculty of Law, 1961–4. Became known as a champion of civil rights. President of Quebec section of the Co-Operative Commonwealth Federation, 1935–6. Chairman of the Legal Research Committee of the Canadian Bar Association, 1954–6. Co-founder of *Preview* (1942–4) and editor of *Northern Review* (1945–7). Chairman of the Canadian Writers Conference, Queen's University, 1955. Member of the Royal Commission on Bilingualism and Biculturalism, 1963–71. Writings include *The eye of the needle* (1957), *Poems of Garneau and Hébert* (translation, 1962), *Signatures* (1964), *Selected poems* (1966), *Trouvailles* (1967). His *Essays on the constitution* won the Governor General's Award for non-fiction in 1977. Other honours include Canada Council special service award, 1960; Lorne Pierce Medal, 1962; Quebec Government literature prize, 1964 and 1967; Molson Award of the Canada Council, 1964.

HANS SELYE, CC, KStJ, FRSC (1907–), research scientist, internationally noted for his studies of stress in humans. Born in Vienna; studied medicine at the German University of Prague. Rockefeller Research Fellow, Johns Hopkins University, 1931. Appointed to staff of McGill University in 1933, rising to associate professor. Since 1945, professor and director of the Institute of Experimental Medicine and Surgery, University of Montreal. Expert consultant to the Surgeon-General, U.S. Army, 1947–57. Director, Scientific Council, American Foundation for High Blood Pressure. Holds many honours. Has written and published over 1100 scientific papers relating to his research as well as many books, including *Stress without distress* (1974), *Stress in health and disease* (1975), *The stress of my life* (1977).

GORDON SINCLAIR (1900–), journalist, broadcaster, author. Born and educated in Toronto. After less than one year of high school worked as

bank clerk and bookkeeper before enlisting as a private in 1917. After brief postwar stints in a calendar factory, slaughterhouse, and rubber company, joined Toronto *Daily Star* in 1923. As wandering reporter on special assignment, travelled more than 360,000 miles around the globe, and wrote *Footloose in India* (1932), *Cannibal quest* (1933), *Loose among devils* (1935), and *Khyber caravan* (1940). Resigned in 1943 to be freelance radio broadcaster. Joined CFRB News Department in 1944 and still works there. In 1957, became a member of CBC 'Front Page Challenge' which in 1966 became the country's oldest continuing TV network program. Recent books include *Will the real Gordon Sinclair please stand up* (1966) and *Will Gordon Sinclair please sit down* (1975). Named to Canadian News Hall of Fame, 1972; H. Gordon Love News Trophy from the Canadian Association of Broadcasters, 1974; Distinguished Service Award of the Radio and Television News Directors Association, 1974, for 'challenging and courageous commentary.'

HON. JOSEPH R. SMALLWOOD, PC (1900–), politician, writer, historian, union organizer, broadcaster. Born in the outport of Gambo, Newfoundland. Spent most of his formative years at Bishop Field College School, St John's, but left at 15 to become a printer's apprentice. Worked as reporter for St John's *Evening Telegram*, Halifax *Herald*, New York *Times*. In New York studied at Labour Temple and Rand School of Social Science. Returned to St John's where he became editor of *Daily Globe* and during 1920s organized trade unions and co-operative societies. Led campaign to bring Newfoundland into Confederation with Canada, and served in two delegations discussing terms of union. Organized and led Liberal Party in Newfoundland and was Premier of that province, 1949–72. Resigned from Newfoundland legislature, 1977. Wrote: *Coaker of Newfoundland* (1926); *The new Newfoundland* (1932), *The book of Newfoundland* (1937 and 1967); *Newfoundland handbook, gazetteer and almanac* (1940), *Life and letters of Dr William Carson* (1940), *Surrogate Robert Carter* (1940), and his memoirs, *I chose Canada* (1973).

ARNOLD SMITH, CH (1915–), diplomat. Born in Toronto; studied at University of Toronto and Oxford University. Editor of *The Baltic Times*, Tallinn, Estonia, 1938–40 and at same time associate professor of political economy, University of Tartu, and attaché, British Legation, Tallinn. Attaché, British Embassy, Cairo, 1940–3. Secretary of Canadian Embassy, Moscow, 1943–5. Member of Economics Division, Department of External Affairs, and advisor on various committees. Associate director, National Defence College, 1947–9. Principal advisor, Canadian delegation to UN, 1949. Posted in Brussels, 1949–53. Special assistant to the Secretary of State for External Affairs, 1953–5. Canadian commissioner on International Truce Supervisory Commission for Cambodia, 1955–6. Canadian Minister to UK, 1956–8. Ambassador to United Arab Republic, 1958–60. Ambassador to USSR, 1961–3. Assistant Under-Secretary of State for Ex-

ternal Affairs, 1963–5. First permanent Secretary-General of the Commonwealth, 1965–75. Lester Pearson Professor of International Affairs, Carleton University, since 1976. Vice-president (Life), Royal Commonwealth Society. R.B. Bennett Commonwealth Prize, Royal Society of Arts, 1975.

P.A. TAVERNER, FRSC (1875–1947), ornithologist and naturalist. Born in Guelph, Ontario; educated at schools in Port Huron and Ann Arbor, Michigan. Worked in architects' offices in Chicago and Detroit, 1900–10. From an early age was fascinated by bird life, and in Detroit formed first bird-banding organization in North America. Appointed to staff of the National Museum, Ottawa, as ornithologist, in 1910. Visited many remote areas of Canada in search of specimens and built a major study collection. Wrote *Birds of eastern Canada* (1919), *Birds of western Canada* (1926), *Birds of Canada* (1934), *Canadian land birds* (1939), and *Canadian water birds* (1939) plus many articles. Fellow of the American Ornithologist's Union; member of the British Ornithologist's Union; honorary curator of National Museum following retirement in 1942.

EDWARD PLUNKETT TAYLOR, CMG (1901–), industrialist and financier. Born in Ottawa. Graduated from McGill University. Entered investment house of McLeod, Young and Weir & Co. Ltd., Ottawa, 1923, becoming a director in 1929. President, Canadian Breweries Ltd., 1933; chairman, 1944. Assistant to the Minister of Munitions and Supply, and president, War Supplies Ltd, Washington, 1941. Also president and vice-chairman, British Supply Council in North America. Director-general, British Ministry of Supply Mission, 1942. Canadian chairman, Joint War Aid Committee (Canada-U.S.), 1943. Has served on many corporate boards, notably Argus Corp. Ltd. Now chairman, New Providence Development Co. Ltd, Nassau. Served as chairman, Ontario Jockey Club, and chairman and chief steward, Jockey Club of Canada. In 1976 horses bred in his Windfields stables topped the world in winnings for an unprecedented fourth year in succession. Received first gold medal for distinguished service of the McGill University Graduate Society, 1957.

HAROLD TOWN, OC (1924–), painter, printmaker, sculptor, writer. Born in Toronto. Graduated from Ontario College of Art, and supported himself as deckhand on an oil tanker, syndicated comic-strip artist, department store backdrop artist, sculptor, illustrator, rug designer, and freelance magazine illustrator. Co-founder of Painters Eleven, 1953. Established reputation for fluent draftmanship and striking sense of design. First exhibited in 1956 at Venice Biennale, Painters Eleven, and Riverside Museum, New York. Has continuously exhibited since then with works represented in major collections in many countries. Murals include huge abstract work for Robert Saunders Hydro Power Station, Cornwall, Ontario. Awards include Arno Prize, São Paulo Biennale, 1957; Guggenheim

International Award, 1960; Royal Canadian Academy Honour Award, 1963. Fellow of Founder's College, York University. Has illustrated and/or written *Love where the nights are long* (1962), *Enigmas* (1965), *Drawings* (1969), *Silent stars, sound stars, film stars* (1971), *Albert Frank, keeper of the lanes* (1974), and *Tom Thomson: the silence and the storm* (1977).

RT HON. PIERRE ELLIOTT TRUDEAU, PC, FRSC (1919–), statesman, elected Prime Minister of Canada in 1968. Born in Montreal and educated at University of Montreal, Harvard University, École des Sciences Politiques, Paris, and London School of Economics. Began law practice in Quebec, 1943, specializing in labour law and civil liberties. Co-founder and co-director of monthly review, *Cité libre.* Appointed associate professor of law, University of Montreal, 1943 and at same time carried out research on staff of Institut de recherches en droit publique. Travelled extensively in Europe, Middle East, and Asia, 1948–9. Elected to Parliament for Mount Royal, 1965. Parliamentary secretary to the Prime Minister, 1966–7. Attorney-General and Minister of Justice, 1967. Elected leader in 1968 of Liberal Party, which under him was returned to power. Wrote *Federalism and the French Canadians* (1968), *Réponses* (1967), *Conversation with Canadians* (1972), and was co-author of *Deux innocents en Chine* (1961); contributed to *Canadian dualism/La dualité canadienne* (1960), *The future of Canadian federalism* (1965), and *Politics Canada* (1966).

PAULINE VANIER, PC, CC (1898–), active in public causes. Born and educated in Montreal. In 1921 she married Georges P. Vanier, lawyer, soldier, diplomat, and (1959–67) Governor General of Canada. They had four sons and one daughter. Mme Vanier worked with the St John Voluntary Aid Department during the first world war. From 1939 to 1945 she represented the Canadian Red Cross in France, for which she received the Jacques Cartier Medal from the French government. Named the first lay Chancellor of the University of Ottawa, 1966, and in 1967 appointed to the Privy Council. Cardinal Newman Award, given annually to a Roman Catholic layman making a notable contribution to the country's intellectual life and exhibiting Christian principles in public activities, 1967. Named Canadian Woman of the Year in a Canadian Press poll of editors, 1965. Patron of the Vanier Institute of the Family, established in 1965 by her husband and herself. In 1972, after selling many of her possessions, she moved to Trosly-Breuil, France, to assist her son, Jean, at the headquarters of L'Arche, a movement helping the mentally handicapped.

FREDERICK VARLEY (1881–1969), artist. Born in Sheffield, England; came to Canada in 1912 after studying at Sheffield School of Art and Antwerp Academy, Belgium. Official Canadian Artist overseas during first world war. *Vincent Massey* (1920) was one of his first works to mark him as a great portraitist. Member of the Group of Seven and its successor, the Canadian Group of Painters. Head, Department of Drawing and Painting, School of

Decorative and Applied Arts, Vancouver, 1926–33. Founded the British Columbia School of Art with J.W.G. Macdonald and Harry Tauber, 1933. One-man retrospective exhibition at the Art Gallery of Toronto, 1954. City of Toronto Gold Medal of Merit for distinguished service to art, 1963. Canada Council Medal, 1964. Royal Canadian Academy Medal (posthumously), 1970.

HEALEY WILLAN, CC, FRSC (1880–1968), organist and composer. Born in London, England. Fellow of the Royal College of Organists at 18. Came to Canada in 1913; head of the Theory Department, Toronto Conservatory of Music. Vice-principal, Toronto Conservatory of Music, 1920–36. Professor of music, University of Toronto, 1938–50, and University Organist, 1932–65. Organist and choirmaster at St Mary Magdelene Church, Toronto, from 1921 until his death. Composed chamber music, songs, organ works, choral and instrumental works. *Deirdre* (1944), commissioned by CBC, was first major Canadian opera of this century. First Canadian composer, in 1952, to have his work performed at the annual Royal Concert of the St Cecilia Festival. Wrote one of the Homage Anthems at Coronation of Queen Elizabeth II, 1953. Lambeth Doctorate of Music was conferred on him, 1956, by Archbishop of Canterbury in recognition of long and distinguished services.

JAMES S. WOODSWORTH (1874–1942), clergyman, social worker, politician, author. Born in Etobicoke, Ontario; family moved west in 1882. Educated at University of Manitoba, Victoria University, Toronto, and Oxford University. Ordained Methodist minister, 1896. Organized Canadian Welfare League, 1913, and in 1916 became director of Bureau of Social Research, an organization supported co-operatively by three prairie provinces. Elected to Parliament from North Winnipeg, 1921, and represented that constituency until his death. Elected chairman of the National Council, Co-operative Commonwealth Federation, 1932, and parliamentary leader of the CCF party. Author of *Strangers within our gates* (1908), *My neighbour* (1910), *Studies in rural citizenship* (1915). Resigned as CCF leader, 1940.

TYPESETTING
University of Toronto Press
and
Cooper & Beatty Limited

DUOTONE SEPARATION
Graphic Litho-Plate Inc.

FILM PREPARATION
Franklin Offset Film Service Inc.

INK FORMULATION
Canadian Fine Color Company, Limited

TECHNICAL CO-ORDINATION
M.P. Graphic Consultants Ltd.

PAPER
Rolland Imperial Offset Enamel 200M
and
Strathmore Pastelle, Deep Grey, 176M

LITHOGRAPHY
McLaren Morris and Todd Limited

BINDING MATERIAL
Columbia Riverside Vellum Silver

BINDING
The Hunter Rose Company Limited

DESIGN
Laurie Lewis FGDC

The Canada Council and the Ontario Arts Council
have assisted the production of this book through their programs
of block grants to publishers